*This book is dedicated with all my heart to my supportive family, friends, teachers and students, and, as always, to R.G.L.*

*30th*
ANNIVERSARY EDITION

# EXPLORING
# COLOR
## workshop

*with* NEW EXERCISES,
LESSONS *and* DEMONSTRATIONS

NITA LELAND

**NORTH LIGHT BOOKS**
Cincinnati, Ohio
artistsnetwork.com

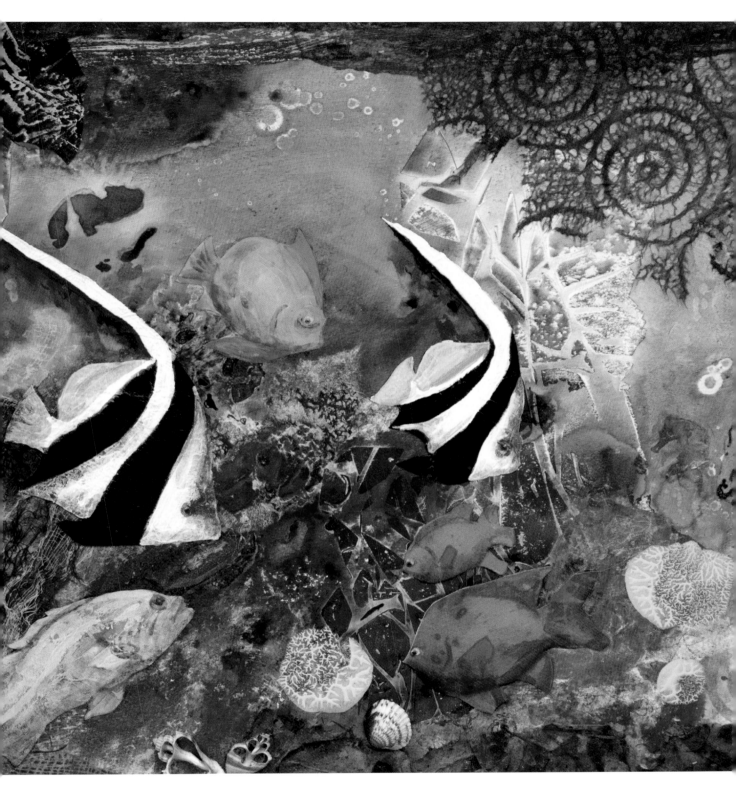

PAINT AS YOU LIKE AND DIE HAPPY. — HENRY MILLER

**AQUARIUM**
Nita Leland
Mixed media acrylic collage
on illustration board
15" × 20" (38cm × 51cm)

# Contents

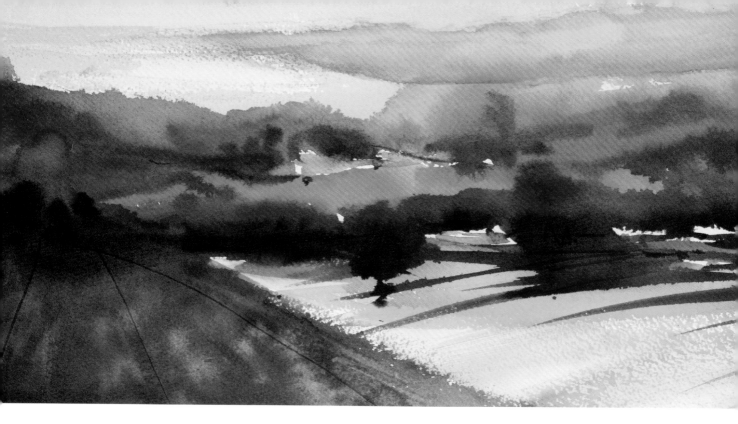

# Color: A Journey and a Destination

If you're an artist and don't understand color, you're like a traveler who left your luggage at home. Sooner or later you'll have to go back and get it if you want to get very far.

Art without color? Inconceivable! But why settle for ordinary color when you can create radiant works of color?

Beautiful color is no happy accident. You can have fantastic color, too. Color can be learned. This book will help you:

- *Build your color vocabulary.*
- *Explore your paints or medium of choice.*
- *Master color mixing with a split-primary palette.*
- *Use harmonious triads and color schemes.*
- *Apply color contrast and design.*
- *Discover distinctive ways of using color.*
- *Expand your appreciation of color science, history and theory.*

To explore color, you can use any type of artists' paint, pastel, oil pastel, colored pencil, yarn, fabric or paper collage—whatever medium you work with. Make collages with colored papers to plan your paintings; make watercolor or acrylic sketches to design your oil canvases. Color knows no boundaries in art media.

Within these pages you'll find fabulous artwork by top artists to inspire you in your color journey. The illustrated glossary in chapter two (and many more terms defined throughout the book) will help you build your color vocabulary. You'll also have a brief introduction to some newer paints and media: interference and iridescent colors in acrylics, PrimaTek mineral pigments, and alcohol-based inks for the adventuresome. Triads and color schemes have been expanded with modern pigments.

Play with color and have fun while you learn. Easy, eye-opening exercises placed throughout the book are designed to help you expand your color skills. Artists in many mediums can do most of these exercises. Reserve some time every day to do one. Collect as many color samples or paints as you can and use them for the exercises. Share with your artist friends and make exploring color a group project. As you do the exercises, you'll see that mastery of color is an achievable goal. Exploring color will make you aware of your color preferences and strengthen your color knowledge.

Once you learn how to mix and arrange colors, exploring harmonious color triads and expanded palettes along the way, you'll have the tools to build a solid foundation for creative color. In no time, you'll start solving the mysteries of color and be well on your way to becoming a master colorist. That means that, if you love color, you can unlock its secrets—if you work at it.

So, begin your travels now in the wonderful world of color, and have a great trip.

—Nita Leland

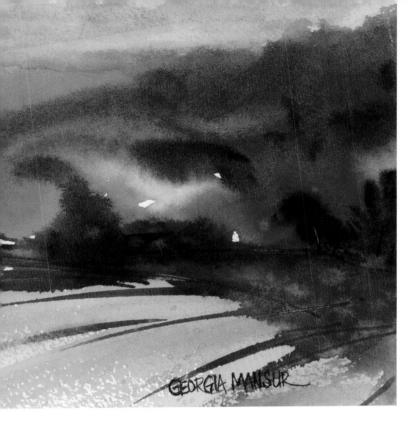

**AUTUMN COLORS**
Georgia Mansur
Watercolor on watercolor ground
8" × 24" (20cm × 61cm)

Mansur's spontaneous brushwork depicts an appealing, vibrant landscape. Here's an artist who is not afraid of color.

## Celebrating 30 years of *Exploring Color*

When I became publisher of North Light Books in 2007, not only did I inherit a legacy of excellence in art instruction, but I inherited a family of authors. Many of those authors I would develop personal relationships with via email and phone conversations, although 90 percent of my authors I have never met in person. Imagine my luck to discover that Nita lives just fifty miles north of our office! It's been a pleasure to be able to meet with her in the office or over dinner where we have discussed new book ideas as well as how publishing has evolved to include blogs, ebooks and videos.

Most art-instruction authors have one book that they can envision, create and share with the world; Nita Leland is one of those rare authors whose vision and passion went well beyond a single book. She's created a dozen books and videos for North Light, always investing her time, energy and professional knowledge to make sure that the products she creates will help artists improve their knowledge of painting. And, she's able to produce so many wonderful products because her personal desire for knowledge about the process of making art is never satisfied. Her generosity, as well as her authority on making art, has made her a gift to the world of art instruction as well as a popular artist and workshop instructor.

When Nita approached us about revising *Exploring Color*, we gave the idea a lot of thought. You don't mess with success. This book had been revised once before, has sold more than 100,000 copies, and has been around for three decades! That's longer than North Light Books has been a part of F+W (North Light was acquired in 1983).

But in the end, we trusted that Nita would deliver, and deliver she did. She and I know that *Exploring Color Workshop* will reach a new generation of artists looking to expand their understanding and use of color. And for those of you already familiar with *Exploring Color*, we hope you enjoy this updated version and all the new art.

Books are only complete once they are read; they need to be touched, dog-eared and maybe even highlighted. So, please explore the pages of this book, savor the images, take in the text and, most of all, apply what you learn to your art. Take as much as you can from these pages and become the artist you desire to be.

—Jamie Markle
Publisher,
North Light Books

1

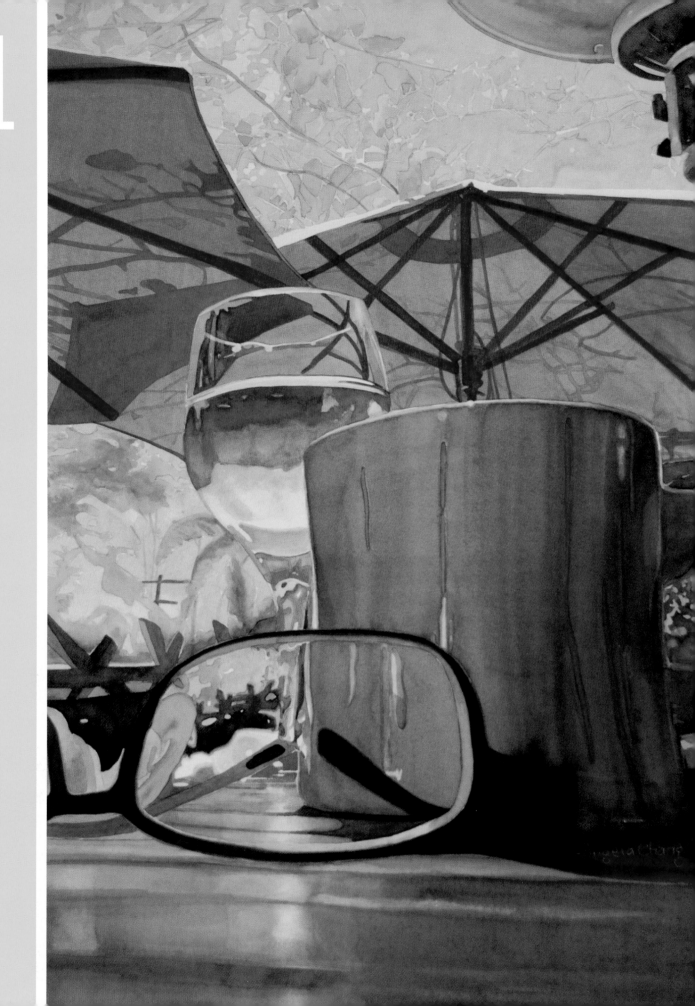

# DISCOVERING THE JOY OF COLOR

ART WITHOUT COLOR WOULD LOSE MUCH OF ITS PURPOSE. — ANDREW LOOMIS

**AFTERNOON AT THE RAMOS CAFÉ**
Angela Chang
Transparent watercolor on paper
28" × 18" (71cm × 46cm)

**MARKETPLACE**
Paul St. Denis
Watercolor with collage
18" × 22" (46cm × 56cm)

When we start out in art, our instructors usually emphasize values and shapes rather than color. That's good, because values are easy to understand. Shapes are, too, since we identify objects by their shapes. But values and shapes make contact with the intellect. Color touches the heart.

Color is important, whether you're a fine artist, graphic designer, decorative painter or fiber artist. After all, to paint is to color a surface; to weave is to mingle colors. But do you really know what you're doing with color? How much time do you spend in trial and error, looking for suitable paint, the right color or the best mixture? Suppose you want to mix a sky color, a skin color or a tree color. Or perhaps you need to match a color for a specific application. Can you use a recipe? Formulas may offer temporary solutions, but one-size-fits-all doesn't work with color.

Develop your color sensitivity and color knowledge, so you can use color with confidence, devising your own solutions to color problems with style and elegance.

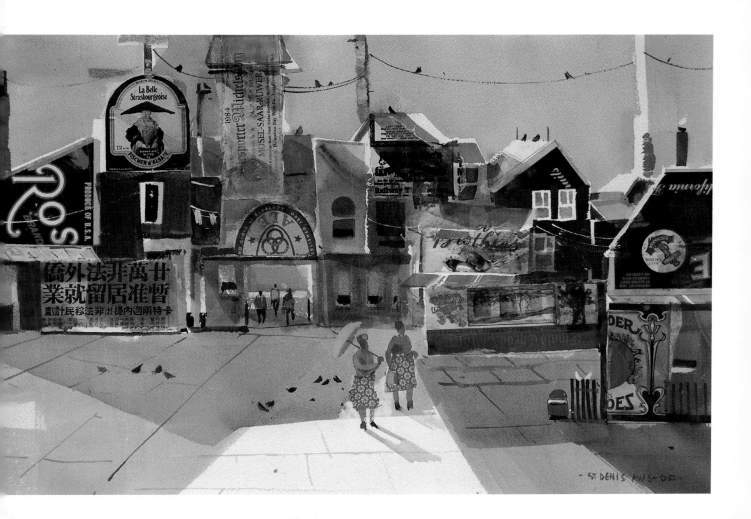

# Color Theory Basics

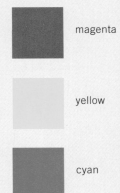

magenta

yellow

cyan

In basic color theory, the **primary colors** cannot be created by mixing other colors, but they can be used to create innumerable mixtures. The traditional primaries of artists' pigments are red, yellow and blue. Ground pigments, which contain impurities and lack spectral clarity, are more opaque than dyes, therefore it is difficult to mix pure colors.

Ideally, red, yellow and blue pigments can be mixed in various combinations to produce the **secondary colors**: red + blue = violet; red + yellow = orange; yellow + blue = green. Mix a secondary with the primary on either side of it on the color wheel to get **tertiary colors**, which take the names of both colors in the mixture. The mixtures are darker than the colors combined to create them when using acrylics, gouache, oils, watercolors and other fine art media.

Modern developments in paint chemistry include many new pigments, such as a modern primary triad of magenta, yellow and cyan. Magenta + cyan = violet; magenta + yellow = orange; yellow + cyan = green. Practice making tertiary mixtures with the colors you have.

**EXERCISE 1:** MIX TO CREATE SECONDARY AND TERTIARY COLORS

This exercise is the foundation of all color mixing and the logical relationships in color theory. Mix the primary colors to make the secondary colors. Then, mix each secondary with a primary to create the tertiary colors. Take time to play with whatever primary pigments you have, making swatches of secondary and tertiary mixtures in a color journal (see Exercise 5). Label the colors you use, so you can refer to them later. Jot down notes on your reactions to new mixtures. Keeping your swatches in rows or columns will come in handy when you're trying to pick a palette for your artwork.

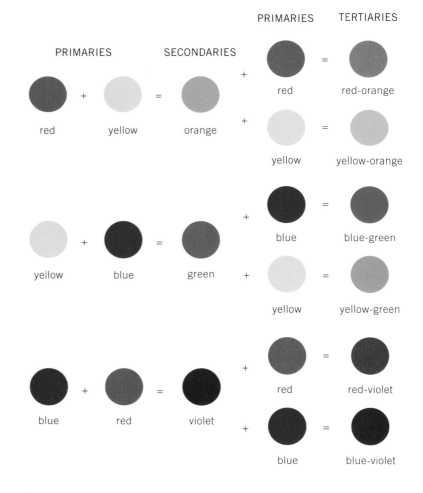

PRIMARIES   SECONDARIES   PRIMARIES   TERTIARIES

red + yellow = orange

red + red = red-orange

yellow + = yellow-orange

yellow + blue = green

blue + = blue-green

yellow + = yellow-green

blue + red = violet

red + = red-violet

blue + = blue-violet

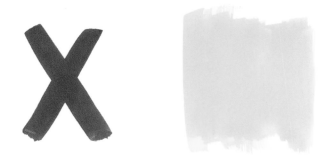

## EXERCISE 2: SEE COLOR CHANGE RIGHT BEFORE YOUR EYES

To see how your eye is affected by strong color, stare at the red X for ten to twenty seconds, then look away at a white space. You'll see the complement (opposite) of red, which is green. Try it again, this time looking at the yellow area. The complementary green mixes with the color you're looking at, turning yellow into yellow-green. This phenomenon—called **successive or mixed contrast**—affects the way you see color as you work, so rest your eyes frequently when working intensely with color.

green + orange
(olive)

orange + violet
(russet)

green + violet
(slate)

## EXERCISE 3: MAKE A TERTIARY TRIANGLE

Artists of the past often combined two secondary mixtures to create what some called compound colors, or muted mixtures. This old-style diagram is based on Johann Wolfgang von Goethe's color triangle. Use primaries to mix secondaries, placing all as shown. Mix two secondaries to create the tertiary color between them.

Create several more triangles, switching out the primaries. Your results will vary depending on which pigments you mix. Some combinations result in subtle chromatic neutrals; others look like mud. Some you may find useful for painting shadows or modifying glazes.

## EXERCISE 4: CREATE COLOR WHEELS FROM BASIC TRIADS

See what mixtures you can make with all the primary colors you have now. Using what you've learned about mixing, create a twelve-color wheel on medium-weight paper, canvas or illustration board. Sort your colors into triads of red, yellow and blue, or magenta, yellow and cyan. Put all other colors aside. Then, mix your different reds and yellows (two colors per mixture) to find the best orange mixture. Place this color on your wheel and label it with the names of the colors in the mixture. Repeat the exercise with every yellow and blue or cyan (for green), then with every blue or cyan and red or magenta (for violet). Study the mixtures for a while. Don't worry if some of your colors look muddy. Color wheels made from triads of primary colors you have help you organize your thinking about color and expand your color choices.

yellow

yellow-
orange

yellow-
green

orange

green

red-
orange

blue-
green

red

blue

red-
violet

blue-
violet

violet

KEY
Square = primary   Circle = secondary   Triangle = tertiary

# Explore Color in Your Medium

Exploring color knows no boundaries in art media. Experience for yourself how color works in your medium, because they all have idiosyncrasies. You may be a painter or calligrapher, a colored pencil artist or pastelist; even collage and mixed media artists, weavers, knitters and quilters benefit from exploring color. Make collages with Color-aid papers to design your color schemes, or use watercolor or acrylic sketches to plan the color in your oil canvases. Then, trust your intuition to lead you to unique color expression.

**EXERCISE 5:** START A COLOR JOURNAL

To find out what colors resonate with you, start a color journal in a sketchbook. List artists whose work you like. Figure out what you like most about them by studying their work. Is it their brilliant use of color or strong values? Do you like unusual color? Do you prefer subtlety to boldness? Write down your reactions. Get a sense of what attracts you—and what you don't like—so you can relate this information to what you learn as you explore color. Play with swatches in your journal, arranging them spontaneously or in columns on a grid. The important thing is to get the information and the colors down while you're working with them and your reactions are fresh in your mind. (Watercolor and ink journal pages by Patricia Kister)

 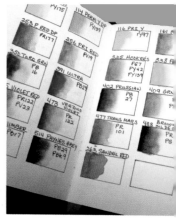

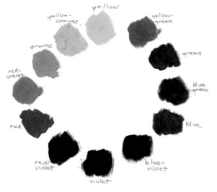

Color wheel in oils

Color wheel in acrylics

Color wheel in fibers (yarn)

**EXERCISE 6:** MAKE A COLOR WHEEL
IN YOUR FAVORITE MEDIUM

Create a color wheel using swatches of your favorite medium—paint, pastel, colored pencil, fabrics, paper or yarn. Apply colors to a wheel drawn on paper, canvas or illustration board, or create mixtures that can be cut out and glued onto a separate support with acrylic matte or soft gel medium. Always put yellow at the top and move clockwise toward green and blue.

Make reference color wheels in every medium you work with. Each experience reinforces your understanding of color principles, regardless of how the colors are mixed and applied. Collage artists adhere paper clippings with acrylic mediums; quilters make cloth samplers. Oil and acrylic painters, as well as pastelists and colored pencil artists, use gessoed paper or canvas. Share materials and colors with artist friends to increase your knowledge.

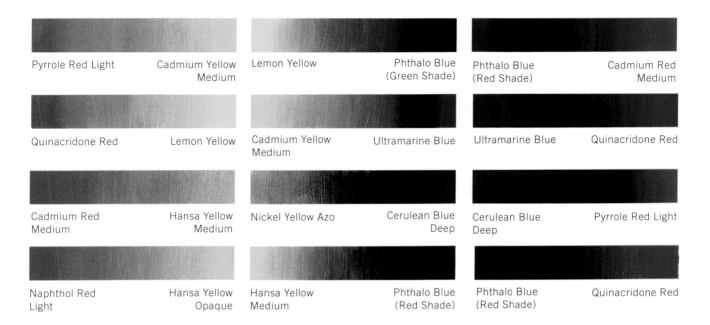

| Pyrrole Red Light | Cadmium Yellow Medium | Lemon Yellow | Phthalo Blue (Green Shade) | Phthalo Blue (Red Shade) | Cadmium Red Medium |
| Quinacridone Red | Lemon Yellow | Cadmium Yellow Medium | Ultramarine Blue | Ultramarine Blue | Quinacridone Red |
| Cadmium Red Medium | Hansa Yellow Medium | Nickel Yellow Azo | Cerulean Blue Deep | Cerulean Blue Deep | Pyrrole Red Light |
| Naphthol Red Light | Hansa Yellow Opaque | Hansa Yellow Medium | Phthalo Blue (Red Shade) | Phthalo Blue (Red Shade) | Quinacridone Red |

**EXERCISE 7:** COMBINE AND COMPARE ACRYLIC PRIMARIES
Which colors should you use for your primaries? Here's where color theory gets confusing. You can see how different these acrylic mixtures are when I use different paint colors for my primaries. For each sample, I applied a different primary to each end of the strip and gradually mixed them across the space, since acrylics don't mingle like watercolors when you use high-viscosity paints. The more you explore your paints, the sooner you'll be able to get the color mixture you want, every time.

Learn to appreciate the unique beauty of different mixtures. Record a swatch of each mixture in your color journal, along with a note about the colors you used. These references will come in handy when you're painting. Maybe that dusky purple will be just right for a blue grape, or the dull orange might make a good shadow for a pumpkin.

SHAPE VS. COLOR
An object is identified by shape, no matter how bizarre its color. Apparently, shape recognition is a function of the intellect, while color awareness is intuitive. You have a great deal of freedom in choosing colors when you're working with a recognizable shape. A blue pear? A purple cow? You can be whimsical, dramatic, even absurd, if you like.

# How Do You Currently Use Color?

Most artists start out using their teacher's colors or copying a palette from a book. Perhaps you've been painting long enough to have developed a color style that clearly distinguishes your work from others. But do your colors always say what you want them to say? Do you find you're repeating yourself with colors? Do you limit your subjects only to those suitable for certain colors? Think for a moment about what you're doing with color now.

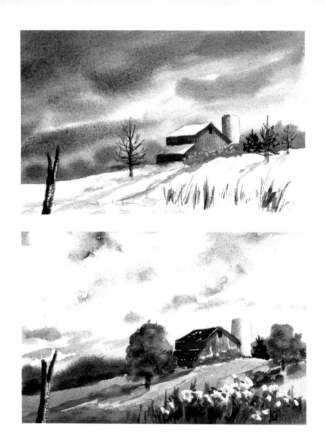
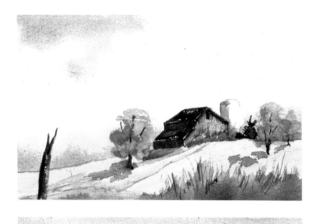
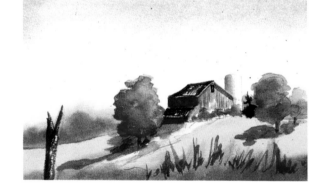

**EXERCISE 8:** PAINT THE FOUR SEASONS

Divide a sheet of paper, illustration board or canvas into four sections. Using the colors and the medium you're most familiar with, sketch the four seasons, or make abstract color sketches of this subject in collage or fibers. If you prefer, you can make a nonobjective design of geometric shapes. Be inventive with the colors you have, but don't experiment with new colors yet. These sketches are a record of how you use color now; they're not meant to be finished work. Keep them for comparison with later exercises.

Your first paintings of the four seasons should show the range of color effects you can get with your present palette before exploring color. Here I've used the three colors my teacher required when I first started painting. The little sketches turned out all right, but some color mixtures aren't exactly what I wanted.

## TRADITIONAL PALETTE

| Permanent Alizarin Crimson | New Gamboge | French Ultramarine |

14

# What's Your Color Personality?

If you've ever taken a color personality quiz online or asked a fashion consultant to match you to your personal colors, you probably had mixed results. One system is based on your intuition and the other on your physical appearance. When it comes to making art, you'll get the best results by combining your knowledge of color principles with your sense of which colors you prefer to look at and to work with. The artists throughout this book have distinctive color personalities. Finding ways to explore color will help you reveal yours.

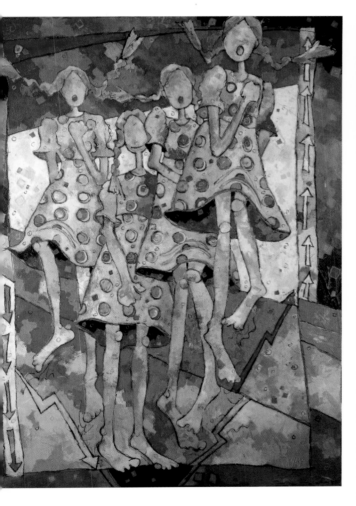

**SKIPPER**
Susan Webb Tregay
Acrylic on canvas
40" × 30" (102cm × 76cm)

ARE WE HAVING FUN YET?
Tregay embraces no-holds-barred color, using bright primaries and adding pink for even more fun. Painting can be serious business, but that doesn't mean you can't play while doing it.

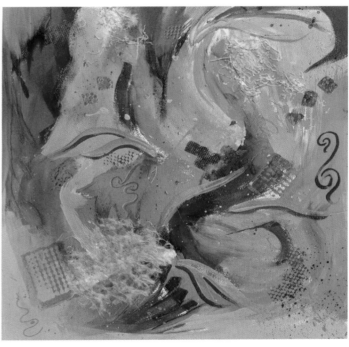

**LOVE THAT TURQUOISE!**
Judy Horne
Acrylic and collage on cold-press watercolor paper
21" × 21" (53cm × 53cm)

HOW BRAVE ARE YOU?
My heart almost stopped when I saw Horne's colorful abstract. I admire the courage of her stunning color and the energetic rhythms of the whirling brushstrokes.

# LEARNING THE LANGUAGE OF COLOR

COLORS ARE FORCES, RADIANT ENERGIES THAT AFFECT US POSITIVELY OR NEGATIVELY, WHETHER WE ARE AWARE OF IT OR NOT. — JOHANNES ITTEN, *THE ART OF COLOR*

**NIGHT IN THE CITY**
Thomas W. Schaller
Watercolor on paper
30" × 22" (76cm × 56cm)

**FREE SPIRIT**
Denise Athanas
Acrylic on canvas
20" × 20" (51cm × 51cm)

In this chapter are three keys to help you unlock the mysteries of color. The first is an illustrated glossary. Artists need words to communicate, but images help us understand their meaning. I placed the glossary near the beginning of the book so you can familiarize yourself with important color terms right away. The second key shows how lighting affects color. No matter what you know about paint and color mixing, the lighting you use to paint or display your work makes a huge difference in how it appears to the viewer. The third key is a discussion of the all-important properties of color: hue, value, intensity and temperature. And then, we'll be ready to talk about paint.

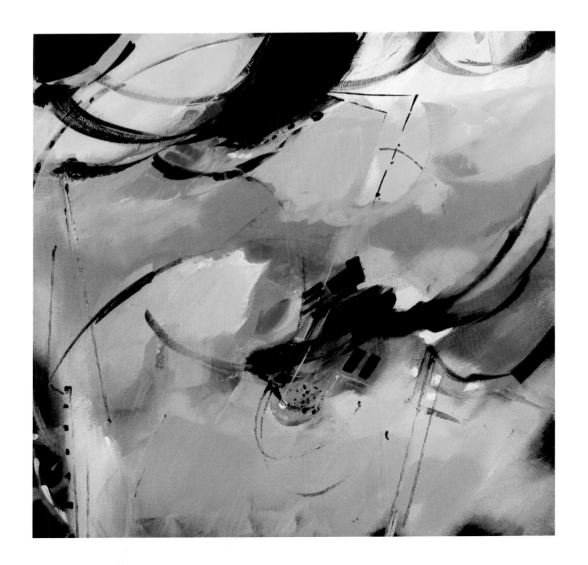

# Illustrated Glossary of Color Terms

Like every specialized area in art, color has its own language. Following are definitions of some of the color terms we will explore in greater depth throughout this book.

**EXERCISE 9:** MAKE A GLOSSARY IN YOUR COLOR JOURNAL
Reserve the last twenty or so pages of your color journal for a glossary. Anytime you come upon something in a techniques book or hear a word that you don't understand at a workshop, add the term to your glossary with an image for easy reference. Jot down definitions of unfamiliar words you want to remember and use a glue stick or soft gel medium to paste in small images that define the words. Another option is starting a shoebox file just for your glossary.

**color contrast:** differences in hue, value, intensity, temperature, complements or quantity

**color harmony:** matching pigments for similarities of intensity, transparency, opacity and tinting strength

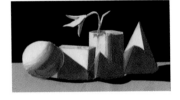

**achromatic:** lacking color; black, gray or white; neutral

**color identity:** an obvious color bias in a mixture

**additive color:** derived from light mixtures

**analogous colors:** colors next to each other on the color wheel, such as blue, blue-green and green

**color index name:** color name and specific pigment identifier, as in PR108 for Pigment Red, Cadmium Red; sometimes called *C.I. Name*

**chromatic:** having color, as opposed to achromatic black, white and gray; opposite of neutral

**color scheme:** orderly selection of colors based on logical relationships on the color wheel

**chromatic neutral:** a neutral mixture that hints at the pigment colors used

**color wheel:** a circular arrangement of the colors of the spectrum

**complementary colors:** opposites on the color wheel; enhance each other when side by side; neutralize when mixed

**gradation:** gradual change; provides transition and movement in color design

**dominant light or color:** the predominant light in a composition caused by changes in season, weather, time of day or region

**granulation:** sedimentary effect in washes; also, *flocculation*

**hue:** the spectral name of a color (red, orange, yellow, green, blue or violet)

**dye or ink:** transparent coloring matter dissolved in fluid; absorbed by a surface

low intensity

high intensity

**intensity:** the degree of purity or brightness of a color; sometimes, *chroma* or *saturation*

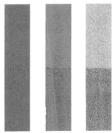

stable    slight change    fugitive

**fugitive color or pigment:** a chemically unstable pigment that fades or changes under normal conditions of light or storage

high key

low key

**key:** the dominant value relationships in a picture

*high key:* medium to light values
*low key:* medium to dark values
*full contrast:* light, medium and dark values

**glaze:** a transparent or translucent veil of color modifying an underlying color

successive layers get darker/neutralized

single layers modify color without darkening

**limited palette:** selection of few colors for an artwork

**local color:** the natural or painted color of an object

**palette:** the surface on which colors are mixed; also, the colors selected for use in an artwork

**pigment:** powdered coloring matter used in the manufacture of paint

**luminosity:** radiance or glow in an artwork

**primary color:** a color that cannot be mixed from other colors; yellow, blue, red, magenta, cyan

**mingle:** to blend paints without excessive mixing, so colors retain some of their identity

 *Hue:* green

 *Value:* dark/light

 *Intensity:* pure/gray

*Temperature:* cool/warm

**properties of color:** hue, value, intensity, temperature

**mixed contrast:** the afterimage of a complementary color seen after viewing a color; overlay of an afterimage on another color

**monochromatic:** having a single color

**reflected color or light:** color or light on an object that is reflected off of adjacent objects

**opaque:** having covering power; not transparent

**secondary color:** a color resulting from the mixture of two primary colors; orange, green or violet

**semi-opaque:** slightly or nearly opaque

**semi-transparent:** slightly or nearly transparent

**optical mixture:** occurs when small areas of color are juxtaposed and perceived by the eye as a mixture; also, *mixed contrast*

**shade:** medium-to-dark value of a color

**paint:** pigment particles suspended in a binder

**simultaneous contrast:** any one of several effects that colors have on each other when juxtaposed and viewed together or successively

**spectral color:** the colors produced when white light passes through a prism: red, orange, yellow, green, blue, violet

weak    strong

**tinting strength:** the power of a color to influence mixtures

**split primaries:** a warm and a cool pigment for each primary color (six primaries), used in color mixing

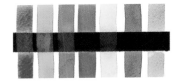

**tone:** a color modified by gray or a complement

**staining color:** a color that penetrates the surface; also, *dye*

**subtractive color:** derived from paint mixtures that absorb all colors except the local color of the object, which is reflected

**successive contrast:** the afterimage of a complementary color seen after viewing a color

**toned support or ground:** paper or canvas having a preliminary color wash or undertone; underpainting

warm hues

cool hues

**temperature:** the relative warmth or coolness of colors

**transparent:** permits light to penetrate and reflect off the surface of a support or allows another color to show through

**tertiary color:** mixture of a primary and its adjacent secondary: for example, red-orange or blue-green

**triad:** a color scheme having three colors with a logical relationship on the color wheel

**tetrad:** a color scheme having four colors with a logical relationship on the color wheel

**value:** the degree of lightness or darkness of a color

**tint:** a light value of a color

**wet blending:** applying several layers of color without waiting for each layer to dry

# The Language of Lighting and How It Affects Color

Your brain controls what your eyes see. If you wear a red sweater, you will probably see it as red no matter what color of light illuminates it. This phenomenon is called color constancy. My students remark that their artwork looks different when they take it home. They notice the change on the way to the car and in different rooms in the house. This effect is directly related to the changing light that surrounds them. Here are some strategies to help you increase your awareness of that elusive light and control the light to achieve more consistent color in your artwork.

Normally, you can't control the lighting that illuminates your painting on someone else's walls, but if you use color-correct lighting when you paint, your work should be presentable in most situations. I use full-spectrum (sometimes called daylight or natural) fluorescent lighting in my studio. The Vita-Lite and GE Sunshine bulbs I've used have lasted 10–15 years and give great color rendition at 5000–5500K. I buy them at lighting specialty and home improvement stores. If your space is small, use desktop lamps or floor lamps with full-spectrum bulbs.

Whatever lighting you use while you paint, I suggest that you view your work under different lighting conditions. I take a break while working on a painting to check the colors under different lights in my home. I carry it to a window for daylight, take it to the laundry room for non-spectral fluorescent, and to my living room for incandescent lighting. Each gives me a different reading and I make a note of my observation in my color journal.

**EXERCISE 10:** COMPARE LIGHTING SITUATIONS WITH YOUR CAMERA
To see for yourself how lighting changes your colors, set your digital camera on manual and photograph a piece of your art using the different white-balance settings offered on your camera. My camera has settings for sunny, cloudy, non-spectral fluorescent, full-spectrum fluorescent and incandescent lighting. Don't use the auto setting, where the camera chooses the lighting for you. For this exercise, do not change the light source or move your picture. Compare the results.

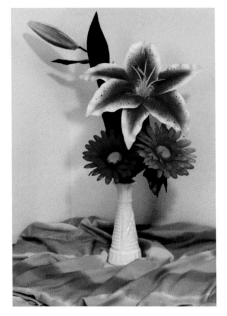 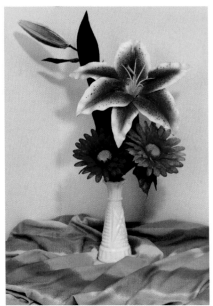 

HOW LIGHTING CHANGES THE COLORS WE SEE
Use consistent lighting when you're exploring color. The three settings I used for these photos are full-spectrum fluorescent (left), daylight/sun (middle) and incandescent (right). I prefer the full-spectrum fluorescent setting, because it doesn't have a strong color bias.

# The Properties of Color

When you visit a foreign country, you're more comfortable if you understand the language. The same is true with color. Artists use commonly accepted terms to describe the properties of color. Hue, value and intensity are the foundation words of color in every medium. **Hue** is the general name of a color; **value** is its lightness or darkness; **intensity** is its purity or grayness. One more property, **temperature**—the warmth or coolness of a color—critically affects color relationships.

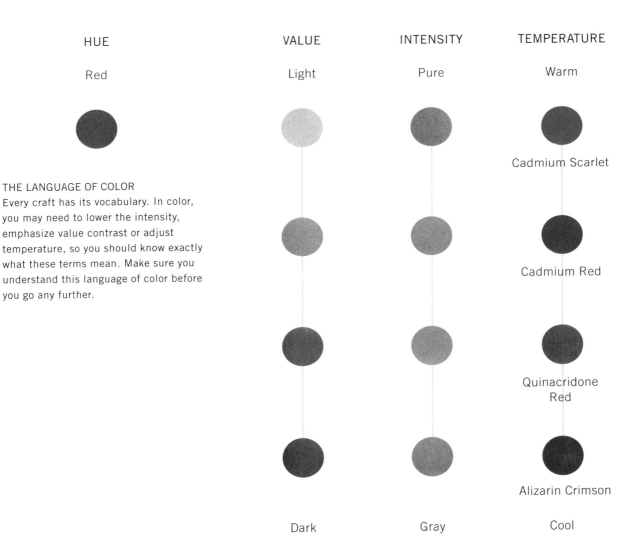

HUE

Red

VALUE

Light

INTENSITY

Pure

TEMPERATURE

Warm

Cadmium Scarlet

Cadmium Red

Quinacridone Red

Alizarin Crimson

Dark

Gray

Cool

THE LANGUAGE OF COLOR
Every craft has its vocabulary. In color, you may need to lower the intensity, emphasize value contrast or adjust temperature, so you should know exactly what these terms mean. Make sure you understand this language of color before you go any further.

# Hue

Hue is the name or attribute of a color that permits it to be designated as red, orange, yellow, green, blue or violet. As each color moves toward the next on the color wheel, it assumes the characteristics of its neighbor. The general names of these in-between, tertiary colors are: red-orange, yellow-orange, yellow-green, blue-green, blue-violet and red-violet. All of these colors comprise the twelve hues on the color wheel shown on this page.

The color wheel establishes logical relationships useful in color mixing and design. You'll frequently use the wheel to organize and study these relationships, so get to know it well. Familiarize yourself with the exact locations and names of hues around the circle. Always orient your color wheels like a map, with yellow, the lightest hue, at the top and violet, the darkest, at the bottom. Place primary red to the lower left on the wheel and blue to the lower right.

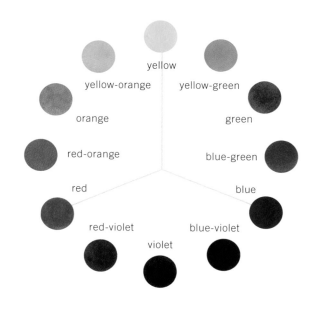

## HUE VS. PAINT NAME
Hue and color are general terms. The hues in this small sketch are red, yellow, green and blue. Pigment and paint names, which we'll examine in chapter three, are more specific. Artists invariably ask what paint colors were used. The paint names used here are Alizarin Crimson, Cadmium Yellow Light, Permanent Green Pale and Ultramarine Blue. Three of the paints are "single pigment" colors. Permanent Green Pale is a mixture of two pigments.

**EXERCISE 11:** PRACTICE PLACING COLORS ON THE COLOR WHEEL
Select a tube each of twelve spectral colors you think will make a bright color wheel. If you're not a painter, make your wheel with colored pencils, fibers, collage papers or whatever your medium is. Don't worry if you don't have a full range of spectral colors; you'll learn to mix colors in chapter four. Now, lay out a color wheel that resembles the face of a clock, beginning with yellow at the top (twelve o'clock). Move clockwise toward green in the following order: yellow, yellow-green, green, blue-green, blue (four o'clock), blue-violet, violet, red-violet, red (eight o'clock), red-orange, orange and yellow-orange. Label your wheel with the names of the paint colors you used in each mixture, as well as brand names, for future reference. (I didn't label mine here, because I want you to use your own selections for this wheel.)

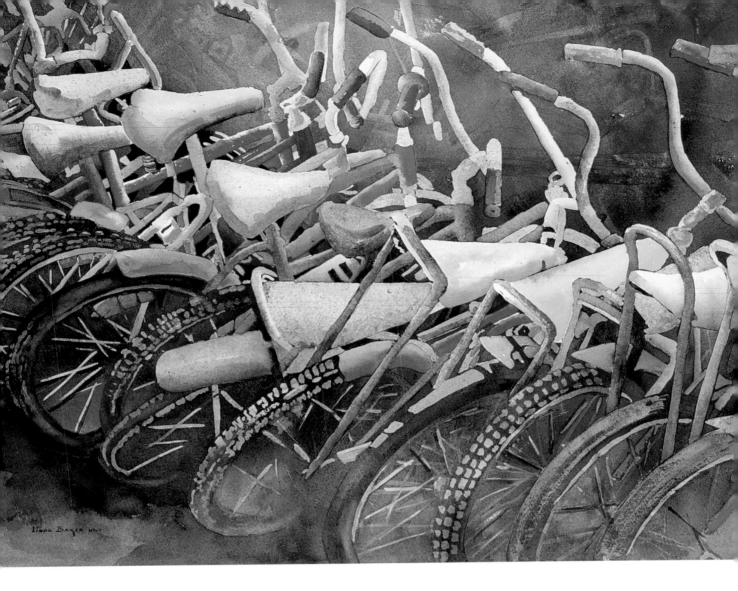

**ALL IN A ROW**
Linda Daly Baker
Transparent watercolor on
cold-press watercolor paper
22" × 30" (56cm × 76cm)

PURE COLORS MAKE A BOLD STATEMENT
Baker's playful watercolor shows an ordinary subject reflecting prismatic colors in sunlight. What is the real subject of this painting? Of course, it's color.

**EXERCISE 12:** SEARCH FOR A FULL RANGE OF HUES
Cut 2" (5cm) squares from fabric scraps or color clippings from magazine pages to make a rainbow. This is more than a fun exercise—it's essential eye training to help you see the differences in color relationships. Make one or more with plain colors and others with dominant colors in prints and patterns. Glue your patches to cardstock using fabric glue or acrylic soft gel medium. Whether you use paint, paper or fibers, you can find a full range of hues to make your rainbows, but you can add more colors if you wish.

# Value

Value is the degree of light or dark between the extremes of black and white. A tint moves toward white; a shade moves toward black. Yellow is the lightest color, becoming white in just a few value steps; violet is the darkest color, quickly descending to black. All other colors fall in between. Red and green, which are similar in value, are situated near the middle of the value scale. Distinguishing values is one of the most important skills in art. Use value to create contrasts between colors, adding visual impact and drama.

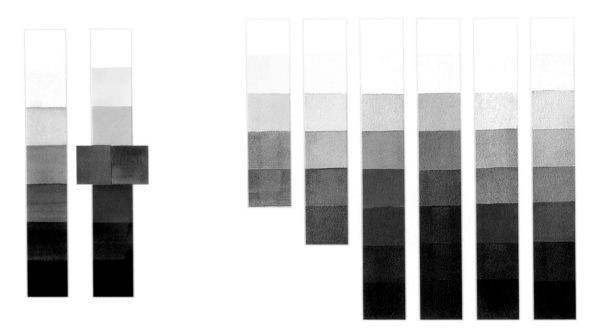

**EXERCISE 13:** COMPARE PURE COLORS TO GRAYSCALE VALUES
Make a value scale from light to dark, showing discernible differences between value levels on the scale. If you paint, add Payne's Gray, Ivory Black, Neutral Tint or some other dark neutral for dark values, and diluent or white for light values. If you work in fibers, select different values of materials from your scrap basket. You may also use colored pencils, or make a collage chart of different values clipped from magazines and pasted to paper or cardboard. Divide a 1" × 7" (2.5cm × 18cm) vertical column into seven 1" (2.5cm) segments. Place black at the bottom of the scale. Leave the top section white, and below the white, place a light gray. Fill in the remaining spaces with intermediate values, showing distinct, progressive steps toward black.

Then, get a good sense of how values work in color by making a scale that shows the approximate color values corresponding to black, gray and white. No color is as bright as white or as dark as black, but every color in its pure state has a value that corresponds to a level on the black-and-white scale.

**EXERCISE 14:** WORK OUT VALUE SCALES FOR VARIOUS COLORS
Select six or more bright colors from your palette, including the purest red, yellow and blue you have. Place each color on a scale at its proper value level, using the black-and-white scale for reference. Now make a value range for each color, mixing with diluent (water or thinner) or white to create lights and Neutral Tint or Payne's Gray for darks. Place the light values above and the darker ones below the pure hue, as shown. From one value step to the next, show a discernible difference.

Some colors have a more extensive value range than others, retaining their identity as they become darker. For example, blue remains recognizable as blue, no matter how dark it gets; but notice how quickly yellow and orange lose their color identity as they get darker.

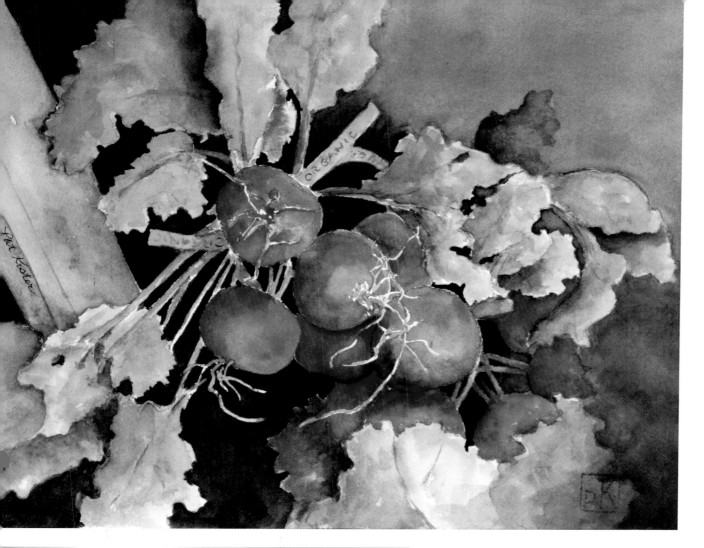

### JUST ORGANIC
Patricia Kister
Watercolor on cold-press watercolor paper
11" × 15" (28cm × 38cm)

RIDING THE RANGE
Emphasizing a full range of values from light to dark, Kister makes a strong visual statement with a simple subject. This is the foundation of good painting.

### LIKE MINDS
Mark E. Mehaffey
Watercolor on paper
35" × 35" (89cm × 89cm)

A CLEVER OBSERVATION
Mehaffey captured striking value patterns with a limited palette of black and white enhanced by skin tones. Casual observers might not notice the interesting juxtaposition of art and fashion; this artist has the skill and the wit to bring the story to life.

# Intensity

The intensity of a color, sometimes called chroma, is its brightness (purity) or dullness. A pure, bright color is high intensity; a grayed color is low intensity. The extreme of low intensity is neutral gray. Pigment colors such as Permanent Rose, Cadmium Yellow and Ultramarine Blue are high-intensity colors, but no matter how bright they look, they can't match the brilliance of spectral colors and projected or transmitted light.

It's important to be able to see—and create—subtle differences in intensity. Varying intensity gives you control over compositional emphasis and creates a setting for extraordinary color effects.

When you mix two neighboring high-intensity colors, the mixture is slightly lower in intensity than either color by itself. Intensity declines most in mixtures when the two parent colors are far apart on the color wheel. Other ways to lower intensity are to mix bright colors with gray, black or an earth color. But remember, once you have lowered the intensity of a color, you can't turn it back into a pure hue, no matter how hard you try. Once a mixture gets muddy, it never seems to improve.

## THE ASPECTS OF A COLOR

When you mix a pure, high-intensity color with white, you get a **tint**; with gray, a **tone**; with black, a **shade**.

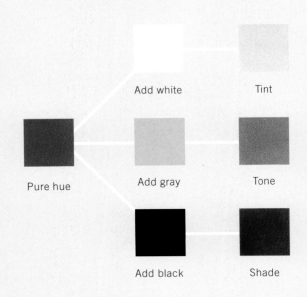

Add white      Tint

Pure hue      Add gray      Tone

Add black      Shade

---

INTENSITY

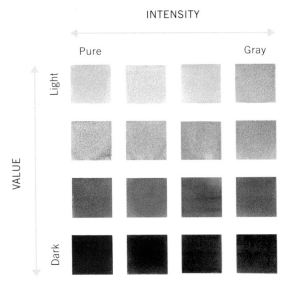

Pure      Gray

Light

VALUE

Dark

**EXERCISE 15:** CREATE SUBTLE DIFFERENCES IN INTENSITY
Starting with a pure, high-intensity color like Ultramarine Blue, make a vertical value scale from light to dark on the left side of your paper or canvas, using only water, thinner or white to change the value. Then, using Neutral Tint or some other neutral, mix a light gray. Add a small amount of this gray to the tint on your palette, trying to match the value of the tint at the top of your chart. Place a swatch of this slightly grayed mixture to the right of the pale tint. Continue across the top row, adding more gray and less color for each swatch as you go, and always trying to match the value of the first tint. The last swatch should be gray, with just a hint of the original color.

Move down to the next row and repeat the process. Remember always to match the value of the first color in the row, as you lower the intensity of that color. Then repeat this exercise with another color. Notice how colors with a lighter value, such as yellow, make appealing tints, but change drastically as they darken. Colors of darker values, such as red and violet, make rich tones and shades and still retain their color identity throughout the change. Also, experiment using earth colors to lower intensity. Make a chart like this one with every color you use.

**ZINNIA GLORY**
Julie Ford Oliver
Oil on canvas
6" × 8" (15cm × 20cm)

### INTENSITY ATTRACTS, WHETHER YOU USE A LITTLE OR A LOT

At left, artist Julie Oliver reserves low-intensity colors for her background and tones down the foreground to emphasize intense flower hues. Below, she embellishes a lowly, unlikely subject— a worn-out broom—with low-intensity earth colors, adding a splash of red to make the viewer smile.

HIGH INTENSITY

| Permanent Rose | French Vermilion | Sennelier Yellow | Permanent Green Pale | Hooker's Green | Cobalt Blue |

LOW INTENSITY

| Caput Mortuum | Light Red Oxide | Yellow Ochre | Olive Green | Green Earth | Indigo |

**EXERCISE 16:** SORT YOUR STASH BY INTENSITY

Gather your tubes of paint, pastels, collage papers or whatever medium you're working with and sort them into two piles: high intensity and low intensity. Divide a page of your color journal into two columns and list the bright, high-intensity colors in the left column and the duller, low-intensity ones in the right column. Place a small swatch beside the name of each color. It takes a while to do this, but it's a real time-saver when you're trying to find or match a color in your artwork.

Colors like Vermilion, Cadmium Yellow and Ultramarine Blue are high intensity as they come from the tube. Others, like Brown Madder, Yellow Ochre and Indigo, are low-intensity paint variations of red, yellow and blue. In fibers, heather yarns and natural-dyed fabrics are low-intensity materials. Learn to see the difference.

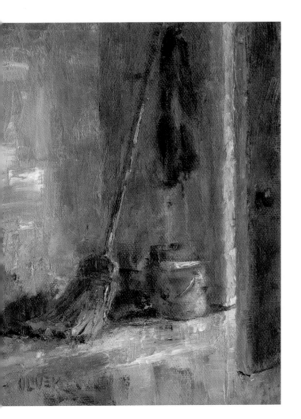

**ABANDONED**
Julie Ford Oliver
Oil on canvas
8" × 6" (20cm × 15cm)

# Temperature

Color temperature helps you create depth, movement and mood. **Warm colors** are aggressive and appear to advance; **cool colors** are passive and seem to recede. The wrong temperature in one area may disturb the balance in a piece, but correctly placed warm/cool contrast can add the zing you need for your focal point.

The spectrum contains both warm and cool colors. Yellow, orange and red are generally warm, and green, blue and violet are considered cool. This is the most easily recognized distinction in color temperature. However, color temperature is relative. A color that appears warm in one place may look cool in another. Red-orange is the warmest color, so as you move away from it in either direction on the color wheel, your colors will all seem cooler, until they reach blue-green, which is the coolest color. Then, as you return from blue-green to red-orange, your colors appear warmer. Study this on your color wheel, so you can see clearly how it works.

Try comparing different blue paints, fabrics or papers. Although you know blue is a cool color on the spectrum, when you line up a series of blues, you'll see that some are warmer, leaning toward violet, while others are cooler, with a bias toward green. Every hue has many temperature variations in pigment. Practice will help you see the differences.

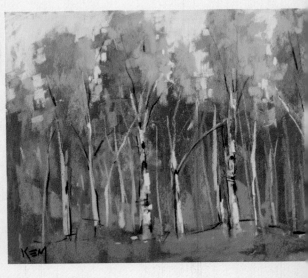

**THE GRAND FINALE**
Karen Margulis
Pastel on sanded paper
9" × 12" (23cm × 31cm)

THE WARMTH OF BLUE
The bright yellow foliage of the aspen trees is enhanced by the blue of the background. This blue doesn't convey cold mountain air; rather, it suggests the warmth of autumn sunshine.

warmer ←——————————————→ cooler

TEMPERATURE IS RELATIVE
Colors move from warmer to cooler in this collage study. The top row starts with a cool red, but the temperature becomes even cooler as it moves toward blue, stopping at blue-violet. That same blue-violet begins the bottom row as the warmest color, moving toward a cool blue-green. The temperature turns slightly warmer as the last chip picks up some green on the other side of the blue-green.

COOLER                              WARMER

| Indian Red | Raw Umber | Light Red Oxide | Burnt Sienna |

| Terre Verte | Indigo | Olive Green | Indanthrone Blue |

| Yellow Ochre | Neutral Tint | Gold Ochre | Ivory Black |

THE TEMPERATURE OF EARTH COLORS
As a group, earth colors are cooler than spectral colors, because they are low-intensity, grayed versions of colors. However, there are still noticeable differences in color temperature from one earth color to another.

30

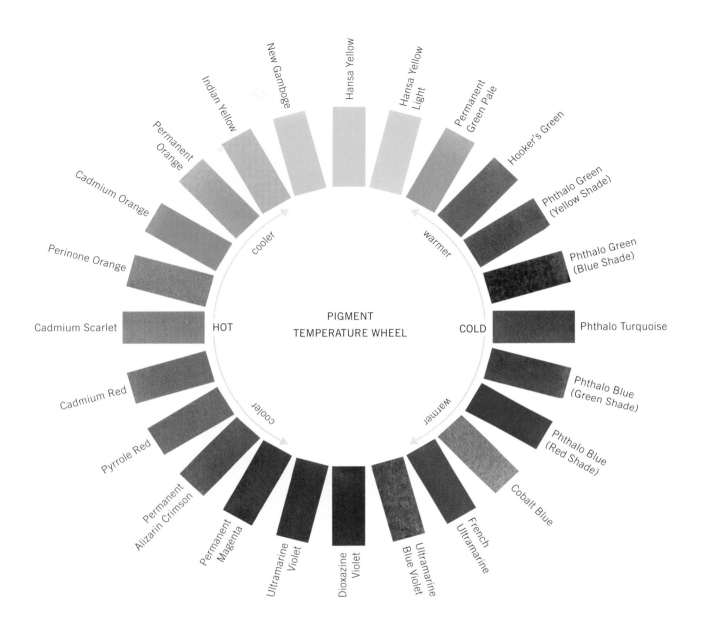

Indian Yellow
New Gamboge
Hansa Yellow
Hansa Yellow Light
Permanent Orange
Permanent Green Pale
Cadmium Orange
Hooker's Green
Perinone Orange
Phthalo Green (Yellow Shade)
Cadmium Scarlet
Phthalo Green (Blue Shade)
Phthalo Turquoise
HOT
PIGMENT
TEMPERATURE WHEEL
COLD
Phthalo Blue (Green Shade)
Cadmium Red
Phthalo Blue (Red Shade)
Pyrrole Red
Cobalt Blue
Permanent Alizarin Crimson
French Ultramarine
Permanent Magenta
Ultramarine Blue Violet
Ultramarine Violet
Dioxazine Violet
cooler
warmer
cooler
warmer

**EXERCISE 17:** EXPAND A COLOR WHEEL
GUIDED BY TEMPERATURE

Sort your high-intensity colors into the twelve primary, secondary and tertiary colors of the color wheel. Put away your earth colors for the time being. On a firm support, such as heavy paper or medium-weight illustration board, start with a true yellow (not greenish or orangish) at the top, and make swatches of colors moving clockwise on a color wheel, toward green. Label the colors as you go along. Continue adding swatches around the wheel, showing a gradual change in color temperature leading from one color to the next and returning to yellow. Every color on this wheel has a slightly warmer color on one side of it and a slightly cooler one on the other, except for red-orange and blue-green, which are the warmest and coolest colors. When you move to the next color, the first one becomes the warmer or cooler one, depending on which direction you're going.

Compare the colors before placing them on the wheel. Rest your eyes occasionally, so you can see the colors more accurately. When you feel confident that you recognize temperature differences in pure colors, make a similar chart using the earth colors.

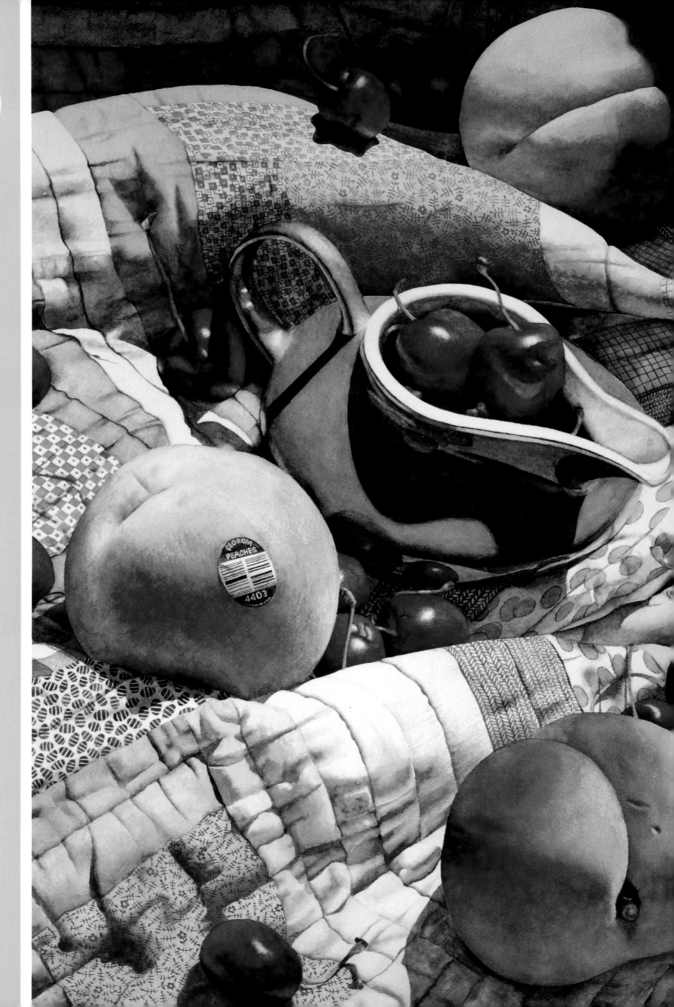

# EXPLORING COLOR CHARACTERISTICS

THE USE OF EXPRESSIVE COLORS IS FELT TO BE ONE OF THE BASIC ELEMENTS OF THE MODERN
MENTALITY, AN HISTORICAL NECESSITY, BEYOND CHOICE. — HENRI MATISSE

**PITCHER WITH PEACHES
AND CHERRIES**
Chris Krupinksi
Transparent watercolor on
rough watercolor paper
30" × 22" (76cm × 56cm)

**BIRCH LANDSCAPE**
David R. Daniels
Watercolor on paper
43" × 63" (109cm × 160cm)

New colors and art media proliferate at the speed of light, it seems. While
it may appear to be "all about marketing," in fact, paint chemistry has made
remarkable advances in the past fifty years, bringing us vibrant new colors,
unique mineral pigments, versatile acrylic paints and mediums, and
much more.

I'll bet you would like to benefit from these developments. This chapter
helps you understand the characteristics of pigment and paint. Do the
exercises to familiarize yourself with every color on your palette and learn how
to test new colors before you add them to your palette.

# Is It Pigment or Paint?

Ground, powdered **pigments** are the coloring substance of most artists' paints, which are made by combining the pigments with a medium or vehicle that surrounds the pigment particles and binds them to the support. The degree to which color reflects from the paint molecules or passes through transparent colors to reflect the support may be determined by the grinding of the pigment particles, the inherent properties of the pigment material and/or the nature of the support.

So, **paint** is pigment *suspended* in liquid, which forms a layer on the painting surface. **Dyes**, which are substances *dissolved* in liquid, are absorbed into the surface. Dyes are more likely to fade than pigments.

There are only twelve hues on most color wheels, but there are hundreds of pigment and paint variations of every hue. For example, Cadmium Red and Permanent Alizarin Crimson are both red pigments. However, not all paints with the same names are made with the same pigments. To further confuse matters, manufacturers continue to invent fanciful color names, such as Saffron or Heliotrope, and it's anybody's guess what those colors might be. The trend toward naming paint colors for the pigment they're made of is a good one. Although the words are tricky, artists are becoming accustomed to using abbreviated forms, such as "phthalo" for phthalocyanine and "quin" for quinacridone. Referring to ASTM C.I. Names, such as PB15:3 to identify Phthalocyanine Blue (Green Shade), will help prevent duplicates in your paint box. Use the ASTM chart in the Appendix to identify pigments before buying your paints.

No doubt you've noticed that paints aren't cheap. Expect to pay more for top-quality paint. Traditional artists' colors contain more colorants than student-grade, which include fillers that dilute the pigment and produce a weak, unsatisfactory paint at low cost to make them more affordable. Buy the finest paint you can, because you'll get better results with concentrated pigments. If you must begin with student paints, upgrade as soon as possible. Prices within an artists' brand will vary according to the availability of colorants and the cost of processing them. Manufacturers prepare some colors from costly metallic pigments, like cadmium and cobalt, and others from rare organic materials, such as genuine rose madder. Daniel Smith uses gems and minerals such as amethyst, azurite and lapis lazuli in their unique PrimaTek series. Many well-known brands are reliable in most media. You will probably prefer the working characteristics of some brands over others. Artists' quality pigments are usually compatible between brands, except for some acrylics. Check with the manufacturer to be sure. No "correct" brand of paint exists.

Most paint manufacturers now prefer using a single pigment in paint formulas, although some mixed colors such as Hooker's Green and Payne's Gray are still available. These pigment mixtures, sometimes called **convenience colors**, tend to vary greatly between brands. Paints with the same name may be manufactured using entirely different pigments. Exploring color will train your eye to look for distinctions between these colors.

## COLOR CHEMISTRY

Chemists study the structures of dyes and pigments, testing their characteristics and making paints from colorants. Starting with William Henry Perkin's discovery in 1856 of aniline dyes made from coal tar, the quality and performance of traditional artists' pigments have improved greatly in modern times. Many synthetic pigments now available have great beauty, strength and durability and are safer for artists to use. Fortunately, reliable substitutes replace most fugitive colors (colors that may fade or change color).

## CODES FOR MANUFACTURERS

I use the following code letters with my swatches to identify artists' quality paint manufacturers who provide rich, reliable color. This is a good time for you to start this practice. Most colors are available in several brands, but you'll soon learn that they don't all look the same. Add a code for your favorite brand if it isn't listed here.

| | | | |
|---|---|---|---|
| **DS** | Daniel Smith | **RE** | Rembrandt |
| **GO** | Golden Artist Colors | **RO** | Daler-Rowney |
| **HO** | Holbein | **SC** | Schmincke |
| **MB** | MaimeriBlu | **SE** | Sennelier |
| **MG** | M. Graham | **WN** | Winsor & Newton |
| **OH** | Old Holland | | |

Transparent Yellow

Hansa Yellow

Aureolin

Permanent Green Pale

Indian Yellow

Cadmium Lemon

Permanent Green Light

Azo Yellow

New Gamboge

Hansa Yellow Light

Permanent Sap Green

Cadmium Yellow

Naples Yellow

Hooker's Green

Hansa Yellow Deep

Quinacridone Gold

Green Gold

Phthalo Green (Yellow Shade)

Pyrrole Orange

Raw Sienna

Olive Green

Viridian

Cadmium Orange

Light Red Oxide

Yellow Ochre

Terre Verte

Phthalo Green (Blue Shade)

Phthalo Turquoise Blue

Burnt Sienna

Phthalo Blue Green

Cobalt Teal

Cadmium Scarlet

Quinacridone Burnt Scarlet

Payne's Gray

Antwerp Blue

Manganese Blue Hue

Scarlet Lake

Pyrrole Red

Burnt Umber

Indigo

Phthalo Blue (Green Shade)

Cadmium Red

Indian Red

Ivory Black

Mars Black

Brown Madder

Neutral Tint

Indanthrone Blue

Cerulean Blue

Winsor Red

Perylene Maroon

Phthalo Blue (Red Shade)

Permanent Alizarin Crimson

Caput Mortuum

Cobalt Blue

Permanent Magenta

French Ultramarine

Ultramarine Violet (Reddish)

Ultramarine Blue Violet

Garnet Lake

Dioxazine Violet

Permanent Rose

Cobalt Violet

Ultramarine Violet

Quinacridone Magenta

Rose Madder Genuine

**EXERCISE 18:** COMPLETE A COLOR REFERENCE CHART
Using your medium of choice, make a reference chart of all your colors. Divide a large circle into six sections. Place swatches of fresh, high-intensity color to represent the primaries and secondaries in the appropriate spots on the perimeter of the wheel, as shown. Place the tertiaries at the midpoint between primaries and secondaries—for example, red-orange between red and orange. Find a place for all your high-intensity colors near colors they relate to, moving outside the circle, if necessary. If you have duplicate colors by different manufacturers, place them near each other, so you can compare them. Inside the circle, place low-intensity earth colors related to the high-intensity colors on the perimeter: Burnt Sienna near red or orange, and so on. Put the neutral grays and blacks near the center. Label every color on your reference chart with its name and a code for the manufacturer. When you buy a new color, place it on your chart near similar colors. Trade swatches with other artists and students, so you can make useful comparisons between colors in many different brands.

I updated this chart with modern pigment names and removed discontinued colors, but some of these will change over time. Not all manufacturers use the same names or make the same colors, so labeling your swatches is important.

# Classifying and Characterizing Pigments

## Organic vs. inorganic

Pigments are classified as organic or inorganic, depending on the source of the coloring matter. This is important only if you prefer traditional colors with specific characteristics, such as granulation. But it really doesn't matter whether a color is a natural material, a metal or a mineral, or a synthetic concocted in a lab, as long as it's the color you want.

**Organic pigments** come from compounds containing carbon, often from living matter—plant or animal material. For example, Rose Madder Genuine is made from plant material; Sepia once came from the ink sacs of the cuttlefish; Phthalocyanine Blue is a synthetic organic pigment made in a laboratory.

**Inorganic pigments** come from earth materials (Raw Sienna and Raw Umber), calcined earth materials (Burnt Sienna and Burnt Umber) and minerals or metals (Cadmium Red, Cobalt Blue, Manganese Blue). The minerals are often brilliant and opaque; the earth colors are usually less intense.

Some materials are costly and difficult to obtain. Other pigments contain unique properties that can't be duplicated in synthetic paints. For example, costly Cobalt Blue simply can't be matched in delicacy and beauty by substitutes formulated using Phthalocyanine Blue or Ultramarine. Substitutes should be labeled hue or tint to indicate they're not genuine pigments. Manufacturers have developed satisfactory synthetic replacements for some colors, but only you can decide if these substitutes are acceptable.

## Lightfastness ratings

Some colors change quickly when exposed to light over a period of time and others appear not to fade at all. In this test, the colors that faded the most over a three-year period showed a marked tendency to fade within the first two weeks of exposure to direct sunlight. Others showed little fading or color shift throughout the test. Check lightfastness ratings and avoid using fugitive, fading colors. ASTM ratings of I and II are reliable. Colors designated N/R haven't been rated by ASTM, but those produced by reliable manufacturers have been tested to meet ASTM standards. Insist on colors that are rated high in lightfastness. See Exercise 21 later in this chapter for a way to run your own test.

## Buyer beware

Artists of the past mixed their paints from scratch. Now you buy them ready-made, but how do you know what you're getting? Don't depend on printed color charts; seek charts with painted chips whenever possible. The American Society for Testing and Materials (ASTM) and the Art and Creative Materials Institute (ACMI) set voluntary standards for labeling, so you may find answers to your questions about toxicity, lightfastness and composition of paint on the label (you may need a magnifying glass to read it!). If the pigment and binder have separated in a newly purchased tube of paint or the paint is hard to squeeze out of the tube, return it to the dealer or contact the manufacturer. Most have toll-free numbers or technical and customer support on their websites.

IDENTIFYING COLORS

Colors can be described by their hue name, paint name, pigment name or ASTM color index name, which consists of a color code (PR = Pigment Red) and a number for a specific pigment (PR108 = Cadmium Red). For most artists, the paint name is the most familiar, but many are now learning pigment and **Color Index Names** (**C.I. Names**) to help them understand their materials better.

| HUE | PAINT | PIGMENT | COLOR INDEX NAME |
|---|---|---|---|
| red | Permanent Rose | Quinacridone | PV19 |
| yellow | Indian Yellow | Metal complex | PY153 |
| blue | Cerulean Blue | Oxides of cobalt, tin | PB35 |

## WATERCOLORS

### PHTHALO BLUE

mass tone

undertone

undertone

### AUREOLIN YELLOW

## ACRYLICS (OUT OF JAR)

Naphthol Crimson

Naphthol Red Light

Cobalt Blue

Cerulean Blue

## OILS (OUT OF TUBE)

Cadmium Red Deep Hue

Ultramarine Blue

Hooker's Green

Cadmium Yellow Light

**EXERCISE 19:** COMPARE MASS TONES AND UNDERTONES

What you see when you squeeze paint out of a tube isn't always what you get when you use it. There may be an actual change in the color bias. For example, watercolor Aureolin looks like honey mustard out of the tube, but when you thin it you get a lovely transparent yellow. Check your paint colors, first diluting each color to about half strength and then to a thin wash, painting swatches of each variation next to a swatch of the full-strength color. Some colors change significantly when they're reduced from their full-strength mass tone to a lighter, diluted undertone.

Oils and acrylics also display the mass tone/undertone effect. Colors here are applied directly from the tube or jar. The acrylics in the left column have been drawn out to show their undertone.

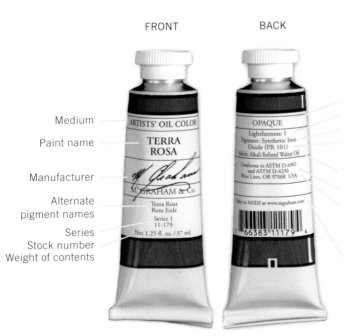

FRONT BACK

Medium

Paint name

Manufacturer

Alternate pigment names

Series
Stock number
Weight of contents

Transparency/opacity
Lightfastness rating
Pigment common name
(Pigment Color Index name/number)

Vehicle/binder

ASTM conformity
Manufacturer's address
(Health warnings if required)

MSDS safety and data sheet reference link

**READING A PAINT TUBE LABEL**
Manufacturers squeeze useful information on their paint tubes. M. Graham's labels, shown here, are surprisingly easy to read considering all the information they contain. There's space on this label to include health warning icons for pigments that require them.

# How Exploring Color Works

We'll begin exploring color in this chapter by testing paints or dry media, to familiarize you with the color characteristics of your chosen medium. Because I'm a watercolor painter, most of the exercises are done in that medium, but you can use oils, acrylics, colored pencil, oil pastels and other media (see the transparency chart later in the chapter) as well, to sharpen your eyes to see color and make comparisons. This will help you when you work with color harmony, contrast and design later in the book.

You can adapt some of the exercises in this chapter to collage papers, fabrics, yarns or whatever medium you prefer. For collage charts, collect and file colored paper or clippings in various hues, values, intensities and temperatures. Fiber artists can use swatches of yarn or fabric samples to compare how textures, patterns, the length and density of fibers, and the shine of metallic threads affect colors in knitting, weaving and quilting. Be sure to include some transparent papers and fibers.

**EXERCISE 20:** MAKE YOUR OWN COLOR WORKBOOK
For a long time I let my swatches pile up without a system to help me find my favorites. Making a workbook made it easier. Buy a sketchbook with heavy paper or make your own. A D-ring binder from the office supply store makes a sturdy workbook. Cut sheets of 90–140 lb. (190–300gsm) watercolor paper or canvas paper/pad to fit.

Mix and mingle colors in the workbook, testing their characteristics and mixing qualities. Jot down brands and color names. Make sample paintings and add (and label) swatches of the colors you use. Record your reactions to the colors. Sharpen your color awareness by comparing new colors in your workbook with more traditional colors or those you tend to use most. Use your workbook and your color journal as sounding boards for your color experiments. Jot down the names of colors you want to try. Note ideas for new color combinations. What did you learn from doing each exercise? Every experience with color teaches you something new to use in your artwork.

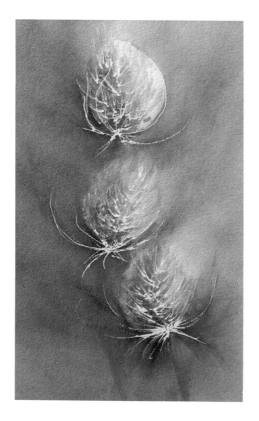

**THISTLES**
Karen Livingston
Watercolor on cold-press watercolor paper
15" × 8" (38cm × 20cm)

MIXING IT UP
Since most watercolor paints are compatible, Livingston experiments with different brands in her paintings. Here, she mingles several layers of paint, resulting in subtle textures. A few sweeping brushstrokes suggest movement.

| MEDIUM | BINDER | DILUENT/SOLVENT | CHARACTERISTICS |
|---|---|---|---|
| acrylic paint | acrylic polymer dispersion | acrylic mediums, water/ denatured alcohol (limited use) | fast drying (dries darker); opaque or transparent |
| OPEN Acrylic paint (GO) | acrylic polymer dispersion | OPEN acrylic mediums | remains wet on palette for extended period |
| alkyd paint | oil modified alkyd resin | oil medium/pure gum turpentine, mineral spirits | similar to oils, but fast drying; compatible with oils; opaque |
| casein paint | milk solids | water | fast drying; opaque; matte |
| colored pencil | wax, gum | mineral spirits, colorless marker | applied in layers; waxy; buff for shine |
| gouache paint | natural gum | water | fast drying; opaque; matte |
| gouache (acrylic) paint | acrylic dispersion | water | same as gouache; dries water resistant |
| ink (pigmented) | gum, shellac or acrylic emulsion | water/denatured alcohol | fast drying; transparent, brilliant color; use lightfast only |
| oil paint or oil sticks | natural oils (linseed, poppy, safflower) | oil medium/ pure gum turpentine, mineral spirits | slow drying; opaque |
| oil paint (water miscible) | modified linseed oil | pure gum turpentine, mineral spirits, water for cleanup | slow drying; loses water miscibility if too much oil is used |
| pastel | weak gum solution | only for water-soluble soft pastel | brilliant pure color; opaque; soft or hard |
| pastel (oil) | natural oils and wax | pure gum turpentine, mineral spirits | opaque pastel effect with no dust |
| tempera paint | egg yolk | water | fast drying; opaque; translucent layers |
| watercolor paint | natural or synthetic gum (some with honey) | water | fast drying (dries lighter); transparent; matte |
| watercolor paint (QoR) | synthetic gum Arabic | water | fast drying; intense color |
| watercolor pencils or sticks | water-soluble gum | water | mostly transparent; wettable for wash effects |

## PAINT COMPOSITION

This chart is a handy reference to characteristics of the most popular art mediums. For more information, browse a manufacturer's website and email or call their technical support team.

### COBALT BLUE

Winsor & Newton

Grumbacher

Holbein

Maimeri

Holbein (hue)

## EXERCISE 21: TEST THE LIGHTFASTNESS OF YOUR COLORS

Permanence from paint color to paint color varies. When in doubt, test the colors yourself. Paint three or four brushstrokes on a piece of paper, cut it in half and place one half in a sunny window and the other in a dark place. Compare the two halves once a month to see how long the color takes to fade. See a sample color test in the glossary entry for fugitive color in chapter two. Most colors are reliable under normal conditions, but atmospheric pollution may be a problem where you live. It's probably fair to say that nothing can be absolutely guaranteed.

## DIFFERENCES IN BRANDS

Be careful about switching brands of a specific color while working on a painting. Brands may vary to a surprising degree in color bias, transparency and tinting strength. The same color may also look quite different in oils, watercolors and acrylics. Here's Cobalt Blue in watercolor, showing a range of color bias and strength across different brands.

# Sorting your colors

Now's your chance to find out what your colors can do. As best you can, find colors in your chosen medium and match them to the list of paint colors below. Add any others you'd like to try. Remember that not all colors are available in every medium or brand, nor do similar colors always have the same name. Check the ASTM chart near the end of the book for the C.I. Name of the colors below.

## TAPING COLOR CHARTS FOR EASY LABELING

Mark grids on your paper or canvas, sized to the exercise you're planning to do, using low-tack, white artist's tape that won't damage the surface when you remove it. As you work, write the names of the paints you use on the tape. After your paints are dry, transfer the names to the paper as you remove the tape. Use a hair dryer on the low setting to warm the tape for easy removal. The white strip between the colors makes it easier to evaluate them.

| HIGH-INTENSITY COLORS | | LOW-INTENSITY COLORS |
| --- | --- | --- |

**MAGENTA, RED AND RED-ORANGE**
Rose Madder Genuine (WN)
Permanent Rose
Quinacridone Magenta
Permanent Alizarin Crimson
Cadmium Red Medium
Winsor Red or Pyrrole Red
Cadmium Scarlet, French Vermilion
or Cadmium Red Light
Scarlet Lake

**ORANGE AND YELLOW-ORANGE**
Cadmium Orange or
Permanent Orange
New Gamboge, Indian Yellow or
Cadmium Yellow Deep

**YELLOW AND YELLOW-GREEN**
Cadmium Yellow Light,
Cadmium Yellow Medium or
Hansa Yellow Medium
Transparent Yellow or
Hansa Yellow Light
Aureolin
Cadmium Lemon
Permanent Green Pale, Permanent
Sap Green or Phthalo Green
(Yellow Shade)

**GREEN AND BLUE-GREEN**
Hooker's Green
Phthalocyanine Green, Phthalo
Green or Winsor Green (Blue Shade)
Viridian
Phthalo Blue Green or Turquoise

**BLUE AND BLUE-VIOLET**
Cerulean Blue
Manganese Blue Hue
Phthalocyanine Blue, Phthalo Blue
or Winsor Blue (Red Shade) or
Winsor Blue (Green Shade)
Cobalt Blue
French Ultramarine or Ultramarine
Ultramarine Blue Violet

**VIOLET AND RED-VIOLET**
Dioxazine Violet
Permanent Magenta

**LOW-INTENSITY COLORS**

Brown Madder
Burnt Sienna
Indian Red
Perylene Maroon
Quinacridone Gold
Raw Sienna
Yellow Ochre
Olive Green
Indigo
Indanthrene or Indanthrone Blue

**NEUTRALS**
Neutral Tint
Ivory Black
Payne's Gray
Flake White (oil, alkyd), Zinc White
(acrylic, gouache, watercolor) for
mixing
Titanium White for opacity

# Cleaning and filling your palette

Don't use your old palette until you've washed off all the contaminated paint—you'll be glad you did! If necessary, soak it for a while and use the tip of a palette knife to scrape out the old paint. I use a cleaning product for glass stovetops to remove stains from my white palettes, rinse with soap and water, and wipe with diluted vinegar. Test a small spot on your palette before using this method.

Use fresh, clean color for the exercises that follow in the book. Squeeze out a generous amount of paint if you're using watercolors. They can be remoistened instead of thrown away. However, fresh paint releases more saturated color on your paper, as shown in the image below. Acrylics must be sprayed lightly and covered with plastic wrap overnight. OPEN Acrylics and oil paints will dry less quickly, depending on the humidity.

## DILUENTS AND MEDIUMS

Use the appropriate product for thinning your medium or cleaning up after painting. Read the label or check the manufacturer's website.

- **For watermedia:** water
- **For acrylics:** water and acrylic medium (use no more than 50 percent water, then continue to thin with liquid medium); alcohol for cleanup
- **For oil and alkyd paints:** pure gum turpentine or mineral spirits, Liquin (by Winsor & Newton) to speed drying of oils

# Finding your own system

Arrange the colors on your palette according to a system that makes sense to you and place your colors in that same arrangement every time you use them. Be organized and consistent. Mark the name of each color on a piece of masking tape or a small sticker next to a color as soon as you put it on your palette, so you don't get your colors confused. You'll find your colors easily once you get used to your own setup.

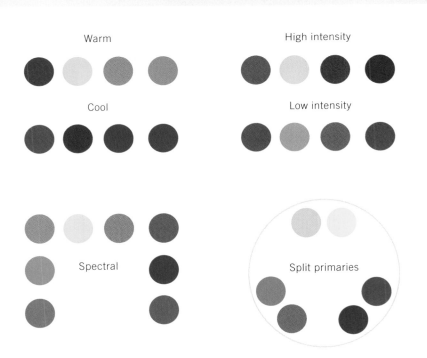

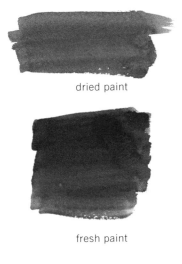

dried paint

fresh paint

### SETTING UP YOUR PALETTE

There's more than one way to set up a palette. A beginner might include just the basic primaries. One logical arrangement is to place the warm colors (red, orange, yellow) on one side and the cool colors (green, blue, violet) on the other. Another way is to place your colors in the order of the spectrum: red, orange, yellow, green, blue, violet. Still another is to separate bright, high-intensity colors from lower-intensity earth colors. One of the best setups for learning color mixing is the split-primary palette (see chapter 4). Once you've decided on a general layout for your palette, use it for exploring the colors in this chapter. Eventually you'll arrange a painting palette based on your favorite setup.

### USING FRESH PAINT

Make a point of using fresh paint for exploring color and making art. Stiff tubes or paint that has dried on the palette may soften somewhat when moistened, but won't release as much color as you would squeeze from the tube just before use.

# Transparency and Opacity

A transparent layer of paint permits a previously applied color, or the white reflective surface of the support, to shine through it. **Transparency**, a natural characteristic of certain pigments, is useful in glazing (see chapter eight). Most watercolor paints are transparent to a degree; a few oils and acrylics also have this trait, although they are more commonly used in an opaque manner. Gouache, casein and tempera are opaque watercolors containing substances that induce **opacity**. Pastels and oil pastels vary in this characteristic. A painting done in opaque colors looks very different from one done with transparent paints.

**EXERCISE 22:** EVALUATE TRANSPARENCY AND OPACITY
Using an old ½" (12mm) brush, paint several strips of undiluted India ink on watercolor paper (for water-soluble or dry media) or on canvas (for oils, alkyds, oil pastels, oil sticks). Let the ink dry thoroughly. With every color you have, paint a band across the ink strip, adding enough thinner to make the paint flow without losing its brilliance; arrange the colors by families for easy comparison, leaving spaces between color groups to add new colors. Notice how some colors seem to disappear when they cross the ink strip; these are transparent colors. Others cover the black entirely; these are opaque. Semi-transparent or semi-opaque colors leave a haze or translucent film. Record your observations in your color journal.

**WHITE FLOWERS**
Fabio Cembranelli
Watercolor on paper
56" × 38" (142cm × 97cm)

THE IMPORTANCE OF TRANSPARENCY
The delicate radiance of sunlit flowers calls for transparency, so you can see the value of knowing the difference between transparent and opaque colors. Transparency allows your support, in this case white watercolor paper, to emit luminosity through several layers of color. Every brushstroke on this watercolor is transparent, including the dark accents behind the petals in the background.

MEDIUM

Watercolor

Ink

Casein

Gouache

Acrylic
gouache

Fluid acrylic

Tube acrylic

Oils

Oil sticks

Oil pastel

Pastel

Colored
pencil

Watercolor
sticks

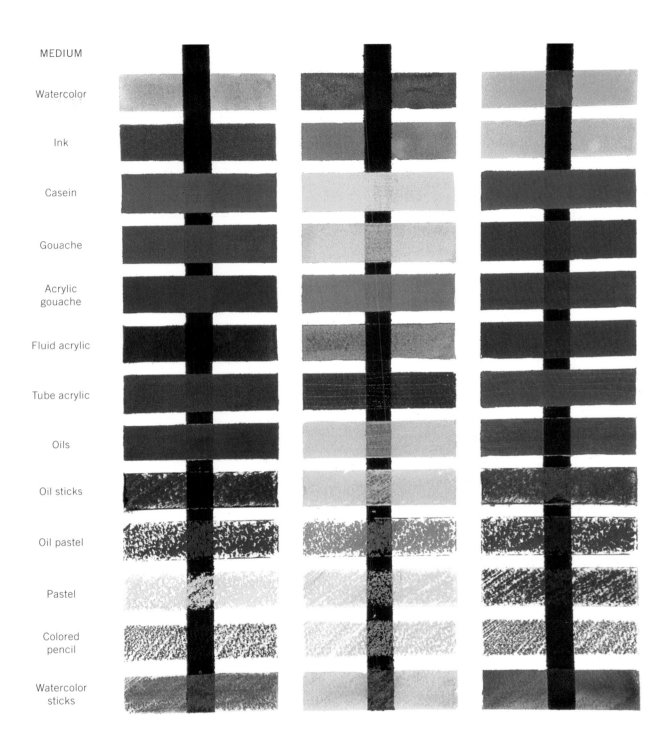

TRANSPARENCY/OPACITY CHART
Transparency and opacity are obvious on this chart, which shows the characteristics of
different media. Notice the extremes of transparent ink and opaque casein. You don't
need to test different media; just study your own medium thoroughly so you can easily
recognize which pigments are transparent and which are opaque.

# Tinting Strength

In color mixing, **tinting strength** is the power of a color to influence a mixture; this is usually determined by the pigment the paint is made of. Some pigments overpower nearly every color you combine them with. Others are so delicate that, even in their most concentrated form, they have little impact on stronger colors. Some artists like weaker paints because they're easy to use as glazes, but be aware that the power won't be there if you need it.

Test tinting strength so your colors don't surprise you by overpowering other colors or by disappearing when you combine them with other colors. Be careful about combining colors that vary too much in tinting strength. Mix delicate colors only with those they have some effect on when mixed in normal proportions. For example, Rose Madder Genuine will have almost no effect on Phthalo Green in a mixture, so this is a poor combination. Better choices would be Rose Madder Genuine and Viridian (both delicate) or Permanent Alizarin Crimson and Phthalo Green (both powerful).

**EXERCISE 23:** COMPARE THE TINTING STRENGTH OF PAINTS
Sort your colors into groups according to hue (reds, yellows, etc.) and paint a 1" (2.5cm) square chip of each color on paper or canvas. As you work, observe which colors seem more powerful and which appear weaker. Note this in your color journal. When your sample chips are dry, cut them apart and sort into delicate, intermediate and powerful colors (low, medium and high tinting strength). Arrange them on a chart in columns similar to the one shown here and adhere them with paste or acrylic medium. Then see what happens when you mix colors from different columns; observe how you have to adjust for differences in tinting strength.

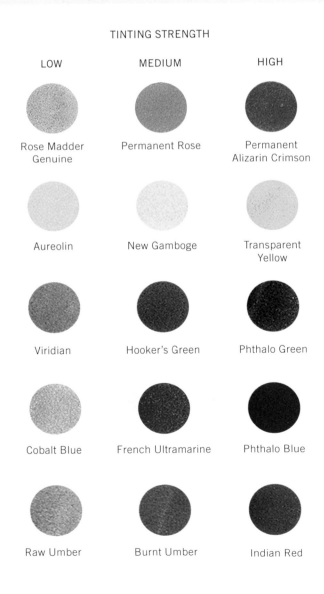

TINTING STRENGTH

| LOW | MEDIUM | HIGH |
|---|---|---|
| Rose Madder Genuine | Permanent Rose | Permanent Alizarin Crimson |
| Aureolin | New Gamboge | Transparent Yellow |
| Viridian | Hooker's Green | Phthalo Green |
| Cobalt Blue | French Ultramarine | Phthalo Blue |
| Raw Umber | Burnt Umber | Indian Red |

**THE MORNING AFTER**
Joan Rothel
Prismacolor pencil on Canson paper
20" × 26" (51cm × 66cm)
Collection of the artist

KNOW THE STRENGTH OF YOUR COLORS
Rothel creates a serene setting by using delicate, unified colors with no powerful colors to overwhelm them. Although colored pencils aren't mixed in the same way as wet media are, it's still important to know the strength of your colors. Once the colors are down, it may be hard to remove them without altering the tooth of the paper and muddying the colors.

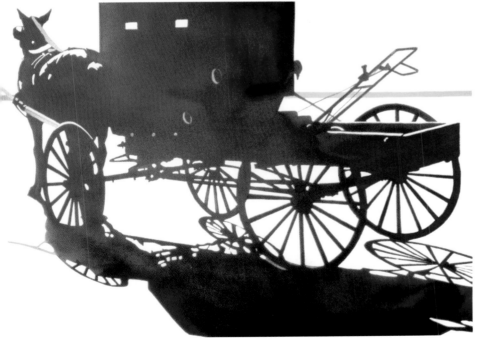

**TO MARKET**
Jane Higgins
Watercolor on paper
22" × 30" (56cm × 76cm)

STRONG COLOR STATEMENT
Powerful colors were used to create this painting, and delicate pigments wouldn't have contributed anything. Higgins knows exactly which colors she needs to make a direct color statement. The strong shapes and bold colors are perfect partners here. Also notice the granulating colors in the shadows. (Look for more on granulation later in this chapter.)

# Staining Quality

**Staining colors** penetrate the fibers of a support and can't be removed without leaving a trace of color or damaging the support. You can't completely sponge or lift them out to correct mistakes. They will stain clothing, fingers and probably your palette. If you're a beginner, you may want to use nonstaining colors.

But don't be too quick to banish staining colors, because they can be some of the most beautiful available. If you paint with little correction or scrubbing, you won't have problems with staining colors. Some artists even use transparent stains in an interesting stain-and-glaze technique, sponging off the surface after the paint stains the support, then glazing with a transparent color. You can use staining colors for glazes, but handle with care. Even a diluted wash may stain slightly, or an underlying stain color may bleed through a glaze. Surprisingly, some powerful colors don't stain, while other weaker colors do. But don't guess. Test your colors to identify their staining tendencies.

TESTING STAINING PROPERTIES
When testing the staining property of your paints, scrub vigorously enough to loosen the surface color without damaging the support. Some colors can be completely removed, but others stain the support permanently. Note also that some supports tend to stain more easily than others. For example, highly sized papers are more resistant to staining; you can also use Winsor & Newton Lifting Preparation on your surface to make it a little less likely to stain.

MEMORIES OF MAUI #1—RED GINGER
Lynn Lawson-Pajunen
Watercolor on shuen rice paper
19" × 19" (48cm × 48cm)

USING STAINING AND OPAQUE COLORS
This artist layers intense staining colors that penetrate the rice paper, then brings out the image on top of the stains with several layers of opaque paint. You can't scrub the paint off rice paper, but you can add opaque paint to develop your image after your paper has been stained. You can do this on other surfaces, too, as long as your paints stain the fibers of the support and don't lift easily when opaque layers are applied.

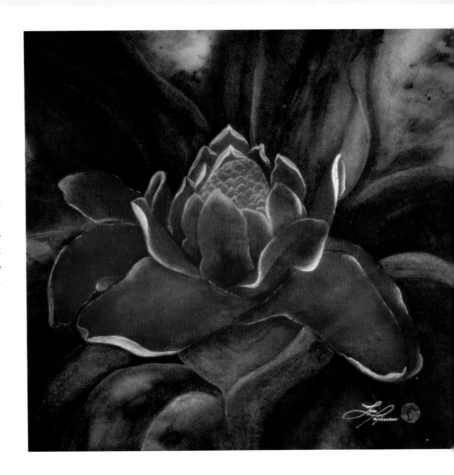

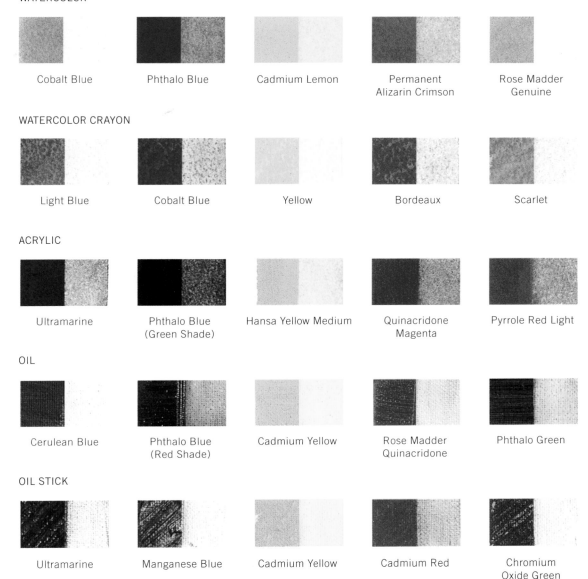

WATERCOLOR

Cobalt Blue | Phthalo Blue | Cadmium Lemon | Permanent Alizarin Crimson | Rose Madder Genuine

WATERCOLOR CRAYON

Light Blue | Cobalt Blue | Yellow | Bordeaux | Scarlet

ACRYLIC

Ultramarine | Phthalo Blue (Green Shade) | Hansa Yellow Medium | Quinacridone Magenta | Pyrrole Red Light

OIL

Cerulean Blue | Phthalo Blue (Red Shade) | Cadmium Yellow | Rose Madder Quinacridone | Phthalo Green

OIL STICK

Ultramarine | Manganese Blue | Cadmium Yellow | Cadmium Red | Chromium Oxide Green

**EXERCISE 24:** RECOGNIZE STAINING AND
LIFTING PROPERTIES

Paint a 2" (5cm) square of every color you have on a sectioned sheet of paper or canvas sized to fit your workbook. Let watercolors dry thoroughly, then cover one side of each square with a scrap of mat board and scrub the visible half with a sponge, picking up loosened pigment with a rag or paper towel. For other media, scrub off the color with mineral spirits (oils and alkyds) or alcohol (acrylics) after the paint sets, but before it dries completely. When you add new colors to your palette, test them for this property. Remember that brands may vary. Label your chart and list the staining colors in your color journal.

No amount of scrubbing will remove some of these colors without making a hole in the paper. Test all your colors so you don't get a nasty shock when you're painting. Many substitutes for artists' pigments are staining. (Note: Some of the colors on this chart are not listed in the comprehensive color chart in the back of the book.)

# Granulating Colors

Some water-soluble pigments, when applied in a fluid manner, will settle into the valleys of textured paper or canvas, making interesting granular effects that suggest fog, the density of a storm cloud or a sandy beach. **Granulation** is a natural characteristic of these colors, not a defect. **Flocculating colors** tend to clump in a watercolor wash. Some artists love this textured effect; others prefer a transparent look.

Test your fluid colors, so you can recognize those that create a mottled texture on a wet surface. These colors deposit visible particles of pigment on almost any support. Nongranulating colors make a smooth film.

**WET-BLEND GRANULATING COLORS FOR RICH TEXTURE**
Layer three or more successive washes with different granulating pigments. Brush each layer lightly on the previous wet layer with a flat brush. Rock the support slightly, then set aside to dry. I used Cerulean Blue, Burnt Sienna, Raw Sienna and Alizarin Crimson here.

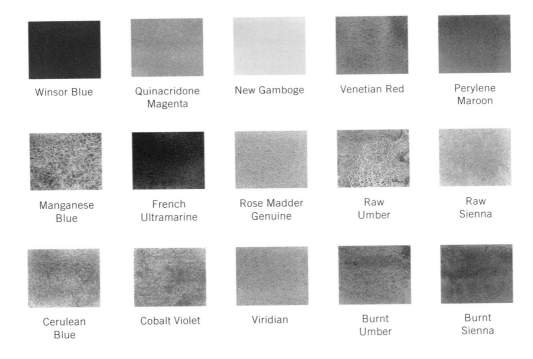

| Winsor Blue | Quinacridone Magenta | New Gamboge | Venetian Red | Perylene Maroon |
| Manganese Blue | French Ultramarine | Rose Madder Genuine | Raw Umber | Raw Sienna |
| Cerulean Blue | Cobalt Violet | Viridian | Burnt Umber | Burnt Sienna |

**EXERCISE 25:** FIND GRANULATING COLORS

On a sectioned sheet of cold-press or rough watercolor paper, dampen a square with water or diluent. Brush fluid paint over the damp area, then pick up the sheet and rock it gently from side to side. Don't brush back over the wash or you may pick up the granulating paint and ruin the effect. Let the paint dry. Repeat with all your colors, and examine each sample for pigments that settle into the valleys of the support. List the names of the granulating colors in your color journal. Several colors shown here in the top row are nongranulating.

Piemontite Genuine

Sedona Genuine

Mayan Blue Genuine

Amethyst Genuine

Hematite Genuine

Jadeite Genuine

Rhodenite Genuine

Serpentine Genuine

Mars Black

**EXERCISE 26:** COMPARE THE GRANULATION OF MINERAL COLORS
Prehistoric painters applied natural minerals in their cave paintings; some of these colors are still in use by today's artists. Manufacturers have revived authentic mineral paints, subtle pigments that granulate beautifully. The pigments shown here are PrimaTek watercolors. To make a swatch showing the granulation of these paints, wet an area about 2" (5cm) in diameter, then load your brush with fluid mineral paint and drop or tap it into the wet surface. Rock the swatch as you did for other granulation studies. These paints make great textures in landscapes, still life and portraits.

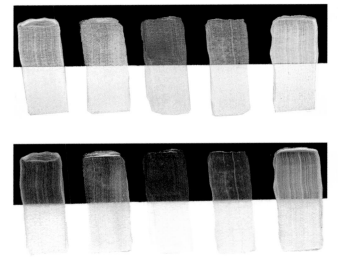

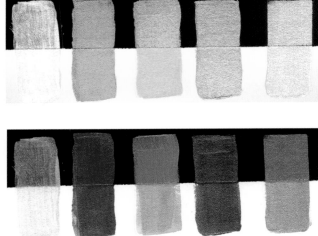

ADD SPARKLE TO YOUR ARTWORK
Fiber and collage artists have glitter and shiny trims to brighten their work. Painters can use touches of interference, iridescent, pearlescent and metallic colors to achieve similar results. These swatches show how the colors shine against dark and light backgrounds.

The two rows on the left contain lustrous interference colors, which change color according to the direction of light. The two rows on the right contain a pearlescent color (first on the left), which doesn't change color, and metallic colors, which have more covering power. Use these special-effect colors as subtle enhancements; a little goes a long way.

# Spreading Colors

While granulating colors stay where you put them, **spreading colors** burst into bloom on a damp surface, creating exciting effects. Some artists call these colors "shooters." They may bleed through top layers of paint or gesso unless sealed with acrylic medium.

Other interesting effects appear when you combine granulating and spreading colors. The spreading color creates a halo around the settling paint, an effect with interesting applications: highlights on edges of fuzzy objects, fur or sunlit clouds, for example. Results vary according to how damp the surface is, how much you load your brush, and how quickly the paint dries. You can use a hair dryer to speed drying if you want to prevent a color from spreading too much.

POUR IT ON
Artist Paul St. Denis sets paintbrushes aside and pours on layers of color instead.

**BLUE ABSTRACT**
Paul St. Denis
Fluid acrylic watermedia
on paper
22" × 36" (56cm × 91cm)

FEARLESS COLOR
St. Denis uses a quirky system for pouring large fluid acrylic watermedia abstractions. He mixes as many as twenty fluid acrylic colors in quart containers for pouring multiple layers of color. The poured colors blend on the support, resulting in spontaneous—and sometimes unexpected— effects. Says St. Denis, "Not for the stingy or faint of heart!"

**TWILIGHT RADIANCE**
Lawrence C. Goldsmith
Watercolor on paper
18" × 24" (46cm × 61cm)

WET-IN-WET TECHNIQUE
Nothing quite compares with the flow of watercolor on wet paper, but it's always more effective if the colors you use are movers. The wetness of the paper also determines how much the paint will spread. Remember that colors are further diluted when applied to a damp surface, so use a little more paint than you would on a dry surface.

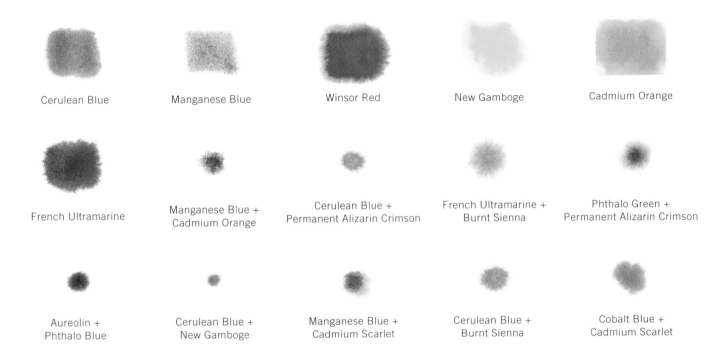

| Cerulean Blue | Manganese Blue | Winsor Red | New Gamboge | Cadmium Orange |

| French Ultramarine | Manganese Blue + Cadmium Orange | Cerulean Blue + Permanent Alizarin Crimson | French Ultramarine + Burnt Sienna | Phthalo Green + Permanent Alizarin Crimson |

| Aureolin + Phthalo Blue | Cerulean Blue + New Gamboge | Manganese Blue + Cadmium Scarlet | Cerulean Blue + Burnt Sienna | Cobalt Blue + Cadmium Scarlet |

**EXERCISE 27:** WATCH COLORS BLOSSOM

On a sectioned sheet of watercolor paper, dampen an area with water or diluent. Load your brush with fluid color, and touch the corner or point of the brush to the support. Let the color move on its own over the damp surface. Repeat with your other colors, and record the results. Do you like what happens when the paint moves? Next, mix a granulating color, such as Cerulean Blue, with a spreading color, like Permanent Alizarin Crimson, on your palette, and touch the mixture to a dampened square on the sectioned sheet. Watch how the colors separate.

Record your observations in your color journal, noting how you might use this effect.

The watercolors shown here were applied to wet paper. Cerulean Blue will stay just about anywhere you put it, because it's a settler. Spreading colors will continue to creep as long as the surface is slightly damp. For example, I'm sure Cadmium Orange would eat your studio if given a chance! When settling and spreading colors are mixed, they tend to separate on a damp surface, creating an intriguing halo effect.

# Tricks for Texture

Most art mediums have reactions with other materials that create interesting faux textures on a support. Here are a few that I've tried in watercolor. Make sure that the material you're using is nontoxic and won't damage or fade your paints or support before using them in your artwork.

One popular trick in watermedia is to sprinkle salt into a damp wash, creating a crystalline texture. Allow the paint and salt to dry completely overnight; brush the dry salt off carefully. As beautiful as the results may be, the permanence of this technique is questionable. Some experts advise against this practice, citing possible effects of salt damage to paper or unknown reactions to mineral pigments. If salt residue remains on your painting, condensation or humidity may reactivate it. For a similar effect, spatter water by flicking it from a toothbrush, paintbrush, small spray bottle or your fingertips into a pigmented wash that has just lost its shine, or use one of the techniques shown on previous pages for texture.

Spattered alcohol creates a circular pattern rather than the crystalline texture made by salt and is less likely to be damaging to your support over time. Hydrogen peroxide produces still another fascinating texture in watercolor washes. Results depend not only on the material you apply to the colored wash, but also on your method of application (spray, brush, fingers, etc.) and the wetness of your support. I achieve better results when the surface is slightly damp rather than sopping wet.

Iodized table salt

Salt crystals

Coarse sea salt

## COMPARING THE EFFECTS OF DIFFERENT SALTS
Salt makes a clear pattern in a damp wash, but it may be hazardous to the health of your painting. Water makes a similar texture, perhaps not quite as crystal-like, which is sharper with some pigments than with others.

**FOCUS**
Nita Leland
Watercolor on cold-press watercolor paper
18" × 24" (46cm × 61cm)

### SPATTERING WATER
Although I love the amazing effects of salt in a watercolor wash, I rarely use it. My preference is to lay a strong wash of color, and after it has lost its shine, I spatter water droplets from my fingertips. The texture is softer than salt and doesn't attract the viewers' eyes away from the main subject.

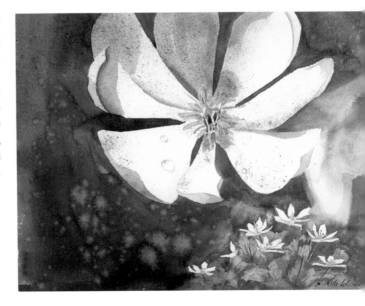

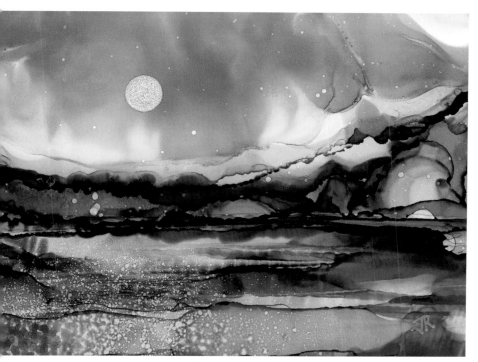

**DREAMSCAPE #100**
June Rollins
Alcohol inks on Yupo
5" × 7" (13cm × 18cm)

## WORKING ON A SLICK SURFACE
Rollins allows alcohol inks to mingle and flow on a slick surface such as Yupo or smooth board. Then, she spatters with alcohol or other ink colors to create a sparkling texture. The inks are highly transparent and brilliantly colored, as you can see from the illustration.

Plastic wrap print

30-percent hydrogen peroxide (dropper)

Rubbing alcohol (dropper)

Salt (shaker)

Water (finger flicks)

Rubbing alcohol (toothbrush)

**EXERCISE 28:** TRY MAKING TEXTURES IN MULTIMEDIA
Here are some texture tricks to try with colored washes:
- Lay a piece of plastic wrap on a wet wash and remove after the paint dries.
- Drizzle with hydrogen peroxide on a brush tip, or apply with a dropper.
- Spritz with droplets of rubbing alcohol, or apply with a dropper.
- Sprinkle salt from a shaker.
- Spritz or finger flick with plain water.
- Spritz rubbing alcohol with a toothbrush.
- Spatter a damp or dry wash with a different color (not shown).

Winsor Green

## WATCH OUT FOR NONREACTIVE PIGMENTS
Some pigments (such as Winsor Green) don't react to salt. Test this technique on damp paint to find which pigments will give the best crystalline effect and which don't react at all. Test your colors before using them in artwork to assure you'll get the results you're hoping for.

**OUT OF THE BLUE**
Lisa Palombo
Acrylic on canvas
48" × 36" (122cm × 91cm)

# CONTROLLING COLOR MIXTURES

COLOR IS A POWER WHICH DIRECTLY INFLUENCES THE SOUL. — WASSILY KANDINSKY

**HANGIN' AROUND**
Linda Daly Baker
Transparent watercolor on
cold-press watercolor paper
22" × 30" (56cm × 76cm)

Successful color mixing depends on how you mix your colors and which ones you mix. The "how" means avoid overmixing and practice color mingling. "Which ones" has to do with using a limited palette of six colors—the split-primary color mixing system—based on logical color theory. Build your palette on this foundation and you'll soon be a color master.

Not only will your color mixing improve with this knowledge, but you'll also discover that you save money on paint when you develop the skill of mixing the colors you want instead of running to the art store to buy another tube of paint.

# Color Mixing

The cardinal rule of color mixing in painting and drawing media is, "Don't mix too much." Even if you're using the right colors, overmixing can dull a mixture. A good mixture shows the original colors used and the mixture itself—for example, yellow and blue, as well as green. This broken color gives livelier color vibration. Also, you may be courting disaster if you put too many colors into a mixture. For greater control over mixtures, mix colors of the same approximate value and tinting strength.

Fiber artists can make small woven, knitted or quilted samples to mix their colors in warp and weft, and collage artists can make mosaics of small paper clippings. In these applications, colors are mixed by the eye instead of a brush.

DON'T OVERMIX
Keep your colors clean and don't mix too much. As you pick up color and lay it on your support, you should still be able to see clearly all the colors used in the mixture.

overmixing (watercolor)

overmixing (acrylic)

light mixing on palette

light mixing on palette

light mixing on
wet paper

light mixing on support

**EXERCISE 29:** PRACTICE COLOR-MIXING TECHNIQUES
Prepare a sectioned sheet with low-tack, white artist's tape. Mix any two or three colors, using the methods that follow, to see the difference between overmixing and correct mixing techniques.

- First, for comparison, mix the colors well into a solid color, and place a swatch of this on your chart.
- Next, mix the colors lightly on a clean palette. Add a little of each color to the edges of the mixture and sweep your brush across the palette to pick up some of each color. Place a swatch of this mixture next to the first one on your chart. Apply the color directly to the dry surface without repeated brushing.
- Then, try mixing your colors on the support instead of the palette by applying them directly to the support and mixing lightly, so you can still see the parent colors in the mixture.

It doesn't really matter what method you use to create lively mixtures, as long as you remember to mix lightly. For the top row shown, I deliberately mixed flat, uninteresting color. In the remaining samples, the color comes alive when I put it down and leave it alone, without overmixing.

# Mingling Colors

Artists don't always mix their colors on a palette and apply them with a brush. Sometimes they drop fluid colors onto a wet surface and "go with the flow." This is one of my favorite ways to start—and sometimes finish a painting. It takes practice to figure out how wet to make the surface and how much pigment to use, as well as how to help the colors move, but it's great fun to dance with your painting and see what the colors will do.

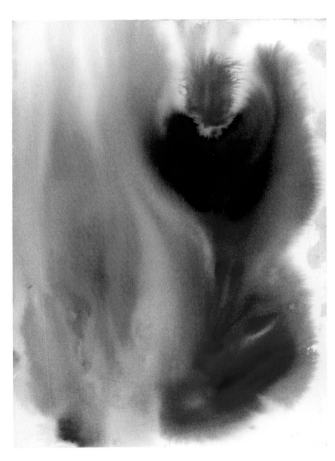

Mingling on wet paper

Indanthrone
Blue

Quinacridone
Gold

Perylene
Maroon

**COLOR BURST**
Nita Leland
Watercolor on cold-press watercolor paper
14" × 10" (36cm × 25cm)

A MINGLED, SPONTANEOUS FINISH
The colors I selected for *Color Burst*—Perylene Maroon, Quinacridone Gold and Indanthrone Blue—didn't disappoint me when I laid them into a wet wash of clear water on watercolor paper. I used plenty of fresh pigment on my brush so the colors wouldn't fade back when they dried. These colors almost moved themselves down the wet paper and delighted me with a blossom at just the right spot.

**EXERCISE 30:** LET COLORS MIX THEMSELVES
Mingling takes advantage of the spreading properties you learned about in the last chapter. Begin by laying down a layer of water or diluent on paper or canvas, then drip fluid paints onto the wet surface and watch the colors mix themselves. Help them a little by tilting or rocking the support. Spreading colors will move quickly to create lovely blossoms and backruns as long as the surface is damp. When your mingled colors begin to dry, lay the support aside to dry thoroughly.

Use this as creative background or search the spontaneous color flow for a design or subject for a painting.

# Split-Primary Color Mixing System

Wouldn't you love to have a foolproof method of mixing color, so you can get the color you want every time? One of my first teachers insisted we limit our palettes to three primary colors, but many of our mixtures were dull and lifeless. It took me a long time to figure out how to overcome this problem by using a split-primary color-mixing system. Once you master it, you'll never make mud again.

To make clean color when mixing secondary and tertiary colors, always use two primaries that have no bias toward the third primary. If either of the primaries has the slightest inclination toward the third primary, the result will be a low-intensity mixture. For example, if you mix Permanent Alizarin Crimson with Indian Yellow, you'll get a dull orange mixture, because the crimson has a definite bias toward blue. Blue, the third primary in this case, is the **complement** (opposite on the color wheel) of the orange you're mixing. In a nutshell:

- *Complements always lower the intensity of mixtures.*
- *The complement of a secondary mixture of any two primaries is the third primary.*
- *For pure, bright color, avoid using the third primary, even in small amounts.*

### THE SPLIT-PRIMARY PALETTE
If you use six colors—two each of the three primaries—it's easy to make pure, bright mixtures. But you must have the right six colors. You need:
- a warm red—Pyrrole Red, Cadmium Scarlet or Cadmium Red Light
- a cool blue-red—Permanent Alizarin Crimson, Quinacridone Magenta or Permanent Rose
- a warm yellow—Indian Yellow, New Gamboge or Cadmium Yellow Medium
- a cool yellow—Winsor Lemon, Lemon Yellow or Cadmium Lemon (not Nickel Titanate Yellow)
- a warm blue—French Ultramarine
- a cool blue—Prussian Blue or Phthalo Blue (Green Shade or Red Shade)

Cadmium Red Light

Indian Yellow

French Ultramarine

Alizarin Crimson

Lemon Yellow

Phthalo Blue

MUDDY

Cadmium Red + Phthalo Blue

CLEAN

Permanent Alizarin Crimson + French Ultramarine

### EXERCISE 31: WHAT MAKES MUD?
Prove to yourself how easy it is to make mud if you're not sure which colors work well together to prevent it. Find as many blues and reds as you can among your paints and make swatches in your journal. Label the colors you use. Some of the violet mixtures will be beautiful; others, flat and dull. Blue and red should make violet, but if either of these two colors has a trace of yellow, the complement of violet, they make mud. Blue and red make a clean violet if they both lean more toward violet.

### FOR BEST RESULTS
When mixing paints, have only the colors you need on your palette. Your palette can be any shape, but I've found that students grasp color-mixing concepts quickly when they can see them on a round Speedball ColorWheel Palette. Keep colors clean by rinsing out your brush before you pick up another color, and wipe your palette before you change mixtures.

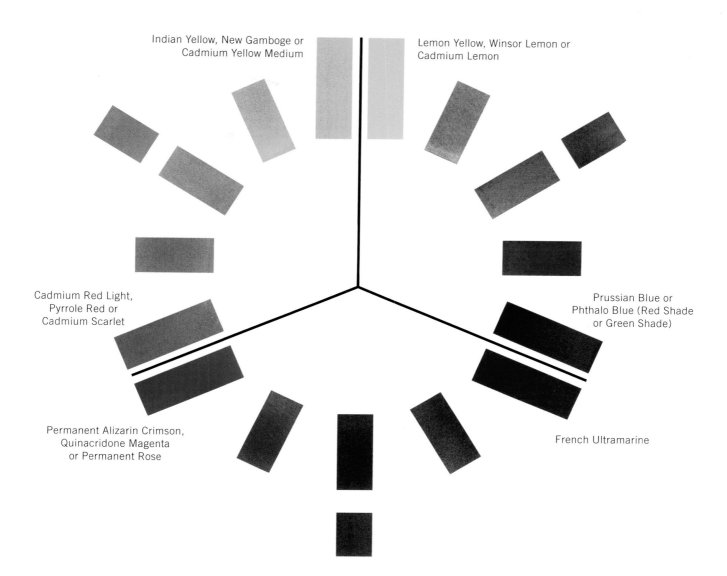

Indian Yellow, New Gamboge or
Cadmium Yellow Medium

Lemon Yellow, Winsor Lemon or
Cadmium Lemon

Cadmium Red Light,
Pyrrole Red or
Cadmium Scarlet

Prussian Blue or
Phthalo Blue (Red Shade
or Green Shade)

Permanent Alizarin Crimson,
Quinacridone Magenta
or Permanent Rose

French Ultramarine

**EXERCISE 32:** MAKE A SPLIT-PRIMARY COLOR WHEEL

On a page in your color workbook, trace around a plate to make a circle 6"–8" (15cm–20cm) in diameter. Draw lines with a black waterproof marker from the center of the circle through twelve o'clock, four o'clock and eight o'clock. Place the primary colors as follows: at twelve, warm yellow to the left of the line, cool yellow to the right; at four, cool blue above the line, warm blue below; at eight, cool red below the line, warm red above. For bright mixtures, follow this important rule: *Don't cross the black line!* For example, start out by mixing orange using warm red and warm yellow, which are both within an area between lines. Place the orange mixture at ten o'clock. For yellow-orange (eleven o'clock), add a little more warm yellow to the orange mixture. For red-orange (nine o'clock), add more warm red to the orange mixture. These three members of the orange family will all be clean and bright if you used the right colors. To mix greens, use a lemon yellow and Phthalo Blue or Prussian Blue. To mix violets, use a blue-red and Ultramarine.

**Don't mix colors across the lines.** If your mixtures look muddy, make sure you've got your colors properly laid out and try again. Record the correct combinations right away in your color journal and memorize them. When this system becomes second nature to you, color mixing will be a breeze. Now, compare this color wheel with the one you painted for Exercise 11 in chapter two.

CROSSING THE LINE FOR LOW-INTENSITY MIXTURES

For high-intensity color mixtures, use only the two primaries inside the lines to mix the colors between them. The colors across the lines have a color bias toward the complement of the mixture that will dull the color you're mixing. I made the three low-intensity mixtures painted outside the wheel on this page by intentionally crossing over both lines. These low-intensity colors don't belong on a spectral color wheel, but they can be useful for shadows and contrast effects.

# Paint Using Split-Primary Color Mixing

Once you've mastered split-primary color mixing, you'll find it easy to use these colors in your artwork. With six primaries to choose from, you have more than enough colors to start with, but it's best to begin with just three or four in your picture so you can achieve color harmony. Let's practice this mixing method as we make a simple watercolor, so you can see how I use my color ideas in the painting process.

## MATERIALS

300-lb. (640gsm) cold-press watercolor paper • Watercolors: Winsor Red, New Gamboge, French Ultramarine • Large flat or round brush • Dagger striper brush • Reference photos • Photocopy of reference photo(s) • Sketchbook and pencil • Tracing paper • ½" (12mm) low-tack, white artist's tape

### 1 SKETCH A PLAN, CONSIDERING VALUES

I usually combine more than one photo or sketch into a single composition, rearranging elements to suit myself. I'll use the sky photo shown here for inspiration to start the painting, but I'll let the watercolors have their own way without trying to match the photo. I make a black-and-white photocopy of the barn to study the existing value pattern, then I do a value sketch and rearrange the values to indicate some light coming in from the left side. Studying values is one of the most important steps in planning color work.

### 2 TRANSFER THE COMPOSITION

Draw the composition on tracing paper the same size as your support, so you can work out the design without damaging the surface of your watercolor paper. I decide to make the barn less bulky than it is in the photo and extend the landscape across the page. Then, transfer the drawing to watercolor paper.

### 3 TEST POSSIBLE COLOR COMBINATIONS

Before making a final selection of colors, squeeze out fresh paint and mingle different combinations until you decide which ones you like best for the picture you have in mind. I like the granulation of French Ultramarine for the sky. I'll use New Gamboge and Winsor Red to round out the primaries. This is a warm palette that will give a glow in the sky and dusky violet shadows on the snow.

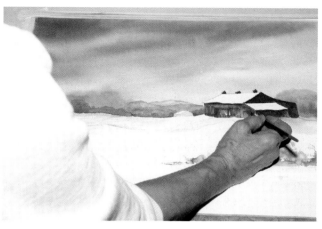

## 4 FLOW IN A BACKGROUND

After taping the edges of the paper, wet the paper with a large brush down to the base of the background trees, going around the shapes of the buildings. Flow the red and yellow around this skyline and into other areas in the sky. Then make a rich mixture of French Ultramarine with the orange mixture of the other two primaries and paint in the dark clouds. While the sky is still slightly damp, put in soft background trees.

## 5 WORK BACK AND FORTH FOR COLOR UNITY

Dampen the paper in the foreground in sections to model the snow, using a diluted violet-gray from the cloud mixture and showing a little light from the sky reflected on the snow. Paint the barn next. Work back and forth across the painting, repeating colors to unify the picture and using cooler colors in the distance.

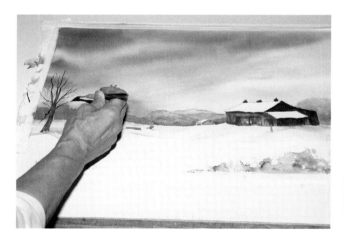

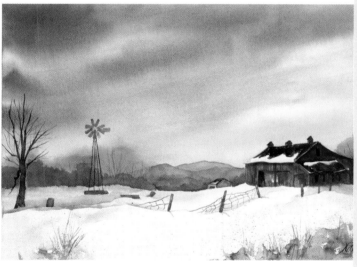

## 6 PUT IN A CONTRASTING TREE

Paint the tree on the left with a dagger striper brush in a darker value to stand out against the sky.

## 7 FINISH WITH DETAILS AND TEXTURE

Add other details to the middle ground and finish up with some spattered texture in the foreground.

**FADING LIGHT**
Nita Leland
Watercolor on paper
15" × 22" (38cm × 56cm)
Collection of Trudy Walter

# Mixing Low-Intensity Colors

Sometimes you need soft neutral colors to make the bright ones shine. Learn to achieve red-gray, violet-gray, blue-gray, green-gray—all the subtle, delicate grays in nature. In the struggle to keep from making mud, many artists avoid low-intensity mixtures altogether and fall back on tube grays and blacks, most of which deaden colors. Give your neutrals and low-intensity mixtures a **color identity**, leaning toward one of the colors in the mixture. I know it's an oxymoron, but I call these mixtures **chromatic neutrals**.

Exact complements (opposites on the color wheel) should mix to make neutral gray, but the result isn't always appealing. The truth is, you're better off mixing luminous, chromatic neutrals and not dull gray. Using the split-primary palette, mix two primaries to get a secondary color, and cross the lines or add the third primary to neutralize the mixture. And remember, don't mix too much. Whatever you do, don't use tube neutrals in your painting, or they'll flatten the color. The best plan is to mix chromatic neutrals from the colors you started the painting with.

**MIXING NEUTRALS USING COMPLEMENTS**
Another way to neutralize is to mix complementary colors. Mix the colors using the split primaries or tube complements, as shown here. These mixtures are much more vibrant than tube neutrals, because you can tweak the color identity in several directions to create a more interesting neutral.

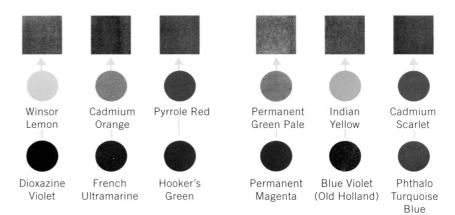

Winsor Lemon / Dioxazine Violet — Cadmium Orange / French Ultramarine — Pyrrole Red / Hooker's Green — Permanent Green Pale / Permanent Magenta — Indian Yellow / Blue Violet (Old Holland) — Cadmium Scarlet / Phthalo Turquoise Blue

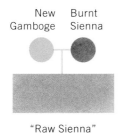

New Gamboge / Burnt Sienna

"Raw Sienna"

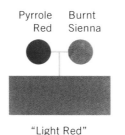

Pyrrole Red / Burnt Sienna

"Light Red"

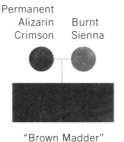

Permanent Alizarin Crimson / Burnt Sienna

"Brown Madder"

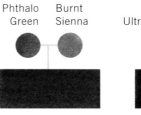

Phthalo Green / Burnt Sienna

"Hooker's Green"

French Ultramarine / Burnt Sienna

"Indigo"

THE MAGIC COLOR
One quick and easy way to lower intensity is to use the magic color, Burnt Sienna. This versatile earth color lowers intensity slightly without altering colors very much. Burnt Sienna modifies bright colors, changing them into subtle earth colors in a jiffy. Add it to your palette of split-primary colors. It's one of the most useful colors you'll ever find.

**EXERCISE 33:** MIX LIVELY NEUTRALS USING BURNT SIENNA
Experiment with lowering the intensity of pure colors by adding Burnt Sienna. Try to match your mixtures to low-intensity earth colors like Yellow Ochre, Raw Sienna, Brown Madder and Indigo. Try Lemon Yellow, New Gamboge, Permanent Alizarin Crimson and Ultramarine mixed with Burnt Sienna. Do you see how the colors retain their hue— red, yellow or blue—as they grow lower in intensity?

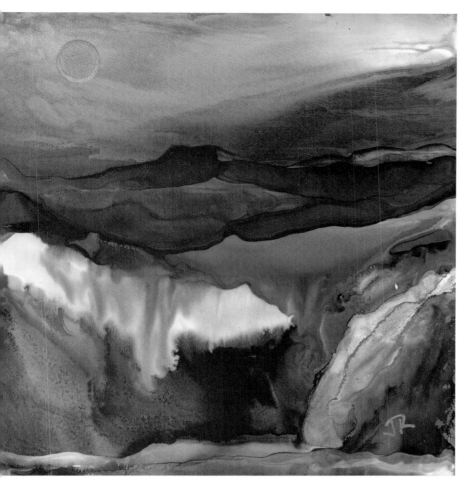

**DREAMSCAPE #640**
June Rollins
Alcohol inks on Yupo
5" × 5" (13cm × 13cm)

**LOW INTENSITY, HIGH DRAMA**
Inks tend to do their own thing as you rock your surface and allow the colors to merge. By including complementary red-orange and blue-green in her palette, Rollins blends and contrasts these intense colors with an exciting range of lower intensity browns to create a vibrant landscape.

**EXERCISE 34:** MIX CHROMATIC NEUTRALS
Make a sectioned chart showing low-intensity, neutral mixtures made with complements. Mix any two complements or near-complements to create a gray or brown mixture, but retain the identity of one of the colors in the mixture. Play with all the colors you have, finding different complementary or near-complementary pairs that achieve lively grays and browns. Add a third color if needed to enhance a mixture. Take careful notes and record the results in your color journal.

CHROMATIC NEUTRAL MIXTURES
You can use many different color combinations to make beautiful low-intensity colors by making sure the colors aren't exact complements. Experiment with two or three colors that are different distances apart on the color wheel and see what happens. The nearer colors are on the wheel, the more colorful the mixture. These chromatic neutral combinations are much more exciting than neutrals such as Davy's Gray and Sepia squeezed from a tube.

DULL NEUTRALS

CHROMATIC NEUTRALS

Davy's Gray
(achromatic)

Viridian +
Permanent Rose

Cadmium Scarlet +
Cobalt Blue

Sepia
(dull brown)

Cadmium Red
Light + Phthalo
Blue (Red Shade)

Cadmium Red Light
+ Phthalo Green
(Blue Shade)

# Mixing Darks

Strong, rich darks may seem difficult to make, but they're not all that different from mixing neutrals. Taking into consideration the characteristics of your paints, you can easily see that some colors, such as those with weak tinting strength, simply won't make dark mixtures. Choose colors that have relatively strong tinting strength and use them throughout the painting, not only in the dark mixtures. Don't introduce new colors into your palette at the last minute just to get darks. Dark colors are more effective when they're transparent, so use complementary, transparent colors to create your mixtures, and don't apply them too heavily. Using formulas for darks almost guarantees you'll ruin your picture. For each painting, pick the combination of colors that is most likely to enhance that particular piece.

Lamp Black
(flat black)

Burnt Sienna +
French Ultramarine

Cadmium Orange +
French Ultramarine

Dioxazine Violet +
Hooker's Green

Garnet Lake +
Sap Green

Ivory Black
(warm black)

Permanent
Alizarin Crimson
+ Phthalo Green

Cadmium Red Light +
Phthalo Blue
(Red Shade)

Cadmium Red +
Hooker's Green

Pyrrole Red +
Phthalo Green

**EXERCISE 35:** MAKE COLORFUL, DRAMATIC DARKS
Look at your transparency chart (from Exercise 22 in chapter three). Select transparent, complementary primary and secondary colors of high tinting strength (from Exercise 23 in chapter three) to start with: red and green, yellow and violet, blue and orange. Mix any red with any green in your medium of choice until you get a dark you like. Sometimes you will get brown or dark gray, instead of black. Place swatches of your mixtures on a sectioned chart in your color workbook. Repeat the exercise with all your complementary and near-complementary pairs, including the tertiaries. Note in your color journal which combinations you like best.

BETTER THAN BLACK
Lamp Black and Ivory Black from the tube have their uses, but they don't make colorful darks. The mixtures shown beside them are much more vibrant. The most powerful colors to use for darks are Permanent Alizarin Crimson and Phthalo Green, with a dab of Phthalo Blue thrown in to change the color bias. If you want strong darks like this, be prepared to use these colors throughout your painting so they don't throw the color out of balance.

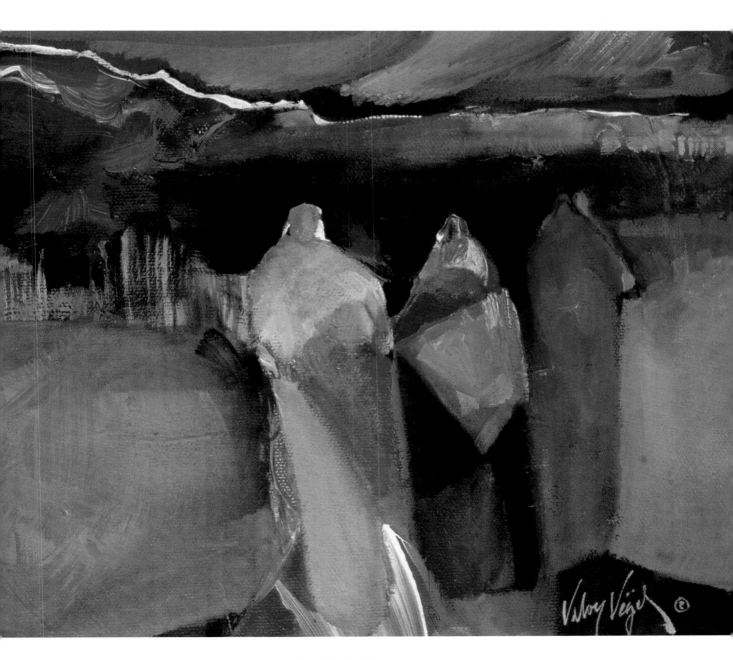

**TENDERNESS**
Veloy Vigil
Acrylic on canvas
8" × 10" (20cm × 25cm)
Courtesy of Gallery Elena, Taos, New Mexico

DYNAMIC DARKS
Vibrant darks are beautifully integrated in this acrylic painting, with a combination of neutrals and chromatic neutrals. Vigil contrasts background darks with slightly lighter low-intensity passages touched with bright color. Dark areas throughout draw the viewer's eye irresistibly to the figures.

# Modifying Tube Colors

When there are so many ways of mixing beautiful colors, why do some artists depend on ready-made colors? Take green, for example. Few manufactured greens are natural looking, and if you have a tube green you like, chances are you use it too much. This is true of almost any color you can name. An infinite variety of mixtures is possible with every color, as this exercise shows you.

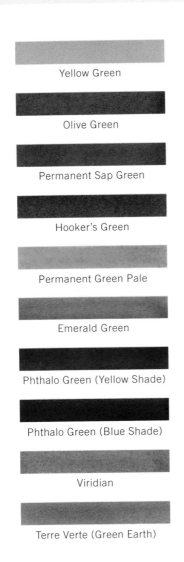

Yellow Green

Olive Green

Permanent Sap Green

Hooker's Green

Permanent Green Pale

Emerald Green

Phthalo Green (Yellow Shade)

Phthalo Green (Blue Shade)

Viridian

Terre Verte (Green Earth)

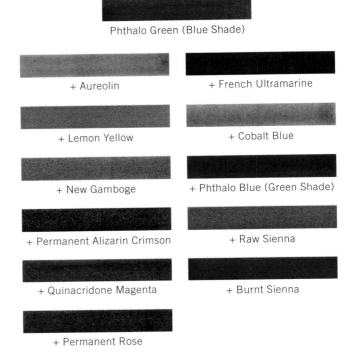

Phthalo Green (Blue Shade)

+ Aureolin

+ French Ultramarine

+ Lemon Yellow

+ Cobalt Blue

+ New Gamboge

+ Phthalo Blue (Green Shade)

+ Permanent Alizarin Crimson

+ Raw Sienna

+ Quinacridone Magenta

+ Burnt Sienna

+ Permanent Rose

## TUBE GREENS

Many beautiful greens are already mixed and packaged in tubes, like those shown here. The problem is, it's tempting to use them too much, and everything begins to look the same. It's much more fun to make your own greens to fit each painting situation.

**EXERCISE 36:** GET THE MOST FROM TUBE COLORS

You can easily adjust paint colors in any medium by adding small amounts of one other color to them. Squeeze Phthalo Green (Blue Shade) onto your palette (or any other color you wish, preferably one with high tinting strength). Mix just enough of a second color with some of the green to change it slightly. Place a swatch of the mixture on a chart. Label the sample with the names of the colors you used. Repeat with every color you have, mixing each with the original Phthalo Green. As powerful as this color is, many other colors modify it beautifully, providing some delightful new colors to work with. Try this with Phthalo Blue, Quinacridone Magenta and Lemon Yellow. You'll discover exciting mixtures, no matter what color you start with.

**KEEL-BILLED TOUCAN**
John Agnew
Acrylic on canvas
17" × 32" (43cm × 81cm)

## USING GREENS EFFECTIVELY

A masterful blend of greens creates a woven texture of light and shadow on tropical foliage throughout this picture. Don't be afraid to use greens. They are troublesome only when you mix warm yellow with warm blue, or if you use the same boring green everywhere. The greens in Agnew's painting are anything but boring.

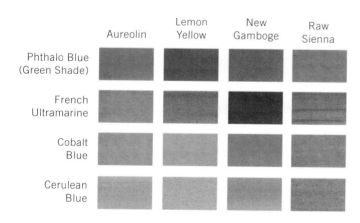

|  | Aureolin | Lemon Yellow | New Gamboge | Raw Sienna |
|---|---|---|---|---|
| Phthalo Blue (Green Shade) | | | | |
| French Ultramarine | | | | |
| Cobalt Blue | | | | |
| Cerulean Blue | | | | |

## WHAT GREENS WILL YOU MAKE?

Yes, blue and yellow do make green—any kind of green you could possibly want. Prove it to yourself by trying these combinations. You can also do this exercise using an assortment of red and yellow paints to mix orange, or different reds and blues for violet.

**EXERCISE 37:** MIX BLUES AND YELLOWS TO MAKE GREENS

Start with a sectioned sheet. Using Phthalo Blue (Green Shade) and Aureolin, mix green and place a swatch of this mixture at the upper left, as shown. To the right of this use Phthalo Blue again, but change the yellow to Lemon Yellow for a slightly different green. Continue across the row with Phthalo Blue, changing only the yellow each time, until you've explored all your yellows. Start the next row with a different blue, French Ultramarine, and mix this with Aureolin, the same as the yellow above. This results in a slightly duller green than the one you made with Phthalo Blue and Aureolin, but it's still a nice green. However, when you mix New Gamboge and French Ultramarine, it's a different story—olive green, for sure. Finish the exercise with the rest of your blues, using the same blue colors across each row and repeating the yellow colors down the columns.

5

**TROPICAL SERIES 125—TROPIC LEAVES**
Mary Jane Schmidt
Acrylic on canvas
72" × 60" (183cm × 152cm)
Courtesy of Rice and Falkenberg Gallery

# WORKING WITH HARMONIOUS COLORS

THE ARTIST IS BORN TO PICK, AND CHOOSE, AND GROUP WITH SCIENCE, THESE ELEMENTS, THAT THE RESULT MAY BE BEAUTIFUL – AS THE MUSICIAN GATHERS HIS NOTES, AND FORMS HIS CHORDS, UNTIL HE BRINGS FORTH FROM CHAOS GLORIOUS HARMONY.
— JAMES ABBOTT MCNEILL WHISTLER

Once you've tested the characteristics of your colors and practiced color mixing, you're ready to start organizing color. The color wheel is the visual aid for understanding cohesive, harmonious color groups. In this chapter we will explore eight unique palettes that start with different primaries, making highly distinctive color wheels of compatible colors.

Problems with color in artwork usually stem from including too many colors or combining pigments that don't work well together. Compatible triads solve both problems. If three colors don't give you the results you want, you can add another color that shares their transparency, intensity and tinting strength without introducing a sour note in your color harmony. You may even find new combinations that work with the unused colors that clutter your paint box. Try these and invent your own exciting triads.

**MORNING DEPARTURE**
Douglas Purdon
Oil on canvas
22" × 28" (56cm × 71cm)

# Exploring Eight Harmonious Palettes

For every color wheel presented on the following pages, the name of each triad (set of primary colors) suits the characteristics of the paints used. Try to work with the exact colors shown on each triad to make your harmonious color wheels. Later on you can play at mixing and matching colors.

Painters can mix the color wheels, while fiber artists and others can match the harmonious wheels with suitable materials, such as colored pencils, yarns, fabrics or paper collage. Mixtures of some compatible colors aren't as bright as the split-primary mixtures, but they're unified by their transparency or opacity, intensity and tinting strength. The result is a group of colors that work well together to approximate, rather than match, the primary hues and their mixtures.

**EXERCISE 38:** PUT DOWN YOUR THOUGHTS ON EACH PALETTE
In your color journal, write down your observations of each harmonious palette you see in this chapter: its value range, the character of the neutrals, your reaction to the mixtures, and possible subjects that might work well with each palette. See if you can find other colors in your paint box that are harmonious with each triad. For each color wheel, make a sketch using the colors.

**EXERCISE 39:** MAKE AND USE A COLOR-WHEEL TEMPLATE
Cut a 6" (15cm) color-wheel template from cardboard or stencil paper. Use a coin to trace twelve small circles equidistant around the wheel at the positions of numbers on a clock. Cut out the circles with a craft knife. Use this template to trace eight color wheels on a 14" × 20" (36cm × 51cm) or larger white support.

Use only the three primary colors recommended for each harmonious color wheel on the following pages, or the closest match you can find in transparency, intensity and tinting strength. Place the colors representing yellow at the top of the wheel, blue at four o'clock and red at eight o'clock, labeling them with their paint names. Using these primaries, mix the colors between them and fill in the entire circle. You can start in any section—I'm working with red and yellow to mix the oranges here. Since there are no lines to cross, as in Exercise 32 from chapter four, you'll find that some of the mixtures aren't pure. That's okay, because we're not trying to make spectral colors—we're going for unity and expression in colors that work well together because they share specific characteristics. Go on to mix chromatic neutrals with all three primaries, showing a color bias toward each color in the mixtures. Place swatches of these neutrals at the center of the circle. For now, don't worry about the color swatches shown outside the wheels—we'll work with those at the end of the chapter.

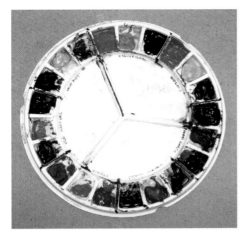

YOU DON'T NEED A NEW PALETTE TO EXPLORE COLOR TRIADS
It's fun to see how different artists set up their palettes. Here are examples from some of the artists in this book (shown clockwise from above: Mike Beeman, Patricia Kister, Nita Leland, David Daniels, Mark Mehaffey and Jane Phillippi). They all arrange their colors in their own way; some use small mixing palettes or paint containers on the side. You can use any palette you have, as long as you keep your paints clean so they don't contaminate the mixtures you are exploring.

# The Delicate High-Key Palette

Delicate tinting colors—Rose Madder Genuine or Permanent Rose, Aureolin and Cobalt Blue—make an exquisite, high-key color wheel, limited in contrast and beautifully transparent. In watercolor the colors are nonstaining, easily lifted and extremely useful as glazes. Although they are pure, bright colors, they all have relatively weak tinting strength. Flowers are delightful subjects for the high-key palette, but there are other options. How about a misty river scene or a soft portrait? Light-filled landscapes are successful with these colors, but you can't make strong darks with them. Powerful darks would destroy the delicacy and subtlety of this palette. Used carefully, Burnt Sienna is a good addition because it enables you to increase your range of darks slightly.

*These two colors have been disparaged in recent years as unreliable. I have had no adverse experiences with either color and continue to use them, as do many other artists. If you're concerned about this, look for pure hues with weak tinting strength.

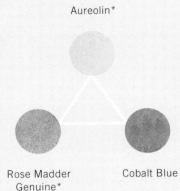

Aureolin*

Rose Madder Genuine*

Cobalt Blue

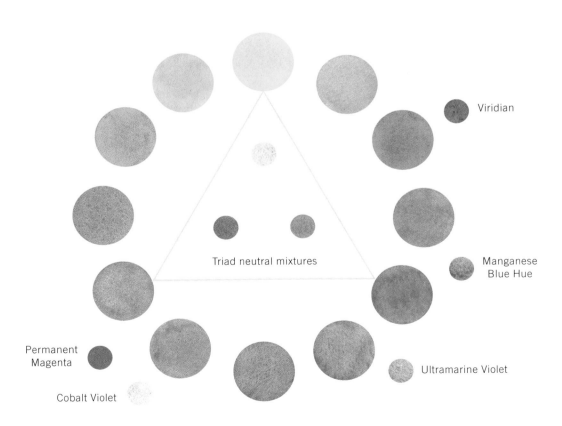

Viridian

Manganese Blue Hue

Triad neutral mixtures

Ultramarine Violet

Permanent Magenta

Cobalt Violet

**DREAM ON**
Nita Leland
Watercolor on paper
9" × 6" (23cm × 15cm)

SOFT AND SWEET

My granddaughter's portrait illustrates the harmony of the delicate high-key palette.
I splashed in the spontaneous background and layered well-diluted colors to model
her features and the shadows, then added details. Soft edges and delicate colors
represent the innocence of childhood.

# The Traditional Palette

The traditional palette is a combination of high-intensity, transparent and opaque colors, with intermediate-to-strong tinting strength. These workhorse colors are found on almost every artist's palette: Cadmium Red, New Gamboge or Cadmium Yellow and French Ultramarine. New Gamboge lends some transparency to the mixtures. Ultramarine is semitransparent, but the cadmium colors are very opaque. Many artists think of this palette as muddy. It has a wide range of values, but doesn't quite match the power of the intense palette shown later. This an ideal palette for natural subjects: the olive greens of trees and grasses, the subtle violets of shadows, beautiful browns and earthy yellows. You can dilute mixtures for high-key paintings, but they lack the subtlety of the high-key palette. Even with its limitations, this is a very useful palette, particularly if you supplement the traditional triad with other colors, like Permanent Alizarin Crimson, to improve its transparency in mixtures.

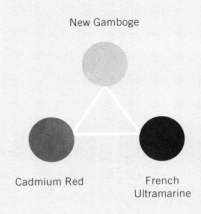

New Gamboge

Cadmium Red

French Ultramarine

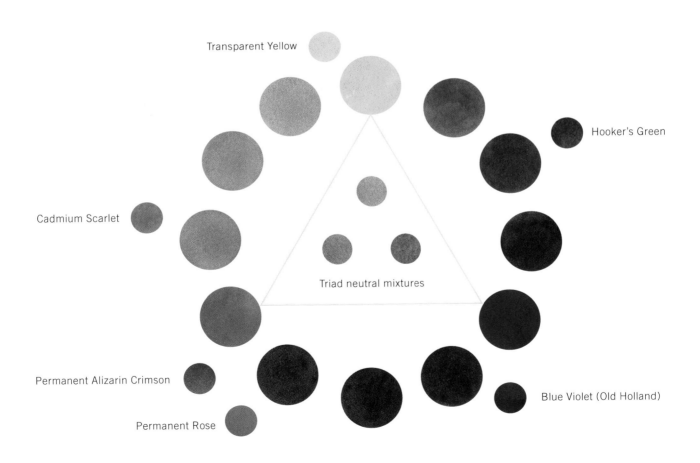

Transparent Yellow

Hooker's Green

Cadmium Scarlet

Triad neutral mixtures

Permanent Alizarin Crimson

Blue Violet (Old Holland)

Permanent Rose

**YELLOW CROCS**
Julie Ford Oliver
Oil on canvas
6" × 8" (15cm × 20cm)

PERFECT PRIMARY HARMONY
Oliver does a great job here of
harmonizing the traditional primary
colors. The background appears to be
toned-down mixtures of these colors and
allows the primaries to dominate the
foreground.

**SONGS FOR THE PIECUTTER**
Donna Howell-Sickles
Acrylic, charcoal and pencil on paper
60" × 40" (152cm × 102cm)

SIMPLY BEAUTIFUL COLOR
Color can be as simple or as complex as
you care to make it. Howell-Sickles takes
the route of simplicity, using primary red,
yellow and blue, beautifully balanced in
strong shapes and clever color repetition.
The standard palette offers a wide range
of possibilities, from bright, high-intensity
colors to toned-down, almost earthlike
mixtures.

# The Bold Palette

Transparent, high-intensity colors of great tinting strength, such as Pyrrole Red or Permanent Alizarin Crimson, Winsor Lemon and Phthalo Blue (Red Shade), make a versatile palette that ranges from dramatic, bold statements featuring rich, intense darks to sensitive, elegant images using delicate tints. The value range runs the gamut from the lightest light to the darkest dark. These dynamic colors generate energy, brilliance and sharp contrast in any subject, including cityscapes, landscapes, portraits and flowers. Nonobjective or abstract compositions can be dazzling with this intense triad. The transparency of these colors makes them useful as glazes when well diluted, but their staining property merits a word of caution: they can't be lifted easily once they're dry.

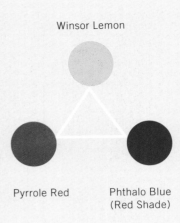

Winsor Lemon

Pyrrole Red

Phthalo Blue
(Red Shade)

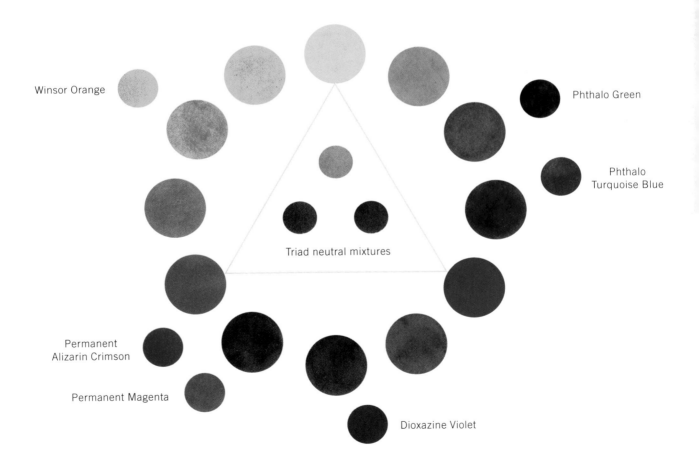

Winsor Orange

Phthalo Green

Phthalo
Turquoise Blue

Triad neutral mixtures

Permanent
Alizarin Crimson

Permanent Magenta

Dioxazine Violet

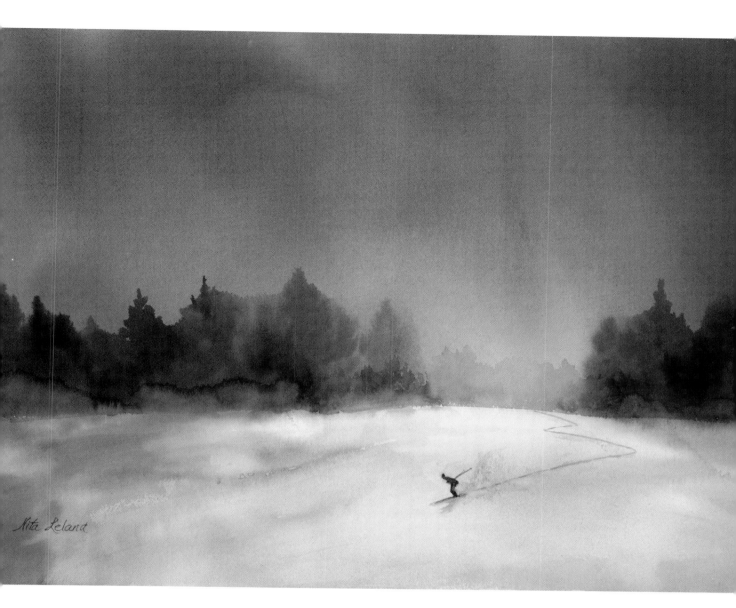

**FREE SPIRIT**
Nita Leland
Watercolor on cold-press
watercolor paper
14" × 20" (36cm × 51cm)
Private collection

MAKING THE MOST OF THREE COLORS
An intense palette of Winsor Red (Pyrrole Red), Winsor Lemon and Winsor Blue
(Phthalo Blue [Red Shade]) makes rich, low-intensity washes surrounding the glow of
the last light of day as it reflects off snow. Does light ever look like this? Maybe not,
but the colors express the time of day just as I imagine it. You can take liberties with
color if you make your point.

# The Modern High-Intensity Palette

Manufacturers have expanded their color ranges far beyond most artists' needs or capabilities of keeping up with the changes. Exploring color is how you learn which of these new colors might work best with those you're familiar with. One useful triad that ought to be on your palette if you love intense, upbeat color consists of transparent colors of powerful tinting strength, such as Quinacridone Magenta, Hansa Yellow or Hansa Yellow Light, and Phthalo Blue (Green Shade) or Turquoise Blue or Cyan. You can dilute these to make delicate tints or run the gamut of values from light to dark. Any realistic subject or abstract composition can be enhanced with these modern hues, but beware that the staining colors can't be lifted easily once they're dry.

Hansa Yellow

Quinacridone Magenta

Phthalo Blue (Green Shade)

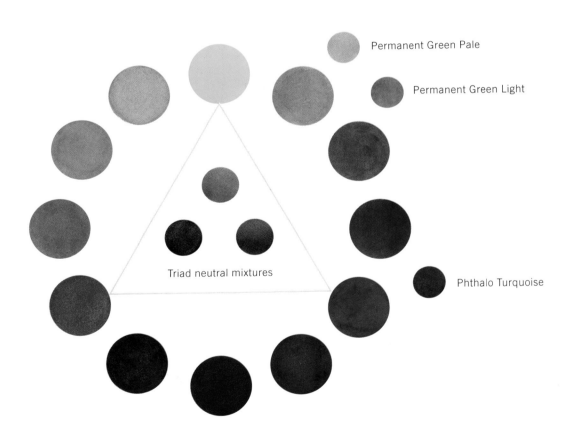

Permanent Green Pale

Permanent Green Light

Triad neutral mixtures

Phthalo Turquoise

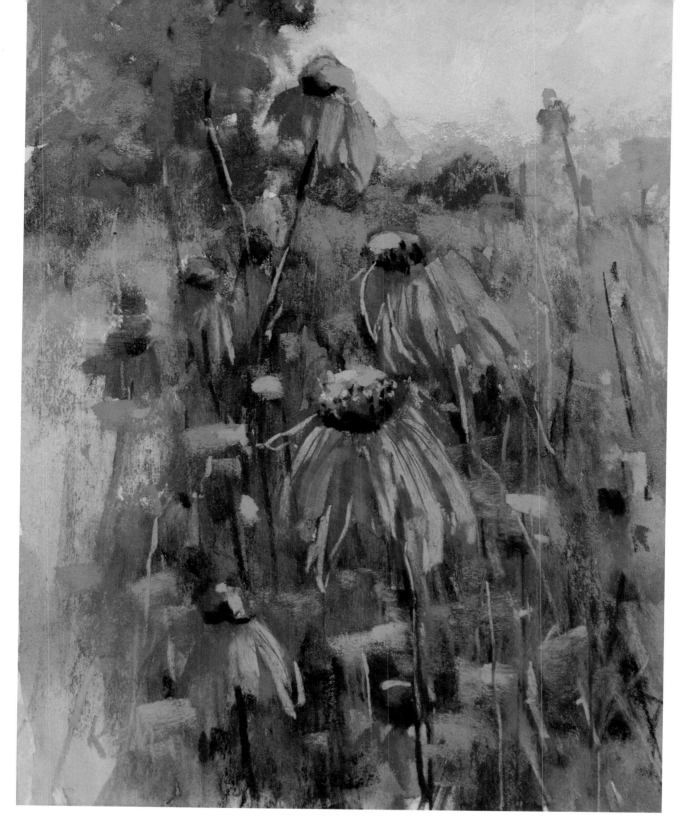

**DOING THE DANCE**
Karen Margulis
Pastel on sanded paper
10" × 8" (25cm × 20cm)

A BOLD EXPRESSION OF COLOR IN NATURE
Although pastels aren't mixed in the same way as fluid mediums, they're the closest thing to working with pure pigment. This bold painting appears to be based upon magenta and cyan with a stunning yellow-green to set off the modern colors. One of the advantages of pastel is the ability to layer bright, intense colors over darker backgrounds and then burnish throughout with light wherever you want it. A plein-air painter, Margulis handles color contrasts masterfully.

# The Opaque Palette

If you're looking for unique expression, the opaque palette is a sure way to get it—but it's tricky. The mixtures are subtle and distinctive. Colors for this wheel are Indian Red, Yellow Ochre and Cerulean Blue. While Cerulean Blue seems a bit bright for a low-intensity palette, its density and opacity allow it to fit right in. Indian Red has a stronger tinting strength than the other two colors, but together they seem to work. Extreme darks are impossible, but you can get dark enough to have effective value contrast. The limited color range of the mixtures makes it interesting. Work on a wet surface with the colors, laying them in with a big brush, then leaving them alone. If you try to move the colors around, you'll make instant mud and disturb the granulating effects of the colors. Paint rocks, buildings and landscapes with this palette, and don't bypass portraits and flowers as intriguing possibilities.

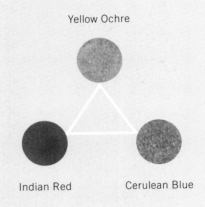

Yellow Ochre

Indian Red          Cerulean Blue

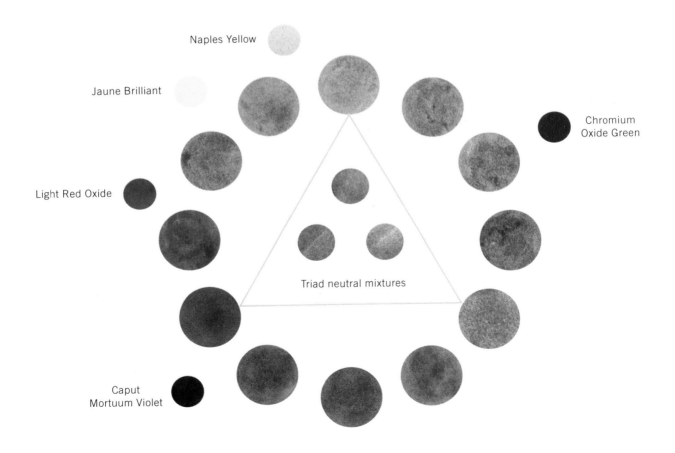

Naples Yellow

Jaune Brilliant

Chromium
Oxide Green

Light Red Oxide

Triad neutral mixtures

Caput
Mortuum Violet

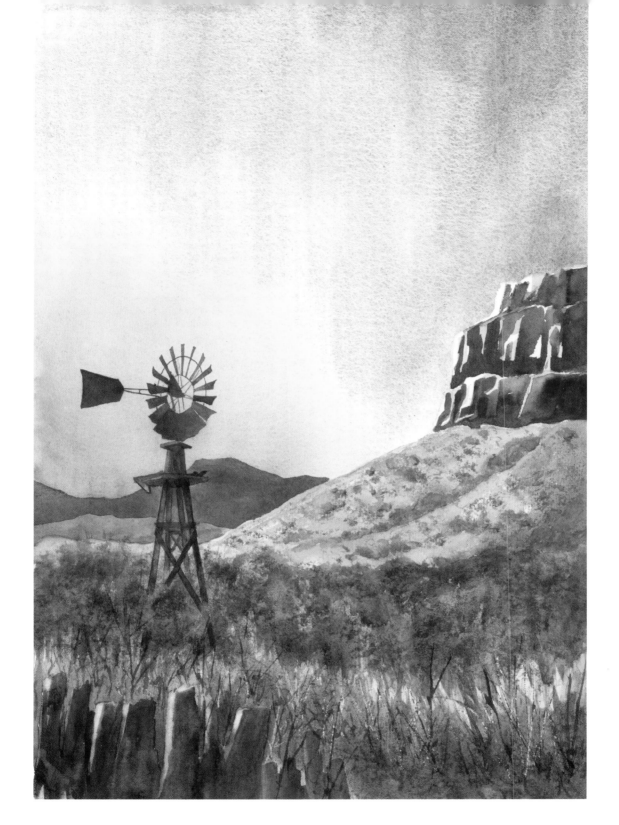

**RELICS**
Nita Leland
Watercolor on paper
25" × 22" (64cm × 56cm)

HARMONIOUS OPAQUE COLORS
Cerulean Blue granulates beautifully on 300-lb. (640gsm) cold-press watercolor paper, so I simply flowed the color onto damp paper with a 3" (8cm) hake brush and rocked the paper gently so the pigment would settle. The opaque palette makes dusky violets and rich, earthy red-oranges, and the low-intensity green mixtures harmonize with all the other colors. Use plenty of water with these colors, so they don't turn thick and chalky on you.

# The Old Masters' Palette

The early masters were limited in their color choices and used those colors very much like the ones in this palette: Burnt Sienna, Yellow Ochre or Raw Sienna, and Payne's Gray. This wonderful palette of values and intermediate tinting strength yields low-intensity and semitransparent mixtures. It's surprising how many artists fall in love with the Old Masters' palette when they try it. Its subtlety is moving and highly effective. Any subject is appropriate, but this palette is especially interesting in portraits and autumn florals and landscapes. With Burnt Sienna and Payne's Gray substituting for red and blue, violet mixtures don't exist; instead, a good dark takes its place. Greens and oranges are low key and mysterious. This is the only time I recommend using Payne's Gray on your palette, as a color in its own right and not as a quick fix to add darks to a painting.

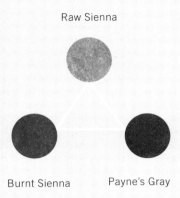

Raw Sienna

Burnt Sienna    Payne's Gray

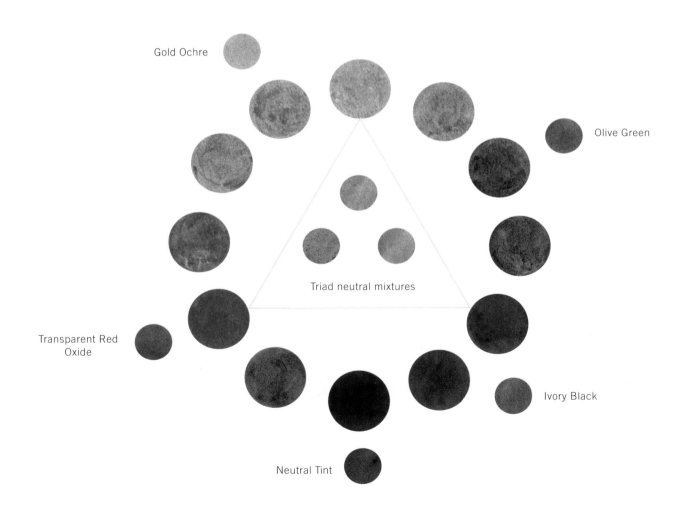

Gold Ochre

Olive Green

Triad neutral mixtures

Transparent Red
Oxide

Ivory Black

Neutral Tint

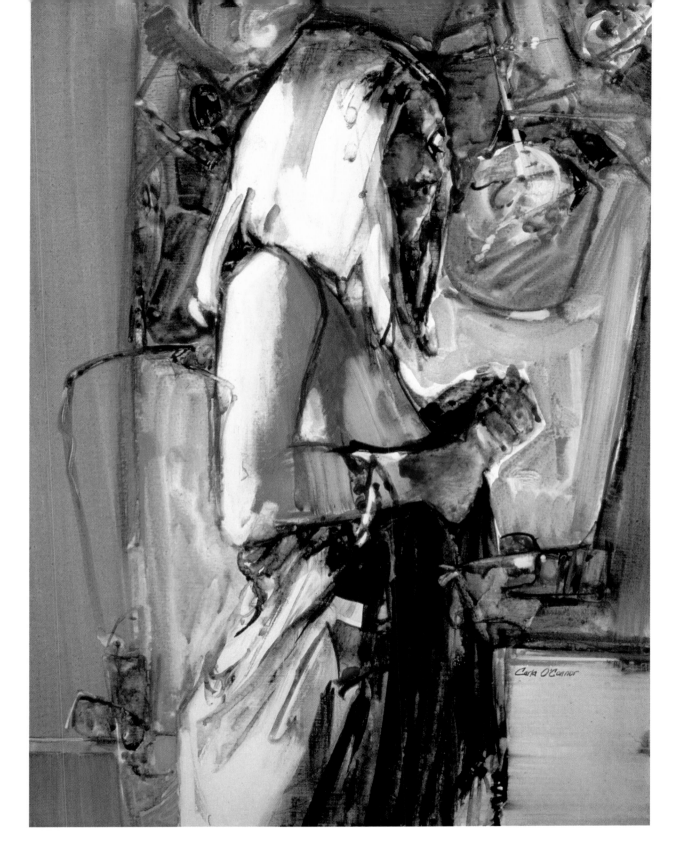

**AFTER EIGHT**
Carla O'Connor
Watercolor and gouache
on watercolor board
30" × 22" (76cm × 56cm)

UNIFIED OLD MASTERS' COLORS
The unity inherent in harmonious colors is evident in this serene figure painting, which reflects the low-intensity color impression of the Old Masters' palette. O'Connor's colors set a pensive mood that whispers rather than shouts. This is clearly not the place for Phthalo Green or Cadmium Orange.

# The Bright Earth Palette

This is my personal favorite among the low-intensity harmonious triads. The bright earth palette has powerful tinting strength and is beautifully transparent. With this palette you can achieve extremes of value from bright lights to rich, powerful darks. Using Brown Madder, Raw Sienna or Quinacridone Gold, and Indigo, you are once again forfeiting violet, but if you need it, you can tweak the color in your painting by including a brighter red or blue that will yield a violet mixture. Color mixtures of the bright earth palette are more transparent and somewhat brighter than those of the Old Masters' palette, but still low in intensity. The palette makes distinctive portraits and abstract landscapes, but almost any subject will work. Brown Madder and Indigo are staining colors, so you won't be able to do much correcting with this palette.

Quinacridone Gold

Brown Madder          Indigo

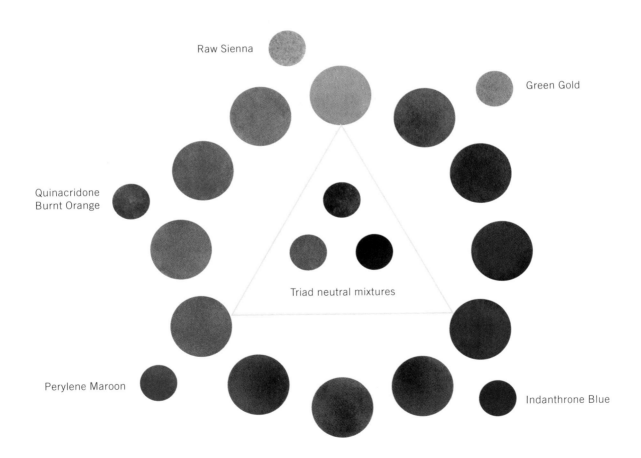

Raw Sienna

Green Gold

Quinacridone
Burnt Orange

Triad neutral mixtures

Perylene Maroon

Indanthrone Blue

Nita Leland

**PIROUETTE**
Nita Leland
Watercolor on illustration board
16" × 12" (41cm × 31cm)
Private collection

STRONG BRIGHT EARTH COLORS
Low-intensity colors of the bright earth palette possess strong tinting strength and create good light and dark contrasts. Although you can mix other colors to make these neutrals, you'll enjoy the convenience of having them together on your palette for low-intensity paintings. They also work well with the modern low-intensity colors you'll see in the next triad.

# The Modern Low-Intensity Palette

This is a new favorite among the low-intensity harmonious palettes. The modern triad is powerful and comprises a complete value range. Perylene Maroon, Quinacridone Gold and Indanthrone Blue provide a solid primary foundation for color mixing, but you can also add in the new mineral colors that are offered by several manufacturers. These are low-intensity colors, many of which granulate or flocculate into amazing textural effects. This palette works with all subjects but is especially effective with nature subjects.

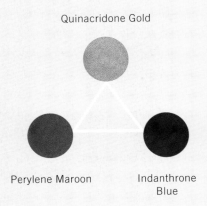

Quinacridone Gold

Perylene Maroon

Indanthrone Blue

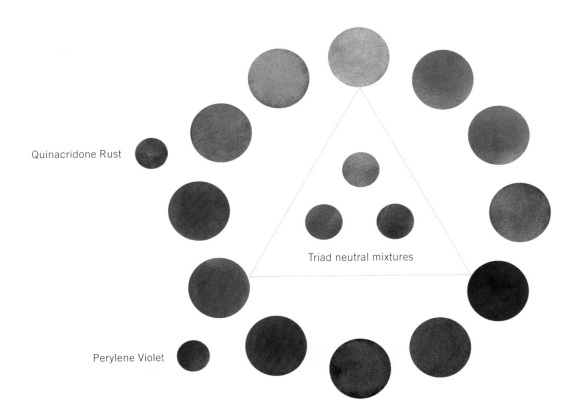

Quinacridone Rust

Triad neutral mixtures

Perylene Violet

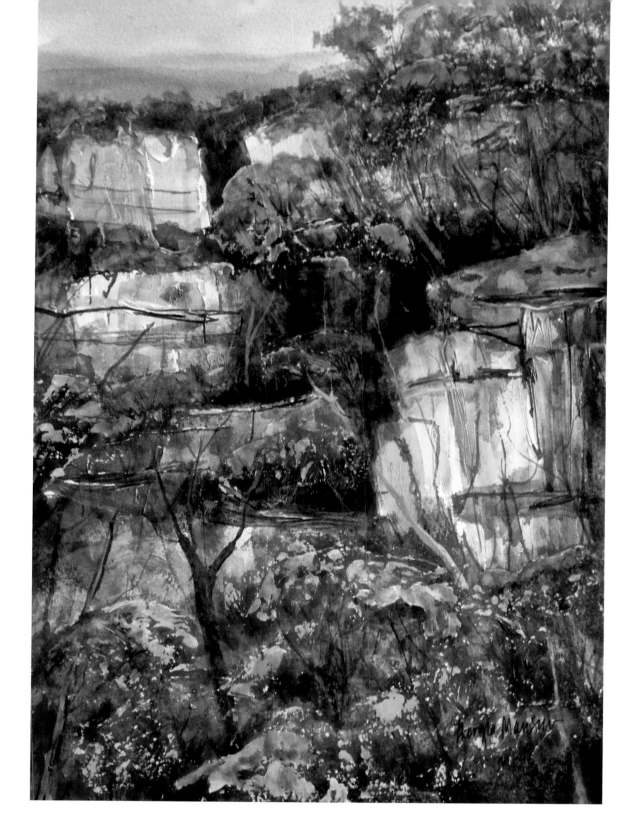

**ROCKIN'**
Georgia Mansur
Watercolor on
watercolor ground
22" × 15" (56cm × 38cm)

MODERN LOW-INTENSITY COLORS ROCK
Synthetic pigments have replaced many colors on the modern palettes of
contemporary artists, but there are also many exciting mineral colors available
now, such as the PrimaTek watercolors by Daniel Smith. These come into play in
Mansur's landscapes and florals.

# Mixing and Matching Harmonious Colors

Pigment compatibility in transparency, intensity and tinting strength is a key to distinctive color. But you don't have to limit yourself strictly to my colors. Compatible colors are points of departure, not formulas. Test your mixtures. Many colors share the characteristics of each group and can be used interchangeably. Use good judgment when you cross over to another group. Permanent Alizarin Crimson may work well with both the intense and the traditional colors, but it's much too powerful for the delicate ones. Burnt Sienna fits in with every palette. Try Permanent Rose on the high-key palette. Explore variations of the Old Masters' palette using Ivory Black or Neutral Tint. Be sure your substitutions share some of the characteristics of the triad you're putting them into, or that you adjust adequately for any differences in transparency and tinting strength. What other harmonious combinations can you find?

**EXERCISE 40:** MAKE A HARMONIOUS COLOR CHART

Now that you've explored harmonious palettes, organize your colors into a workable system with this exercise. Your test charts from chapter three will help you group colors according to their transparency or opacity, intensity and tinting strength. Begin by separating your colors into two major groups: high intensity and low intensity. Next, within each of those two groups, sort the colors according to their tinting strength: delicate, intermediate or strong. Finally, within each of these groups, match the colors for their transparency or opacity. Study the chart on this page to get you started. Make one like it in your color journal, adding your own colors. After you've selected the colors for each category, place a swatch of each compatible color outside the edges of the appropriate wheel on each harmonious color wheel chart, as shown in mine in this chapter, to provide a visual reference for colors that share similar characteristics. Some colors may work equally well on more than one wheel.

## HARMONIOUS COLORS CHART

### HIGH-INTENSITY COLORS

| DELICATE HIGH-KEY (TRANSPARENT) | TRADITIONAL (TRANSPARENT OR OPAQUE) | BOLD (TRANSPARENT) | MODERN HIGH-INTENSITY (TRANSPARENT) |
|---|---|---|---|
| Rose Madder Genuine | Cadmium Red Medium | Quinacridone Magenta | Quinacridone Magenta |
| Permanent Rose | Cadmium Scarlet | Permanent Alizarin Crimson | Hansa Yellow Light |
| Aureolin | Cadmium Lemon | Pyrrole Red | Phthalo Blue (Green Shade) |
| Cobalt Blue | New Gamboge or | Winsor Lemon | Phthalo Turquoise |
| Manganese Blue Hue | Indian Yellow | Phthalo Blue (Green Shade or Red Shade) | Phthalo Green |
| Viridian | French Ultramarine | Phthalo Turquoise | Permanent Green Pale |
| | Permanent Green Pale | Phthalo Green | Phthalo Turquoise Blue |
| | Hooker's Green | Winsor Orange | Dioxazine Violet |
| | Cadmium Orange | Dioxazine Violet | Pyrrole Orange |
| | | Permanent Magenta | |

### LOW-INTENSITY COLORS

| OPAQUE (VERY OPAQUE) | OLD MASTERS' (TRANSPARENT OR OPAQUE) | BRIGHT EARTH (TRANSPARENT) | MODERN LOW-INTENSITY (TRANSPARENT OR OPAQUE) |
|---|---|---|---|
| Indian Red | Burnt Sienna | Brown Madder | Perylene Maroon |
| Naples Yellow | Raw Sienna | Perylene Maroon | Perylene Violet |
| Yellow Ochre | Ivory Black | Raw Sienna | Quinacridone Gold |
| Cerulean Blue | Neutral Tint | Indigo | Indanthrone Blue |
| Caput Mortuum Violet | Payne's Gray | Indanthrone Blue | Quinacridone Burnt Orange |
| | Olive Green | Olive Green | PrimaTek mineral pigments |

Demonstration

# Compare Harmonious Palettes

The color effects of harmonious palette groupings are so useful that artists in nonpainting media can also use them to create harmonious artwork. In this demonstration you'll see how compatible palettes compare by making eight sketches of a single subject using each of the palettes. The goal is to create a distinctive mood, pushing the colors in each palette to show their special characteristics.

## MATERIALS

12" × 16" (31cm × 41cm) or larger sheet of paper suitable for your medium of choice • Harmonious palette colors in medium of choice • Colored pencils • Drawing pencil • Tracing paper • Soft graphite pencil • Cotton swab • Rubbing alcohol • Color journal

### 1 MAKE A SIMPLE DRAWING

Section a 12" × 16" (31cm × 41cm) sheet of paper (or larger) into eight equal rectangles. Then make a simple drawing on tracing paper that you can easily transfer eight times to this support. I include just a few large shapes and an area that will remain white, leaving out unimportant details. You can make your sketches of simple nonobjective designs if you want to. Then, shade in a simple value pattern.

### 2 TRANSFER THE DRAWING

Turn the sketch over and rub the back with a soft graphite pencil where you see the lines through the tracing paper. To set the graphite so it won't smear my watercolor paper, I dampen a cotton swab with rubbing alcohol and wipe lightly over the rubbing. When the alcohol is dry, I turn the drawing over and lay it on each section of the watercolor paper, tracing the lines with different colored pencils for each section, so I can see which lines I've traced. If the transfer becomes too faint, simply rub the back with graphite again and set with alcohol.

### 3 TRY OUT COMBINATIONS

In your color journal, mingle the colors of each compatible palette, trying out different combinations and color effects. When you find ones you like, mark them with the names of the palettes and the paint colors included in the mixtures, so you know which ones to use on the comparison sheet. I rarely use more than three colors for each palette, but you can include other colors you find compatible.

### 4 PAINT THE FIRST COLOR SKETCH

After I've selected the colors I plan to use for all the sketches, I paint the first sketch with the high-key palette.

# 5 FINISH SKETCHES USING EACH PALETTE

When your sketches are completed, place swatches of the colors you used above or below each one, then label the sketch with the name of the palette you used. Step back and examine the sketches. Which do you like best?

What other subjects can you think of for each palette? Write your reactions to the colors in your color journal. The next time you're planning a picture, try out several different harmonious palettes before you begin.

Delicate high-key palette

Traditional palette

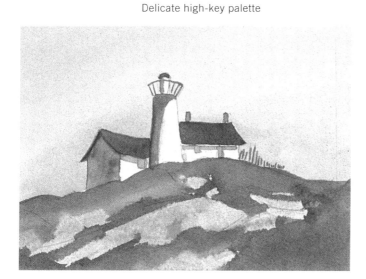

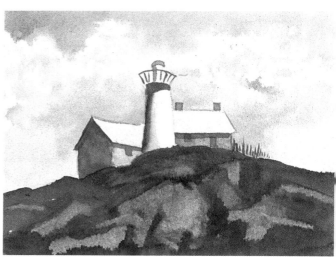

Bold palette

Modern high-intensity palette

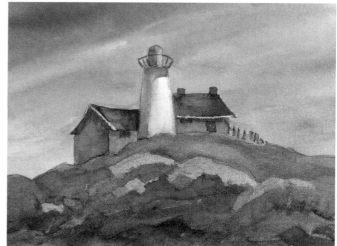

Opaque palette

Old Masters' palette

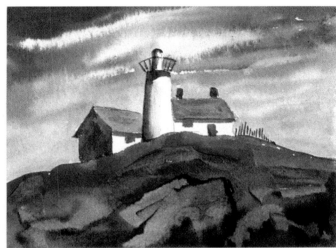

Bright earth palette

Modern low-intensity palette

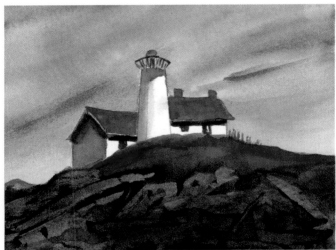

# Your Personal Basic Palette

It's time to narrow your color selection to a workable number of eight to ten colors that reflect your individuality. The exercises in this book will help you decide on a balanced palette. Have at least two sets of primary colors similar to the split-primary palette or from any combination of two harmonious triads. Be sure to include Burnt Sienna and a couple of your personal favorites. Remember, this is a *limited* palette; eventually, you'll expand it. When you've selected your colors, arrange them on a clean, white palette, leaving spaces between to add additional colors later. (See chapter three for suggestions on setting up your palette.) Experiment with your basic palette for a few weeks until you know it well, but don't hesitate to use other colors any time you want to. Relax and have fun with the colors. And never stop exploring. Dash off a couple of color mixtures or a quick sketch in odd moments, when you don't have time to do a finished piece.

Aureolin, Permanent Rose,
Cobalt Blue

Aureolin, Rose Madder Genuine,
Manganese Blue

Quinacridone Gold, Perylene Maroon,
Indanthrone Blue

## VARIATIONS ON HARMONIOUS PALETTES
Try these palettes and make up new ones of your own based on harmonious colors you find. Whenever you experiment with new colors, change just one color at a time, so you can evaluate the effect it has on mixtures with your other colors. Mingle swatches in your workbook and be sure to label your colors.

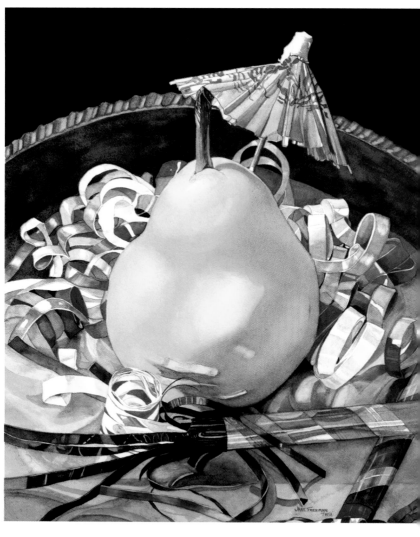

**PARTY PEAR**
Jane Freeman
Watercolor on cold-press
watercolor paper
21" × 17" (53cm × 43cm)

EXPRESS YOUR COLOR PERSONALITY
The artist creates a festive mood with a harmoniou palette featuring high-key primary colors, then tosses in a touch of green. The strip of black and burnished container create an effective backgroun without diminishing the party atmosphere.

Bold palette: Winsor Red (Pyrrole Red), Winsor Lemon, Phthalo Blue

Delicate high-key palette: Rose Madder Genuine, Aureolin, Cobalt Blue

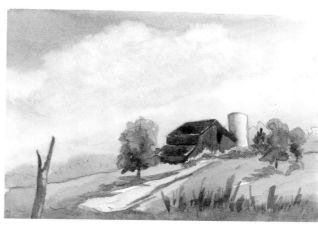

Traditional palette: Alizarin Crimson, New Gamboge, French Ultramarine, Cobalt Blue

Modern low-intensity palette: Perylene Maroon, Quinacridone Gold, Indanthrone Blue, Cerulean Blue

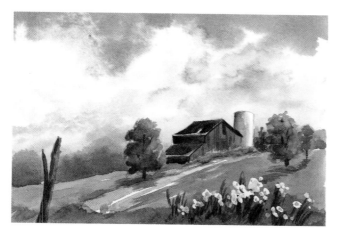

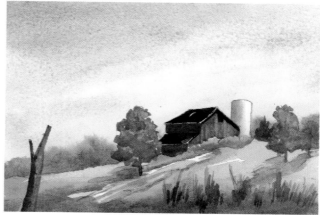

**EXERCISE 41:** REVISIT THE FOUR SEASONS

Make sketches of the four seasons from your choice of the eight palettes, using just three or four colors. When these sketches are completed, compare them to those you did in chapter one. How do the new ones differ from the ones you did using your old palette? Tell it to your journal.

For my four-seasons paintings I used the bold palette, the delicate high-key palette, the traditional palette (plus Alizarin Crimson), and a new palette of modern low-intensity pigments (plus Cerulean Blue) so you could see some of the color possibilities I've presented in this chapter. Compare these four sketches to the ones I did in chapter one.

6

# EXPANDING YOUR PALETTE WITH COLOR SCHEMES

COLORS ARE NOT USED BECAUSE THEY ARE TRUE TO NATURE, BUT BECAUSE
THEY ARE NECESSARY TO THE PICTURE. — WASSILY KANDINSKY

**EASY POSE**
Mike Beeman
Pastel on Wallis Belgium Mist paper
8" × 6" (20cm × 15cm)

**ORANGE TREE REFLECTIONS**
Harold Walkup
Watercolor on rough
watercolor paper
13" × 19" (33cm × 48cm)

The harmonious triads explored in chapter five provide a great variety of color selections: high key, low key, intense and neutral. All are at your fingertips. The complete range of hues of the color spectrum can be represented in compatible pigments—not in spectral perfection, but harmoniously combined, giving mixtures of delicacy, strength or gentle neutrality. Color expression can be subtle and sensitive or dynamic and forceful, as you wish. What will you gain, then, by increasing the number of colors on your palette?

Your goal is to learn as much as possible about pigments to achieve greater personal expression through color. So far, we've mixed all the colors on the circles from a limited palette of three primary pigments. Imagine the possibilities of a palette having a complete selection of pure, unmixed colors straight from the tube to represent the hues—twelve fully saturated primaries, secondaries and tertiaries. Such a palette can greatly expand your color expression. Now, you're going to learn about two systems that will propel you somewhere over the rainbow, where all good colorists belong.

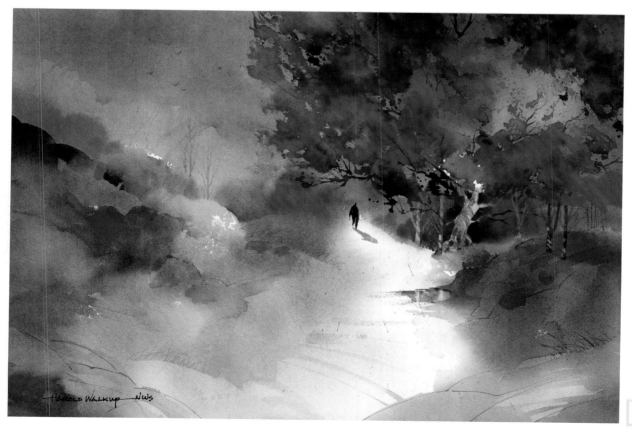

# Setting Up Expanded Palettes

In 1895 educator Milton Bradley recommended a palette for teaching color that included red, yellow and blue, plus premixed secondary green, orange and violet, thus eliminating the students' mixing of muddy secondary colors. My **traditional** expanded palette for artists, explained in this chapter, is based on Bradley's setup, plus six tertiary colors. Not long after Bradley's innovation, Herbert E. Ives suggested an alternative twelve-color system based on magenta, yellow and cyan as primaries, eliminating red-orange and blue-violet; this is the basis for my **modern** expanded palette.

Before you choose your colors for the expanded palettes, be sure you've tested them for transparency and tinting strength, determined their handling characteristics, and recorded the results in your color journal. Now, separate your paints into high- and low-intensity colors. Next, sort each category by transparency and opacity. Finally, consider each pigment's weak or strong tinting strength. Select transparent colors wherever possible, and look for similar tinting strength. Choose the colors you like best, but, if you discover that they don't suit you, put your color personality to work and change them. If a color scheme calls for lemon yellow, and you prefer a warm yellow that leans toward orange, don't be afraid to use it.

**A DIFFERENT METHOD FOR EXPANDED PALETTES**
I said earlier that you didn't need a new palette for exploring color, but now I'll confess that when I work with expanded palettes, I make preliminary color swatches in my workbook using this forty-well palette, which contains most of the pigments I use for color schemes. After I decide on the colors I want in my painting, I squeeze out fresh paint on an 11" × 15" (28cm × 38cm) or larger enamel butcher's tray. This gives me plenty of room to mix without contamination from colors not in my scheme.

**PREMIXED COLORS**
Milton Bradley's expanded palette led to the manufacture of school paint boxes such as this one. Premixed secondary colors made it easier to teach color theory, but not color mixing. You're better off with artist-quality colors.

**A FRESH START**
Throw away stiff, broken tubes and inferior student colors. Sort out colors you don't like and give them away. You'll probably never use them anyway. Clean your palette, no matter how long you have avoided this task. Soak watercolors in lukewarm water to remove old, soiled paint and dried-up colors; scrape your oil and acrylic palettes to get a fresh start on a whole new way of thinking about color.

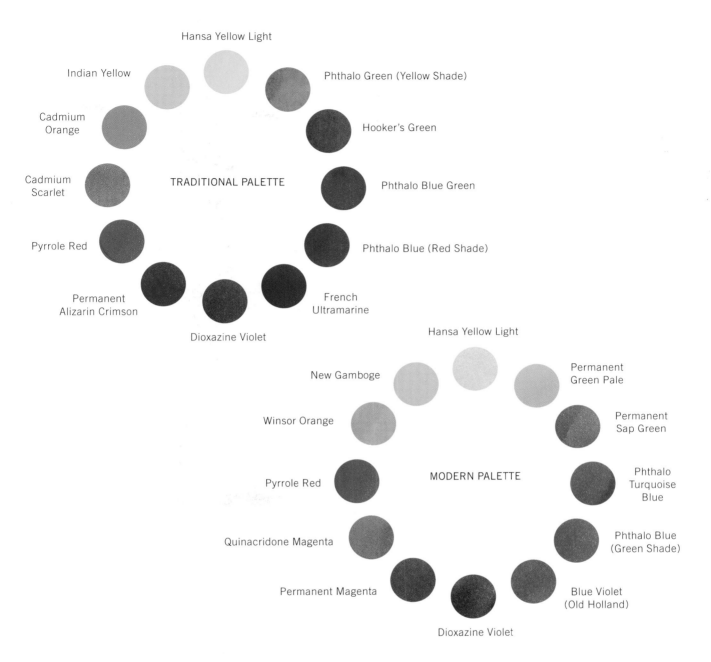

Hansa Yellow Light

Indian Yellow

Cadmium Orange

Cadmium Scarlet

Pyrrole Red

Permanent Alizarin Crimson

Dioxazine Violet

TRADITIONAL PALETTE

Phthalo Green (Yellow Shade)

Hooker's Green

Phthalo Blue Green

Phthalo Blue (Red Shade)

French Ultramarine

Hansa Yellow Light

New Gamboge

Winsor Orange

Pyrrole Red

Quinacridone Magenta

Permanent Magenta

Dioxazine Violet

MODERN PALETTE

Permanent Green Pale

Permanent Sap Green

Phthalo Turquoise Blue

Phthalo Blue (Green Shade)

Blue Violet (Old Holland)

**EXERCISE 42:** EXPAND FOR TRADITIONAL AND MODERN PALETTES

Using the examples on this page as your guide, select twelve colors for each expanded color wheel. Collage and fiber artists can gather papers, fabrics or yarns to match the colors. You don't have to duplicate my colors; if you like Permanent Rose better than Quinacridone Magenta, use it. Check the supply list in chapter three to fill in the gaps. Trace two color wheels on a white support, using the template you made in chapter five. Starting with a high-intensity yellow for each wheel, place a swatch of it in the top circle. It's okay to use some colors on both wheels, or they can be completely different.

Continue around the wheel, placing pure bright colors in their appropriate places. Be sure to label the paint names.

Use only high-intensity pigments for these expanded color wheels. You don't have to use different colors in every section, just at the locations of the primaries red and blue (magenta and cyan for the modern wheel). On the traditional palette, these colors are Pyrrole Red and Phthalo Blue (Red Shade), and on the modern palette, they are Quinacridone Magenta and Phthalo Blue (Green Shade). Notice other differences between the palettes as well; for example, on the modern wheel, Pyrrole Red moves up to displace red-orange (Cadmium Scarlet on the traditional wheel), rather than acting as a primary.

# Variations on Expanded Palettes

If you prefer not to use colors as powerful as the ones on the traditional and modern palettes, you can work with pale tints and low-intensity colors, using either the delicate or the earth-color expanded palette.

For tints, simply use the delicate tinting strength pigments or dilute traditional strength colors. For low intensity, use the earth colors. Choices are more limited with these variations, so you may have to mix some of the colors, as shown here.

You can even make unusual palettes of iridescent acrylic paints (add the tiniest speck of black paint to bring out the color) or heather tweed yarns, for example.

The color schemes you will learn in this chapter will help you use these colors much more effectively than by trial and error. Color schemes can be applied to almost any color palette, including the split-primary color-mixing system in chapter four and the harmonious basic palettes in chapter five.

# Working with Color Schemes

It doesn't matter whether you work with paints or dry media: you can use the logical relationships of colors on the color wheel to control your palette. There are many exciting possibilities for selecting colors without time-consuming guesswork. **Color schemes**, each of which is based on similarity and difference, usually feature a dominant color. Color schemes of similarity are **monochromatic**—one color in different values—or **analogous**—several colors adjacent on the color wheel. Color schemes of difference are generally based on **complementary** (opposites), **triadic** (three-color) or **tetradic** (four-color) relationships.

The harmonies and contrasts built into color schemes unify your work. This isn't an exact science, though, so you've got a lot of leeway. Trust your intuition. If you feel a color outside the scheme will enhance your painting, make a test scrap of the color and see how it looks with the other colors in the painting before putting it down permanently. Play with color schemes to see what you like. Then take risks and experiment with unusual color combinations. Understanding the color schemes on the pages that follow will free you to be more adventurous in your color selection. The examples of mingled colors shown with them are just a few of the many possible combinations of color schemes.

**EVALUATING COLOR WITH COLOR SCHEME OVERLAYS**
I use old file folders to make an overlay mask for each color scheme. I place these over my painted color wheels so I can evaluate color relationships in my paintings.

| | | | |
|---|---|---|---|
| Monochromatic | Analogous | Complementary/ Near complementary | Triadic (three colors) |
| Split complementary | Analogous complementary | Double complementary | Tetradic (four colors) |

**EXERCISE 43:** MAKE COLOR SCHEME OVERLAYS
Use your color wheel template from chapter five to make color scheme overlays to fit the expanded palette wheels you just made. Following the color scheme diagrams above and those for triadic and tetradic color schemes found later in this chapter, cut out circles the same size as those on your color wheels to match each color scheme (except for monochromatic). Label each overlay with the name of the color scheme. To use the overlay, place it on top of a color wheel and rotate so the openings reveal the colors that can be used in that color scheme. The dotted circles here indicate optional colors that could be used in addition to the other colors shown in the color scheme represented.

# Monochromatic

The least complicated of the color schemes, a monochromatic scheme has no discord. Simply use strong value contrasts of one color to create lights and darks with a dominant hue. Lighten paint colors with diluent or white and darken them with touches of black. To achieve the effect of light, don't darken your values to solid black; give them a clear color identity. Plan a source of light and create a sense of illumination from the implied source. Reserve the lightest values for the highlights and lit planes. Emphasize soft edges and middle values for a misty effect.

Monochromatic

yellow-green,
Neutral Tint

red-violet,
Neutral Tint

blue-green,
Neutral Tint

red-orange,
Neutral Tint

**EXERCISE 44:** MAKE THE MOST OF ONE COLOR
Mingle a high-intensity color with Neutral Tint or Payne's Gray to discover the range of values from light to dark that you can make with this combination. Make several small, monochromatic sketches with a different base color in each. Experiment with value contrasts to achieve dynamic visual impact with a single color. Write your reaction to these color schemes in your color journal.

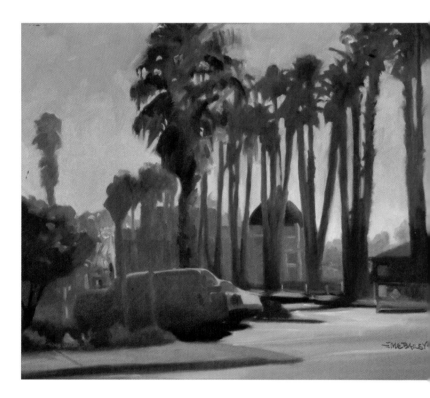

**CASINO DAWN**
Mike Bailey
Oil on stretched canvas
16" × 20" (41cm × 51cm)

BATHED IN COLORED LIGHT
Bailey has captured one of those rare moments when the ambient light is so powerful that it overpowers all other colors. The monochromatic color scheme is perfect for rendering this dramatic effect.

# Analogous

An analogous scheme is always harmonious, because analogous colors are adjacent to each other on the color wheel, and enhance each other beautifully through subtle gradation from one color to the next. Color mixtures of three or four analogous colors are bright and clear; the color mixtures darken as they move toward a complementary relationship. With an analogous color scheme, you can create a strong suggestion of illumination using gradual changes in value and intensity.

Analogous

yellow-green, yellow,
yellow-orange, orange

orange, red-orange,
red, red-violet

red, magenta,
red-violet, violet

yellow, yellow-green,
green, blue-green

**EXERCISE 45:** WORK WITH FRIENDLY NEIGHBORS
Using either expanded palette, select three or four adjacent colors from the warm side of the color circle (anywhere from yellow to red-violet). Mingle the colors to test their mixtures. Then, using the purest saturation of the colors as the darkest value, without adding gray or black, make a sketch using these warm colors to suggest a bright mood. Repeat the exercise, using colors from the opposite side of the wheel to project a cool, serene feeling. As you can see, analogous colors work beautifully together. Make a note of this in your color journal and jot down ideas for subjects using analogous color schemes.

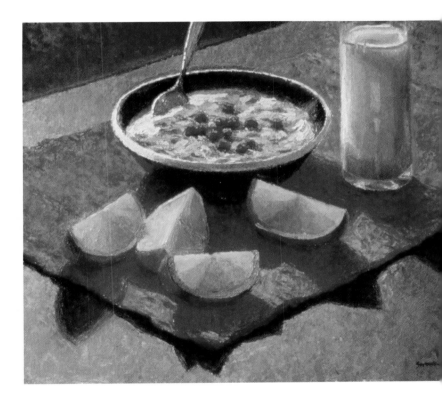

**BREAKFAST**
Susan Sarback
Oil on board
20" × 24" (51cm × 61cm)
Collection of Drs. Leonard and Phyllis Magnani

AROUND THE WHEEL
Sarback has made a bold swing all the way around the color wheel, starting at yellow-orange with her warm analogous colors. She then moves counterclockwise through orange, red and violet, ending with a few accents of cool colors from blue-violet to blue-green. Notice how the pure colors are masterfully juxtaposed without a lot of muddy mixing.

# Complementary/Near Complementary

It's amazing how colorful art can be when using just two colors opposite each other on the color wheel. These colors in their pure state look brighter side by side because they possess the most dynamic of all color contrasts; but they neutralize each other when mixed. You can take advantage of both characteristics in a dynamic complementary color scheme.

You can also use the color next to the complement, instead of the direct complement itself. Mixtures of these near complements won't make dull grays, no matter how hard you try. They yield lively, low-intensity colors with a slight color bias that adds vibrancy to the mixtures. All of the complementary and near-complementary color schemes are distinctive and worth exploring.

Complementary/Near complementary

red, green

red-orange, blue-green

orange, blue

yellow, red-violet
(near complements)

**EXERCISE 46:** EXPLORE TWO COMPLEMENTS
Look at the colors of each pair of complements on your palette side by side, then mingle them. Select the combination you like best and do a small sketch using the two colors. Let them mix throughout the sketch, but use them at maximum intensity near your focal point. Make sketches with other complementary pairs for many rich, unusual color combinations. Try Ultramarine Blue and Burnt Sienna for a remarkable range of colors. Burnt Sienna is a near complement to the blue, giving beautiful gray and dark mixtures. Find other combinations consisting of a pure color and an earth-tone complementary. Write them all down in your color journal.

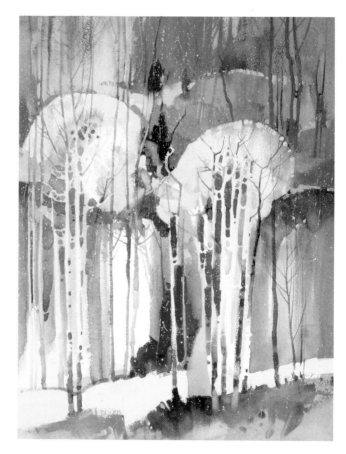

**ASPEN PATTERNS, GOLD & BLUE**
Stephen Quiller
Watercolor and gouache on paper
26" × 18" (66cm × 46cm)
Private collection

COMPLEMENTARY INTERACTION
Quiller's painting is a good example of an inventive color scheme that strongly suggests a sense of place easily recognizable to anyone who has been to Colorado in the fall. Golden aspen against blue sky and blue and blue-violet complementary shadows interact beautifully.

# Split Complementary

Split-complementary color schemes comprise three colors: one color and the two on either side of its direct complement. These wonderful color schemes provide a new dimension for overall color effects, while maintaining orderly relationships on the color wheel for harmony and control in color mixtures. The colors in their pure state contrast strikingly and make colorful low-intensity mixtures.

Split complementary

red, violet,
yellow-green

yellow-orange,
red-orange, blue

cyan, green, red

blue-violet,
blue-green, orange

### EXERCISE 47: SPLIT THE COMPLEMENTS
Mingle various split-complementary combinations around your expanded-palette color wheels. There are twelve of these on each wheel; try them all. Play with the colors to see what kinds of mixtures they'll make. Do they make rich darks? Do the mixtures lean toward gray or brown? Pick out your favorite combinations and make some sample sketches. List your ideas in your color journal for subjects using some of these combinations. In your opinion, how do these palettes stack up against the complementary color schemes?

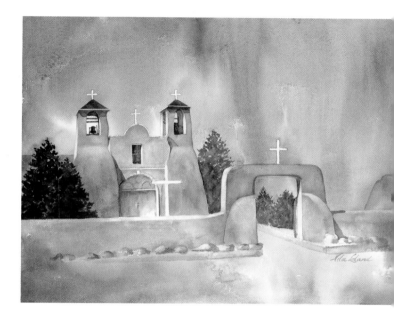

**MIRAGE**
Nita Leland
Watercolor on paper
46" × 61" (117cm × 155cm)

### SPLIT COMPLEMENTS AND SURPRISES
I created a red-orange, yellow-orange and blue color scheme with Cadmium Scarlet, New Gamboge and French Ultramarine. Wet-in-wet mingling sometimes allows colors to intermix and make colors that aren't part of the basic color scheme. The blue-violet that appears here works just fine, but I was careful to avoid mixing greens.

# Analogous Complementary

The more colors you use, the more important it is to establish logical relationships among them. When you combine three analogous colors with the complement of one of those colors, the resulting color scheme is one of analogous complements, which possess both the harmony of similarity and the contrast of difference. The analogous colors create color dominance; the complement enhances this effect by contrast and also neutralizes the mixtures. Take your choice of one or more of the three complements available for any trio of analogous colors. If you include all three, however, be sure you retain the color dominance of one set of analogous colors.

Analogous complementary

blue-green, green,
yellow-green, red

red-violet, violet,
blue-violet, yellow

magenta, red, orange,
blue-green

Yellow, yellow-orange,
orange, blue-violet

**EXERCISE 48:** USE HARMONY AND CONTRAST TOGETHER
Select three of your favorite analogous colors from the expanded color wheels, along with one complement of these colors. Mingle the colors, then make a sketch with them. Add a second complement and repeat the exercise. Next, use all three complements, keeping the dominance of the original analogous colors. Finally, using all six of the analogous complements, reverse the dominance to the complementary side of the color wheel and repeat. Note the subtle differences between each combination of colors and record them in your color journal. How do these compare with the color schemes you explored earlier?

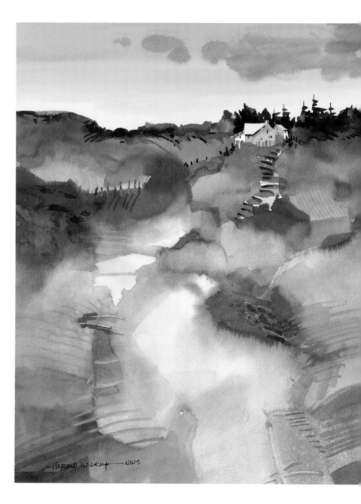

**BERRY FARM MORNING**
Harold Walkup
Watercolor on rough watercolor paper
23" × 17" (58cm × 43cm)

USING ANALOGOUS COMPLEMENTS FOR COLOR EXCITEMENT
Complementary vibrations bring a subject to life. Here, analogous earth reds and golds flow upward through the painting to meet the complementary blue that directs the viewer's eye to the center of interest near the top of the painting.

# Basic Triadic

Here we consider basic triads as color schemes and not simply a means of mixing other colors. As discussed early in this book, the two primary basic triads are: 1) red, yellow and blue; and 2) magenta, yellow and cyan. Both of these bold and energetic triads are popular in contemporary art and design.

The secondary basic triad in both expanded palettes is green, orange and violet. This combination is more difficult to use than a primary triad and less popular with artists, but I find it intriguing. The swatches for secondary triads are shown in the exercise on this page, along with two sets of tertiary triads available on every color wheel. All of these yield provocative and challenging mixtures. Try different combinations of pigments for every color scheme—a brighter green, or a darker violet, perhaps. The color scheme is just a starting point.

Triadic

magenta, yellow, cyan
(primary)

orange, green, violet
(secondary)

yellow-green,
blue-violet, red-orange
(tertiary)

Yellow-orange,
blue-green, red-violet
(tertiary)

**EXERCISE 49:** GO BOLD WITH BASIC TRIADS
Play the colors in each primary triad against each other, without allowing the colors to mix too much. Use bold, high-intensity colors. Then, mix some low-intensity variations of these primaries; contrast them with the pure primaries. Also see what happens when you allow one of the primary colors to dominate. Make sample sketches with combinations you like. Jot your observations in your color journal as you go along, so you'll have a record of your first impression of each combination to help you make important color choices later on.

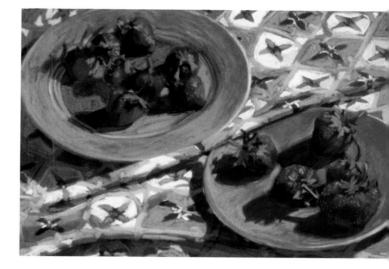

**STRAWBERRIES**
Mary Padgett
Pastel on paper
12¾" × 19½" (32cm × 50cm)

BASIC PRIMARY TRIAD
Padgett's use of the primary basic triad works well. Blue dominates through repetition in the shadows and pattern on the tablecloth. The colors are of similar intensity, and no extraneous colors weaken the color effect. Flip back to the Donna Howell-Sickles piece at the beginning of chapter five to see another effective use of the primary basic triad as a color scheme.

# Complementary and Modified Triadic

Complementary triads are easy to find and fun to use with exciting contrasts. Just select any two direct complements and add one of the two colors halfway between them. For example, if you select red-orange and blue-green tertiary complements, the third color could be either yellow or violet. Each adds a distinctive spark to the original pair of complements and gives a totally different color accent.

Modified triads are made up of three colors just one step apart on a twelve-color wheel. They are nearly analogous, making for harmonious mixtures. But at each end of the three-color arc they make up, there are two colors that come close to being complementary, providing slightly more contrast than analogous colors. There are twelve unique modified triads.

Complementary triad

Modified triad

red-orange,
blue-green, yellow

magenta, violet, cyan

magenta, green,
blue-violet

magenta, orange,
yellow

**EXERCISE 50:** EXPLORE COMPLEMENTARY
AND MODIFIED TRIADS
Mingle the colors of the complementary triads, then the modified triads. Can you see the striking differences between the two types of color schemes? Which do you prefer, the powerful contrasts or the more gentle harmonies? What subjects would work with each combination of colors? Make samples and sketches with the ones you like best.

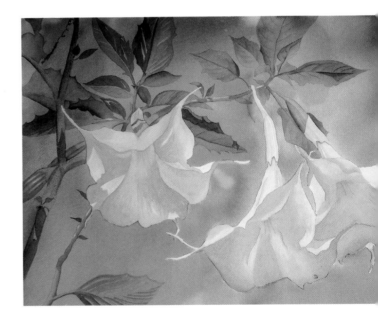

**ANGEL DANCERS**
Judy Horne
Watercolor on cold-press watercolor paper
21" × 29" (53cm × 74cm)

MODIFIED TRIAD COLORS
The artist's use of yellow, green and cyan allows a crisp separation that makes the flowers stand out sharply against the background. She has included a small amount of a complementary reddish color, which is related to the yellow-orange that defines the flower petals.

# Double-Complementary Tetradic

Double-complementary tetrads are four-color combinations that use two pairs of complementary colors. Tetrads may form a square or rectangle of any pair of complements plus the pair of complements equidistant between them; they may also consist of two adjacent colors with the two colors directly opposite them, or they may be formed by selecting two colors with one space between them and adding their complements.

**COLOR SCHEMES ARE FLEXIBLE**
Color schemes are a place to start, not the final destination. It doesn't matter if you can't identify a color scheme after the painting is done, as long as the colors in the painting work.

Double-complementary tetrads

magenta, green,
violet, yellow

red-orange, blue-green,
yellow, violet

red, green, violet,
yellow

red, blue-green,
yellow, violet

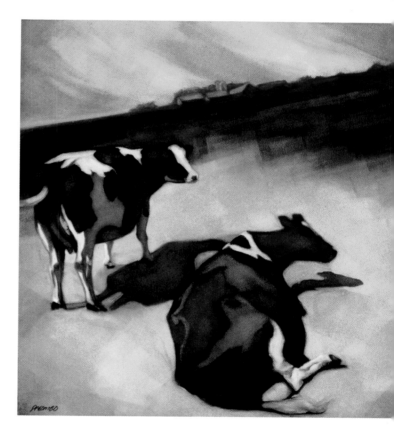

**NUCLEAR COWS**
Lisa Palombo
Oil on paper
16" × 16" (41cm × 41cm)

DOUBLE-COMPLEMENTARY FUN
Now you can't say you've never seen a purple cow! I'm reading this scheme freely as a double-complementary tetrad of yellow, violet, orange and blue, although you can see traces of other colors here and there.

**EXERCISE 51:** ADD COMPLEMENTS TWO PLUS TWO
Mingle the colors of a complementary tetrad and compare the results with the mixtures you made of a complementary triad based on the same colors. Do you like the addition of the fourth color? Work with other tetrads to find distinctive color combinations, mingling them and making sketches and samples. Review what you've done so far. Do you think you're a warm or cool color personality? High or low intensity? Have you discovered a strong preference for transparency or opacity? Are you leaning toward the traditional or the modern palette?

# Demonstration

# Find a Subject for a Color Scheme

Like many artists, I used to have difficulty finding subjects for my paintings. As soon as I began working with color schemes, I found a new way to get started. Now I play with color combinations or sort through my swatches collection until something catches my eye. Then, I find a suitable subject and I'm halfway there.

## MATERIALS

140-lb. (300gsm) cold-press watercolor paper • Watercolors: Cadmium Scarlet, Phthalo Turquoise, New Gamboge, Dioxazine Violet • Assorted Nupastels or soft pastels • India ink • 1" (2.5cm) or larger flat natural hair watercolor brush • Thin flexible twig or drawing stick

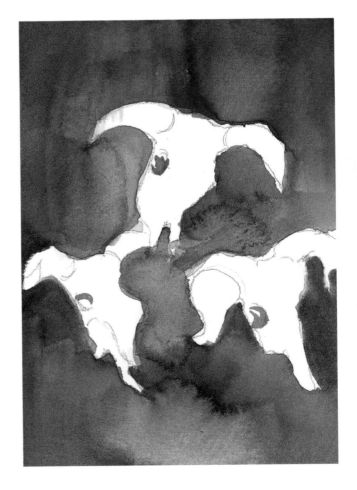

## 1 GET INSPIRED BY COLOR
Red-orange and blue-green complements make me think of the southwestern landscapes I love. I decided to add the two complements between them—yellow and violet—to complete a tetrad. This had possibilities, so I searched my files for a subject.

## 2 FIND A SUBJECT
I found a small line drawing of three skulls I had photographed outside a shop in Albuquerque, New Mexico. I painted my sketch with watercolor, wetting the background around the skulls and mingling the colors I wanted to use. I liked what I saw. This one was very different from earlier versions I'd painted of the same subject. This version emphasized the red-orange and blue-green color scheme, and my brushwork here was freer and more spontaneous.

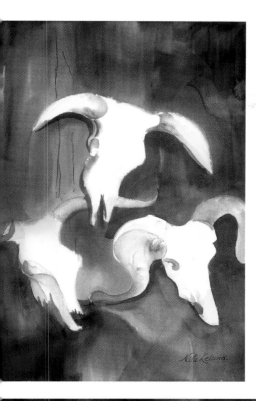

### 3 NOT QUITE FINISHED

At this point I thought my painting was finished—but something was missing. I laid it aside with my unfinished watercolors for a long time. Then, on an impulse I took the painting to a watercolor class I was teaching to demonstrate how to add other media to a watercolor to perk it up.

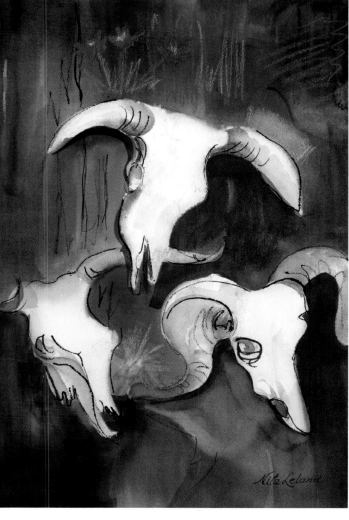

### 4 SUPPORT THE SCHEME WITH OTHER MEDIA

I dipped a flexible twig into India ink and made loose, gestural lines around the subject, plus a few vertical textures in the background. Then, I spontaneously selected a few bright pastels related in color to those in my chosen scheme and just played with color. I used marks, colors and values to suggest the objects and skulls floating in an ambiguous, dreamlike space. A fiesta sprang to life. It seems like every watercolor I do teaches me something new.

**LOS TRES AMIGOS**
Nita Leland
Watercolor with ink and pastel
on cold-press watercolor paper
20" × 14" (51cm × 36cm)

Demonstration

# Choose a Color Scheme for a Subject

Color schemes are incredibly exciting to work with, but sometimes it's hard to know where to begin. With so many to choose from, it helps if you make studies to judge the color effects. Your color personality and intuition will help you decide which combination works best for the subject you want to paint. The following illustrations show you how to get started with color schemes in oils, acrylics and watercolors.

## MATERIALS

Colors in your medium and color scheme of choice • Support and brushes/application tools for your chosen medium • Low-tack, white artist's tape • Small rectangular viewfinder cut out of cardboard • Magazines or photos • Sketchbook • Drawing pencil

## 1 MAKE REUSABLE VIEWFINDER DESIGNS

Make nonobjective designs that you can use over and over again as test patterns for color schemes. Cut a small rectangular viewfinder out of cardboard, and place it over a magazine ad or photo. Move it over the surface until you see a design you like—not necessarily a picture, but an interesting arrangement of lines and shapes. Don't worry about the color. Copy several of these designs in your sketchbook. When you're ready to do your color studies, pick a design. Enlarge it and transfer it to a sheet sectioned with tape.

Analogous

Split-complementary

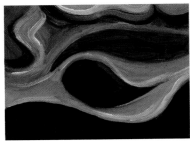

Monochromatic

Complementary

## 2 CONSIDER DIFFERENT POSSIBILITIES

Here I'm trying out several of the color schemes I want to use with oil paints. I mix the colors on my palette with a small amount of Winsor & Newton Liquin to speed drying. In my sketchbook, I've laid out four color schemes: an analogous scheme of warm colors, a monochromatic scheme in Alizarin Crimson, a complementary scheme contrasting a value range of cool blue-green with bright red/orange, and a split-complementary scheme of red opposite blue-green and yellow-green.

## 3 CREATE COLOR SCHEME SKETCHES

My finished oil sketches are done on Fredrix Canvas Pad, a good surface for color studies in oils or acrylics. Each sketch is based on a logical relationship on the color wheel that results in color harmony and/or contrast. Try a new color scheme with each painting; you'll never get in a color rut again.

## 4 TRY OUT COLOR COMBINATIONS

For the watercolor studies below, I decided to do a different subject for each color scheme, matching the colors to the subject or mood I want to paint. For example, for the second study shown, I selected an analogous palette of blue, blue-green and green to represent the colors of the sea. I mingle the colors I selected—Phthalo Turquoise Blue, Winsor Blue (Red Shade) and Hooker's Green—on wet paper in my sketchbook to see how I like them.

## 5 MAKE COLOR SKETCHES OF YOUR SUBJECT

After transferring the sketches to a sectioned sheet, I began with the seascape. You don't have to worry about unhappy accidents with colors if you do the mingling in your sketchbook, as I did. It's better to find mixtures that might throw a color scheme off in your sketchbook, rather than in the middle of a painting.

## 6 EVALUATE AND TAKE NOTES

After you've explored various color schemes in your sketches, remove the tape from your sectioned sheet. Place swatches of the colors you used below each sketch, labeling them with the name of the color scheme you used. I write notes in my sketchbook to remind myself to try the monochromatic snow scene with Cadmium Scarlet to see how it looks, and to experiment later with a small amount of complementary red or red-orange accent in a seascape for contrast. I decide that the analogous-complementary triad has possibilities for a southwestern or tropical landscape.

Monochromatic

Analogous

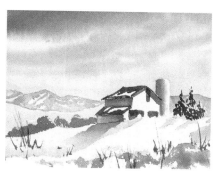

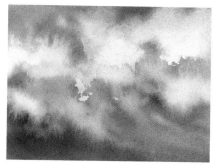

Complementary

Analogous Complementary

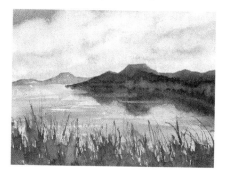

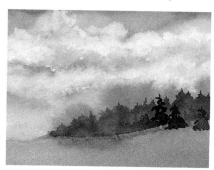

# USING COLOR CONTRAST

I AM ALWAYS IN HOPE OF MAKING A DISCOVERY . . . TO EXPRESS THE LOVE OF TWO LOVERS BY A MARRIAGE OF TWO COMPLEMENTARY COLORS, THEIR MINGLING AND THEIR OPPOSITION, THE MYSTERIOUS VIBRATIONS OF KINDRED TONES. — VINCENT VAN GOGH

**ANCIENT PITCHER**
Julie Ford Oliver
Oil on canvas
12" × 9"
(31cm × 23cm)

**BARNOGRAPHY**
Larry Moore
Oil on wood
20" × 20" (51cm × 51cm)

Color contrast is an easy concept to understand, but it helps to know why this is considered so important to artists. Renaissance painters used mainly value contrast. At the beginning of the nineteenth century the art world was ruled by academies that controlled the standards by which artists were judged in competition, the key to success for an artist at the time. Mastery of values still superseded color. In 1839, a French chemist, M. E. Chevreul, published a study concerning the principles of harmony and contrast of colors that became the basis for color practice as we know it today. English painter J. M. W. Turner preferred intensity contrast, playing pure tints against low-intensity colors. The Impressionists relied on temperature contrast, and the Fauves contrasted pure hues.

In this chapter you'll learn how to use color contrasts as the key to unity in your artwork.

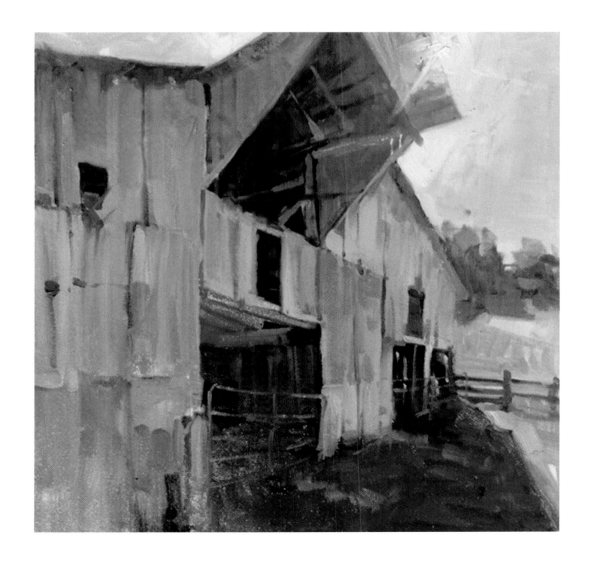

# Hue Contrast

Intense colors placed side by side produce powerful contrast. Primitive artists and children use hue contrast naturally and effectively. Stained glass, mosaics and Pennsylvania Dutch stencil designs are other good examples. Use as many colors as you like, as long as they're all pure and bright.

Different hues,
same background

Same hue,
different backgrounds

**EXERCISE 52:** PLAY WITH HUE CONTRAST

Paint samples of pure, bright colors and cut them into 1" (2.5cm) and 2" (5cm) squares, or cut colors from Color-aid papers or magazine ads. Arrange different combinations of the squares (as shown), starting with a single color mounted on a background of another color. Notice how the colors react to each other; some combinations seem to vibrate more than others. Which are your favorites? Make a sketch, using all the colors on your expanded-palette color wheel. Emphasize flat shapes, and go for bold, aggressive color using hue contrast.

**MY FEARLESS FUTURE**
Susan Webb Tregay
Acrylic on canvas
24" × 24" (61cm × 61cm)

COLOR RULES!

Don't be afraid to play with color. Tregay's girls are all about color—the brighter, the better. The trick is not to let the colors blend into mud.

**ROOSTER**
Mark E. Mehaffey
Watercolor and gouache
on watercolor paper
22" × 29" (56cm × 74cm)

CONTRAST THAT MOVES
THE EYE
The center of interest in
this dynamic abstract is
the shocking red against
a variety of neutral
grays, blacks and white.
There is so much going
on in the periphery that
the eye invariably darts
throughout the picture.
Brilliant turquoise at the
edges is only one of many
entertainments, but the
viewer can't escape that red
against a sea of neutrals.

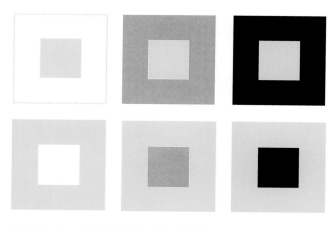

### PURE HUE AGAINST A NEUTRAL CONTRAST
The contrast of pure color against neutral gray, white or black lends itself to strong graphic statements and is widely used in commercial advertising and lettering applications. For the most striking contrast, use either light, high-intensity colors against black, or dark, high-intensity colors against white. For a more subdued contrast, use a gray background. Keep in mind that any color bias in the neutral will affect the appearance of the pure hue.

### EXERCISE 53: USE BRIGHTS WITH NEUTRALS FOR GRAPHIC POWER
Explore the following contrasts in simple studies, using your favorite medium:

- Use high-intensity colors against white, then gray, then black. Which do you like best? Write down your observations in your color journal.

- Now reverse the effect, making the background a pure color, and the image a neutral.

- Lower the intensity of pure colors with a little black or a drop of Burnt Sienna. Check them against the neutrals again, noting the effects in your journal.

# Value Contrast

Full-contrast artwork has a complete range of values from white through midtones to dark, and suggests normal illumination. Middle values usually provide the framework for value painting, with light and dark value contrast giving the work its visual impact. Learn to see degrees of difference in black-and-white contrast, so you can use value contrast more easily in color. A good value scheme enhances your color. For example, to create lustrous color with values, make a dark neutral background that suggests dim illumination, then you can add light-value touches of bright color that will glow against the darker background.

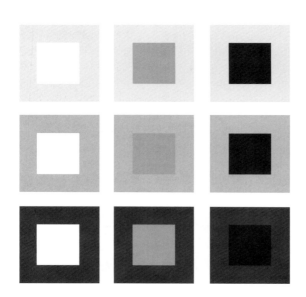

**EXERCISE 54:** EXPLORE VALUE CONTRAST
Make a chart with three sections across and three down. In the first row, place three 2" (5cm) light-gray squares. In the second row, place three medium-gray squares; and in the last row, three black squares. Then, in the first column, place a 1" (2.5cm) white square on top of each 2" (5cm) square, from top to bottom; in the second column place three middle-value gray squares; and in the last column, three nearly black squares. Examine the value contrasts and comment on them in your journal. The squares with the greatest value contrast capture your attention; lighter squares seem filled with light, and darker squares appear more somber. When there is little or no contrast, the squares become almost indistinguishable from each other.

**THE CONVERSATION—GIRONA**
Thomas W. Schaller
Watercolor on paper
14" × 10" (36cm × 25cm)

VALUES EMPHASIZE SHAPES
Strong value contrast adds impact to powerful shapes in this painting, while patches of light and low-intensity color create a striking visual effect in the background. Schaller is a master at manipulating values and edges and highly skilled in using a limited palette.

# Color Key

Use color key to bring your artwork to its full dramatic potential. **High-key** colors, the tints and middle tones at the light end of the value scale, are usually pure colors and represent bright illumination. Artwork using high-key color is cheerful and optimistic. **Low-key** color contrast is at the other extreme, indicating dim illumination, and is restricted to middle and dark values and low intensity colors that create a serious, pensive mood.

**HIGH KEY**
Quinacridone Magenta,
Transparent Yellow,
Manganese Blue

**LOW KEY**
Brown Madder,
Raw Sienna,
Payne's Gray

**EXERCISE 55:** PLAY IT HIGH OR LOW KEY

Select three colors for a high-intensity triad and lighten the colors with water or white to achieve tints and light midtones. Then, mingle the tints and tones slightly to see the effect of high-key color contrast. Next, use the same or another triad and modify the colors by mixing to lower their value ranges to middle tones and dark. Mingle these low-key tones and shades. Make sketches from each combination, choosing a subject that suits the distinctive mood of the colors.

Note the difference in mood between these two swatches. Starting with high-key or low-key dominance, you can add light or dark color accents to emphasize your focal point and to create special effects of light.

**APTOR**
aul St. Denis
atercolor dyes, inks and gouache on paper
4" × 34¾" (112cm × 88cm)
ollection of the artist

**TRIKING CHROMATIC NEUTRALS**
t. Denis's painting illustrates a dramatic use of striking, hromatic neutrals. The somber, somewhat ominous overall mpression is caused by the low-key color. Can you think of a ubject suitable for low-key color? Give it a try.

**LIFE IS JUST A BOWL OF CHERRIES**
Sylvia Dugan
Watercolor on cold-press watercolor paper
6" × 7¼" (15cm × 18cm)

**HIGH-KEY COLOR FOR DELICATE CHINA**
An optimistic mood is projected by the high-key colors in this painting. The cherries stop short of the dark value ranges, while highlights and shadows suggest early morning sunshine.

# Intensity Contrast

Intensity contrast comes from placing pure, bright color within areas of grayer, low-intensity color. Bright colors or pure tints surrounded by a field of neutrals sing out.

J. M. W. Turner was a master at using pure, delicate tints adjacent to low-intensity colors. In Turner's day value contrast reigned supreme in the academies. In modern times many artists exploit values and intensities for unusual effects of light and for personal expression. Limit intensity contrast to pale tints and grays to emphasize the light.

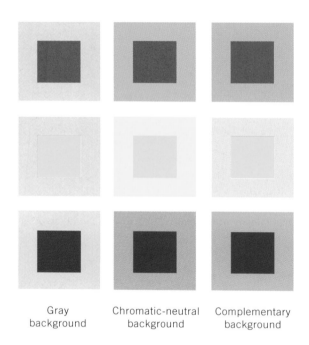

| Gray background | Chromatic-neutral background | Complementary background |

**EXERCISE 56:** EXAMINE INTENSITY CONTRAST
Make a chart with 2" (5cm) squares of light-to-medium neutral gray and low-intensity colors, as shown here. In the first column, place the neutral grays. In the second, place low-intensity versions of primary colors. In the last, place low-intensity complements of the primaries. Place a 1" (2.5cm) square of one pure primary on the colors across each row, as shown. Write comments in your color journal about these intensity-contrast effects. Next, select a color scheme and make a sketch or sample piece, mixing all colors to lower their intensity, then adding pure, bright colors from the same color scheme for accents.

Pure color stands out against neutral gray and low-intensity backgrounds. Which effect do you think is stronger, a pure hue against the same hue in a lower intensity (center), or a pure hue against a complementary, low-intensity background (right)?

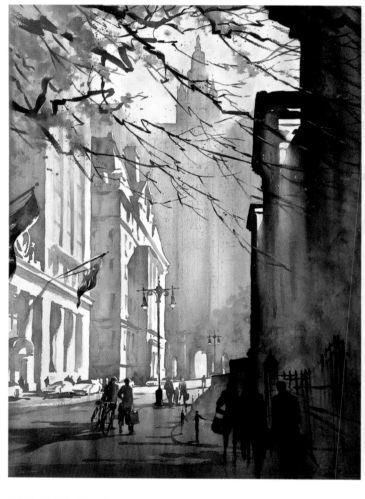

**CHAMBERS STREET—NYC**
Thomas W. Schaller
Watercolor on paper
30" × 20" (76cm × 51cm)

HIGH INTENSITY SUGGESTS LIVELINESS
Schaller showcases strong value contrast here, using a pearlescent low-intensity limited palette. A few high-intensity hues in the foreground suggest that the figures are becoming active.

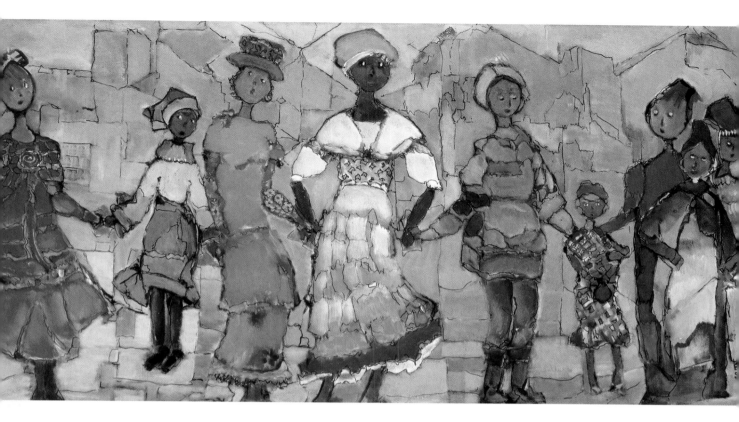

**TIMES OF LIFE**
Ellie Rengers
Acrylic on canvas
24" × 48" (61cm × 122cm)

INTENSE FIGURES, LOW-INTENSITY BACKGROUND
Bright, pure hues bounce against a low-intensity background, allowing the whimsical figures to stand out sharply. Notice how the colors in the foreground are echoed in the background, creating a unified color statement throughout the picture.

MAKING COLORS GLOW
Achieve a high-key, almost iridescent luminescence by mingling delicate pastel tints and surrounding them with neutrals. Use transparent, high-key colors and be sure to leave areas of white to suggest reflected light.

# Temperature Contrast

The Impressionists relied more on temperature contrast than on value contrast to suggest light. Paul Cézanne used temperature as a tool to manipulate form and space. Contemporary artists sometimes reverse warm and cool relationships to create energetic, provocative movement. Radiance emanates from artwork with warm dominance. When the cool temperature dominates, warm contrast keeps the piece from seeming unpleasantly chilly. Warm and cool contrast also provides movement around forms and through space, because warm colors appear to advance and cool colors recede. All complementary contrasts are also temperature contrasts, but not all temperature contrasts are complementary.

**EXERCISE 57:** TRY OUT TEMPERATURE CONTRAST
Choose a color scheme that is predominantly warm—for example, an analogous scheme including red-orange, orange, yellow-orange and yellow. Then, select a single contrasting complement of any one of these colors, between blue-green and violet, to provide temperature contrast. Make a sketch with warm dominance, using the cool color to add contrast in important areas. Then, select a range of cool colors with one opposing warm color and make a sketch with cool dominance and temperature contrast.

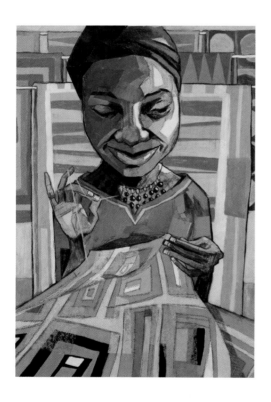

**TABITHA'S GIFT**
Cody F. Miller
Cut paper, acrylic and charcoal on Masonite
24½" × 16½" (62cm × 42cm)

COOL COMPLEMENTS AROUND A WARM SUBJECT
This collage painting is radiant with the dominance of warm colors in the face and figure. Slightly cooler hues recede into the background, but the viewer is drawn to complementary blues in the foreground. White highlights on the face draw the eye to the joyful face of the quilter.

**LOOKING FOR THE SHORE**
John Agnew
Acrylic on canvas
16" × 20" (41cm × 51cm)

STRONGEST CONTRAST AT THE CENTER OF INTEREST
With a naturalist's eye for detail, Agnew captures the colors and textures of stones on the shore. The colors are predominantly cool, but the softened reds, greens and blues are convincing. The green frog against the red stone, a subtle temperature and complementary contrast, makes this center of interest a delightful discovery.

# Reversing Color Temperature

If the illusion of distance is enhanced by placing warm colors in the foreground and cool ones in the background, it stands to reason that reversing the temperature would create ambiguous pictorial space. When a cool color overlaps a warmer color, the warmer color seems to push through the cooler one. Artists use this to create a push-and-pull effect that expresses vibrant energy.

**EXERCISE 58:** REVERSE THE TEMPERATURES

Plan an arrangement of overlapping shapes, such as a landscape with distant hills and sky, or several geometric figures on a plain background. Make two copies of your design, using tracing paper or a lightbox. Start with realistic colors, giving the first sketch a typical cool background and warm foreground. Then, reverse the temperatures, using the same colors to make a sketch with a warm background and cool foreground.

Typically, you place warm colors in the foreground and cool ones in the background, to achieve a sense of distance and to control eye movement throughout the picture. When you reverse this natural effect, you create ambiguous space, as the warm colors push forward and flatten the picture plane. Turn these sketches upside down for another view of color temperature reversed.

Warm background, cool foreground

Cool background, warm foreground

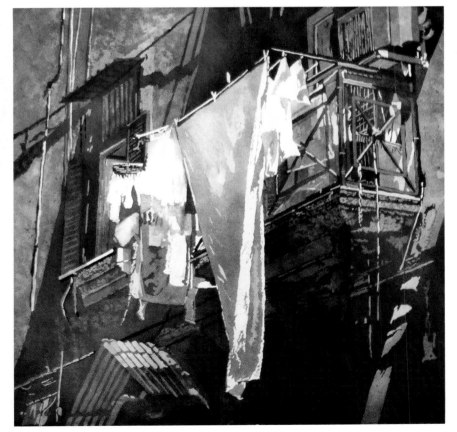

**AFTERNOON BREEZE**
Linda Daly Baker
Transparent watercolor on
cold-press watercolor paper
22" × 22" (51cm × 51cm)

WARM COLORS ADVANCE
Although the wall on the left side of this painting may be farther back in space, its warm colors push forward and flatten the picture space around the laundry hanging on the balcony. A fragment of daily life is made intimate by surrounding it with warm color and bringing it visually closer to the viewer.

# Complementary Contrast

Complementary colors, as you know, are opposites on the color wheel. Placed side by side
in high or low intensity, they enhance each other, but they neutralize each other in mixtures.
Complementary contrast is one of the most useful—and widely used—contrasts in an artist's bag
of tricks.

Primary and secondary
complements

Tertiary complements

**EXERCISE 59:** PAIR OFF FOR COMPLEMENTARY
CONTRAST
Make a chart illustrating complementary contrast,
using your brightest paints or colored-paper
clippings. Cut one set of twelve 2" (5cm) squares
representing each hue on the color wheel and
glue these to a white support. Then cut a set of 1"
(2.5cm) squares of the same colors. Pair off the
complementary colors and glue these small squares
to the centers of the larger ones. If the colors you
selected are truly complementary, the colors will
seem to vibrate on the page.

These studies reflect powerful combinations of
complementary contrast, temperature contrast and
contrast of pure hues. If you want unusual color,
pay special attention to tertiary complements.
They're less commonly used than primary/secondary
combinations.

**GREEN REFLECTIONS**
Denise Athanas
Acrylic on paper
21" × 23" (53cm × 58cm)

THE STRONGEST COMPLEMENTS
In this expressive abstract there are flickers of yellow and violet
complements, but these do not affect the power of the dominant
red-green complementary contrast. Hue, value and temperature
contrasts also contribute to the visual impact of this striking painting.

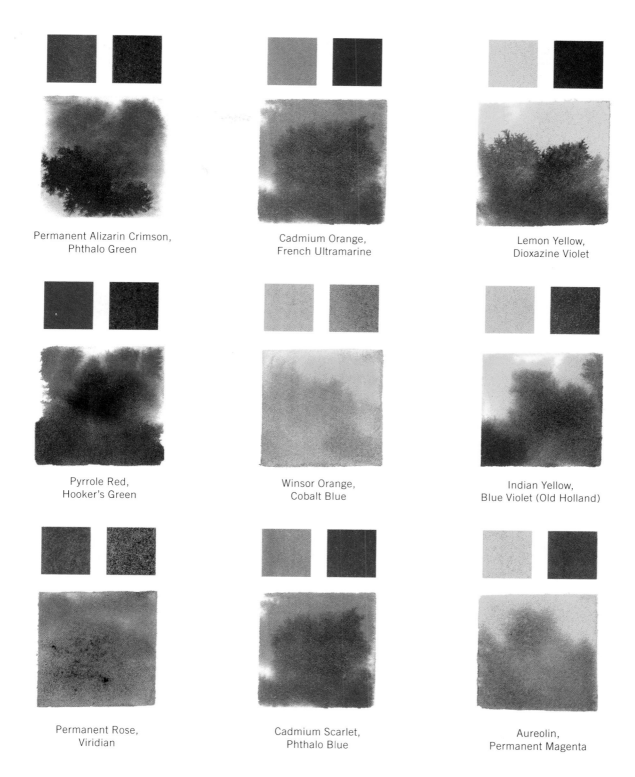

Permanent Alizarin Crimson,
Phthalo Green

Cadmium Orange,
French Ultramarine

Lemon Yellow,
Dioxazine Violet

Pyrrole Red,
Hooker's Green

Winsor Orange,
Cobalt Blue

Indian Yellow,
Blue Violet (Old Holland)

Permanent Rose,
Viridian

Cadmium Scarlet,
Phthalo Blue

Aureolin,
Permanent Magenta

**EXERCISE 60:** MAKE COMPLEMENTARY MIXTURES

You have a lot of leeway in selecting complements to take advantage of their powerful contrasts. Go through your paint box and select several pairs of complementary or near- complementary colors. Mingle or mix the colors on a sectioned support, so you can judge the effects of the pure complements and their mixtures. Exact complements make gray, but near complements make much more interesting

chromatic neutrals and provide exciting complementary contrast. Write about these effects in your color journal and note combinations you'd like to use in future artwork.

Mixtures of complements should retain the color identity of one or both colors in the mixture, in order to continue the effects of complementary contrast. You can use various pigments to represent complementary pairs; you will always have temperature contrast between the colors.

# Quantity Contrast

In *The Art of Color* Johannes Itten states that colors have a specific proportional relationship to their complements, which must be maintained in order to achieve color balance. Since yellow is more brilliant than violet, use one part of yellow to three parts of violet for balance. One part of orange is as bright as two of blue, while red and green are roughly equal. To create visual vibration, change these proportions. Use a large color area to strengthen your color impression, or break the colors into small areas to create energy and movement. However, pure color can be overwhelming, so when the large area is lower in intensity, even small bits of bright color within it appear brighter. Quantity contrast tends to make other contrasts even more effective.

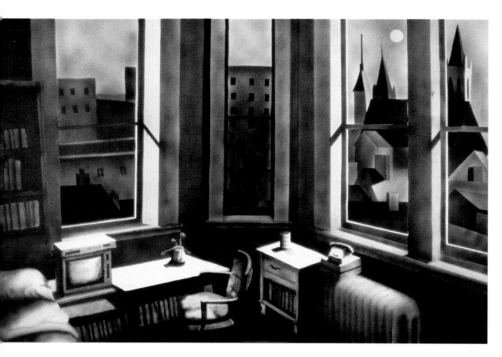

**AFTER MIDNITE**
Larry Mauldin
Watercolor on board
30" × 40" (76cm × 102cm)

**A TINY BUT POWERFUL TOUCH**
The focal point of red flowers in this airbrushed painting is perfect. Small, bright touches of color in a vast black-and-white background illustrate contrasts of quantity, value and intensity.

3 parts violet visually balance 1 part yellow.

2 parts blue visually balance 1 part orange.

Red and green visually balance each other equally.

**EXERCISE 61:** PLAY WITH COMPLEMENT PROPORTIONS
Select a pair of complements, such as red-violet and yellow-green. Make a sketch or design using the same amount of each color. Repeat the design, using a very small amount of one pure color and a large field of the other. Then, reverse the colors in the same design. In another sketch, lower the intensity of one color and use it as a background for its opposite pure color, changing the proportions of the colors. Repeat this exercise with several different color combinations.

These swatches show the correct proportions of complements to establish color balance when you're working out a complementary color scheme, according to Itten's theories. However, this isn't rocket science, so use your intuition as you play with different proportions of the colors to achieve the most effective contrast.

**RETREATING STORM—
OCEAN GROVE, NJ**
Douglas Purdon
Oil on canvas
16" × 20" (41cm × 51cm)

A LITTLE GOES A LONG WAY
What caught your eye in this painting? Let me guess: the red bikini. Was it the red or the bikini? Never mind. Just remember that a point of strong color can be used to draw the viewer's eye to your center of interest.

# Perceptual Contrast

When your eye is exposed to intense color, it adjusts by seeing the color's complement simultaneously. The eye seems to need the complement for relief. In **simultaneous contrast**, adjacent colors produce complements at the edges where the two colors meet. For example, a bright red passage next to yellow may have a barely perceptible greenish bloom around the edges that affects the yellow, making it seem cooler. You can anticipate this and overcome the effect by using a warmer yellow to begin with.

**Successive contrast** is a complementary afterimage that appears when you look at a color for a while and then look away. You experienced this in chapter one with the red "X"

(Exercise 2). If you look at a second color, the complementary afterimage blends in mixed contrast, projected onto the color like a glaze. As you work, rest your eyes occasionally for more accurate color impressions and adjust your colors, if necessary, to compensate for mixed contrast.

**Optical mixtures** result when colors are not physically combined, but juxtaposed as small bits of color, placed so the eye is unable to differentiate individual colors from a distance. They are perceived as a mixture, having the average of the brightness of the component colors. In painting, this technique, called pointillism or divisionism, creates a distinctive beauty, a hazy luminosity.

**BLUE HILLS**
Roger Chapin
Pastel on Canson paper
18" × 24" (46cm × 61cm)

TINY DOTS OF COLOR BLEND VISUALLY
This is a fine example of the pointillist technique; hold the picture some distance away from your eyes to appreciate how all the tiny dots of pastel blend into harmonious color. Look at it more closely to see how Chapin has combined these dots to create the effects of changing colors and values.

**STILL HOPEFUL**
Maggie Toole
Colored pencil on rag board
16" × 30" (41cm × 76cm)

OPTICAL MIXING, OPTIMAL EFFECT
High-key values express a luminous light, drawn entirely with circles using colored pencils and avoiding strong darks. The result is similar in appearance to the optical mixing observed by Chevreul and employed in pointillism, a technique practiced by some neo-Impressionists.

**EXERCISE 62:** EXPERIMENT WITH OPTICAL MIXING
Select a color scheme and make a sketch using small bits or dots of pure color on a white ground. To darken an area, place the dots closer together and include complementary colors. When you've finished this exercise, you'll appreciate Georges Seurat's achievements on the large canvases he painted using this method. His well-known work *A Sunday on La Grande Jatte* measures 81¾" × 121¼" (208cm × 308cm).

# Demonstration

# Take Risks with Contrast

Pull out the stops and use vibrant colors with strong contrasts. To make this work, simplify shapes and avoid too much detail. Decide what color scheme is most effective and which contrasts are needed.

## MATERIALS

Colors in your medium and color scheme of choice • Support and brushes/application tools for your medium of choice • Reference photo (and photocopy) • Sketchbook • Drawing pencil • Eraser • Scrap paper or canvas

### 1 STUDY SHAPES AND VALUES FIRST

Create a strong abstract design with colored shapes that emphasize value, temperature and complementary contrast. The big shapes and strong value contrasts in this photo of an adobe house are just what I have in mind. Make a photocopy and a value sketch of your photograph, keeping the sketch relatively free of detail. That way you can study the shapes and visualize the color placement.

### 2 TRANSFER YOUR DRAWING

If you don't want your transferred drawing to be distorted from your reference photo, draw a grid on your sketch and on your support—mine is 16" × 20" (41cm x 51cm) stretched canvas—in the same proportions. Then, sketch the corresponding sections of the photo grid into the support grid. Erase the grid if necessary. Since I'm working in opaque acrylics, I don't need to erase the grid, but I do, just so the lines aren't confusing.

### 3 SELECT A COLOR SCHEME

I like the idea of an analogous-complementary color scheme with a warm dominance (yellow-orange, orange, red, red-violet and blue-green), based on the modern expanded palette in chapter six using acrylic Indian Yellow, Pyrrole Orange, Pyrrole Red Light, Quinacridone Magenta and Quinacridone Violet with complementary Cobalt Teal and Cobalt Turquoise. To preview the color harmony and visual vibrations of the colors you've selected, try them out on a scrap of canvas.

### 4 CREATE PAINTED GUIDELINES

I sketch out the shapes onto my final canvas with a mixture of Quinacridone Magenta and Titanium White. This covers the pencil lines and gives me guidelines for the underpainting to be applied. The painted lines will gradually disappear under succeeding paint layers. Colors and values can be adjusted relatively easily with opaque acrylic paints.

## 5 A UNIFYING UNDERPAINTING

I cover the entire canvas with an underpainting of red-orange, which will show through all the other layers of color to be applied over it, helping to unify the painting. Each shape is defined up to the magenta lines around it, with no texture applied at this stage.

## 6 SKY AND DOORS

I paint in the contrasting blue-green sky first, allowing just a sparkle of red-orange to peek through. I use the same color on the doors to help move the eye around the picture, but these will be modified later so they don't resemble the sky so closely

**ADOBE**
Nita Leland
Acrylic on canvas
16" × 20" (41cm × 51cm)

## 7 CONTINUE TO BUILD, ADDING ACCENTS OF COLOR

I gradually build the adobe forms (without trying to duplicate the photographic image) by painting layers of texture, color and value. Yellow-orange highlights help to define some of the shapes; a few strokes of bright magenta are touched into the finished piece to catch the eye.

# EXPRESSING THE HARMONY OF LIGHT AND SHADOW WITH COLOR

A PAINTER IS ALSO MASTER OF HIS CHOICE IN A DOMINANT COLOR, WHICH PRODUCES UPON EVERY OBJECT IN HIS COMPOSITION THE SAME EFFECT AS IF THEY WERE ILLUMINATED BY A LIGHT OF THE SAME COLOR, OR, WHAT AMOUNTS TO THE SAME THING, SEEN THROUGH A COLORED GLASS. — M. E. CHEVREUL

**RED TARP ON A COLD DAY**
Mark E. Mehaffey
Watercolor on
cold-press paper
29" × 21" (74cm × 53cm)

**SAINT EMILION**
Fabio Cembranelli
Watercolor on paper
56" × 38" (142cm × 97cm)

Simulating light is a great way to use color creatively. Colors are influenced by natural light, artificial light, reflected light, shadows and textures. Careful observation is key to painting light. Light varies so much, it can be difficult to see color accurately. Daylight is a combination of white light from the sun and blue reflected light from the sky, which changes throughout the day, season or region. Your eye doesn't automatically see these changes, because your brain unconsciously adjusts to illumination. When Monet painted haystacks at different times of day, he was overriding this and recording what his eye actually saw in the changing light.

In this chapter you'll learn how to suggest luminosity and use glazing techniques to represent light and shadow in landscapes and portraits. You'll also discover the importance of observing the dominant light on your subject and using it to unify your artwork.

# Color Harmony with a Single Light Source

To achieve a sense of illumination, use a monochromatic or analogous color scheme and strong value contrast in areas affected by the light. Start with a source of light present in the picture or strongly suggested. From this, create a brilliant light that reflects from the focal point and bounces off other planes facing the source of illumination. Then, allow values to fall away gradually into darkness. The lightest area in the painting may have an aura of light around it. Create highlights at the focal point by using a color that is lighter than the subject's color and adjacent to it on the color wheel. If your lighting effect works, the picture will appear to illuminate the area where it hangs.

**EXERCISE 63:** PORTRAY THE EFFECTS OF STRONG LIGHT

Arrange a model or still life using a strong light source: a figure by firelight, a fruit bowl with a lit candle, or perhaps a chair near a small sunny window. Observe the planes that receive strong light directly from the source. These will be the lightest values, white or high tints. Use these areas to move the viewer's eye around the composition. Do a monochrome study first, keeping edges hard where they are struck sharply by the light, then blending them into darkness with lost and found edges. Surround the light with middle tones and strong darks. Repeat the study in color, using warm colors and light values for the lit areas and deep, chromatic darks for the background.

**VERMEER'S TABLE**
Jada Rowland
Watercolor on paper
9½" × 7½" (24cm × 19cm)
Private collection

SEEING THE LIGHT
The strong light shown in this watercolor is the subject of the painting, holding the eye effectively, with its shapes repeated in the background. Rowland has done an excellent job of observing and representing how the light plays across the table and the figure. Remember, observation is the key.

# Luminosity

J. M. W. Turner was a master of luminosity, as were the nineteenth-century American Luminist painters, such as Albert Bierstadt and Frederick Edwin Church, who painted landscapes with stunning atmospheric effects. Intensity and complementary contrasts work well here. Strong value contrast can be used as a framing device. Make the purest area of color smaller and lighter in value than the low-intensity area around it. Allow this color to influence the composition throughout by using subtle gradations of analogous colors moving toward chromatic gray. Add accents of the dominant light, reflected throughout. Keep the color of the light untextured so it suggests light, not substance.

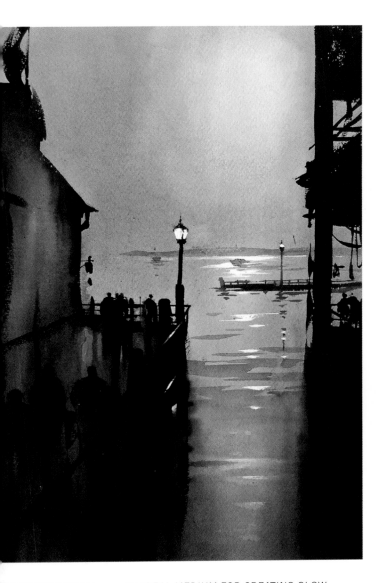

**COMPOSITION IN VIOLET**
Thomas W. Schaller
Watercolor on paper
24" × 18" (61cm × 46cm)

AN IDEAL MEDIUM FOR CREATING GLOW
The light in Schaller's misty harbor scene is surrounded by soft watercolor washes that gradually change as they move away from the source of illumination.

Pure color will glow against a low-intensity background made with a low-key neutral, suggesting dim light.

Make distant trees slightly darker against the luminous sky, gradually changing to a darker violet or gray at the composition's edges. The glow of the light spreads then fades into darkness.

**EXERCISE 64:** USE COLOR TO SUGGEST LUMINOSITY
Overlap the edge of an area of pure light yellow with a pale red tint and blend the colors into an aura of yellow-orange to light red-orange around the yellow. Encircle with a slightly darker, less intense (by adding complementary blue) mixture of the same colors. Blend as you move away from the light, until you have a mid-value chromatic neutral at the outer edges. To place an object in front of this backdrop, use slightly darker values of the same color used in the immediate background.

133

# Reflected Light and Color

All color is reflected light. All colors in nature are influenced by surrounding colors that reflect back on them. Use this fact to unify your painting, by showing how light bounces off a surface and is reflected off another surface nearby. This repetition of reflected color moves the viewer's eye around your picture and helps to unify it.

No reflected color, only local (or natural) color, results in a static picture.

Reflected color from the vegetables makes the scene more dynamic.

**EXERCISE 65:** BE ON THE LOOKOUT FOR REFLECTED LIGHT
Hold a brightly colored object next to your hand in strong light and move it away and back again. Observe how the color of your hand appears to change when you move the colored object. Use such visual phenomena to make your work more colorful and exciting. A still life of vegetables may reflect the colors of tomatoes and peppers on each other and the vase. Use this reflected light to move the viewer's eye around your composition and to unify your colors so objects and shapes aren't isolated from each other. Look for reflected colors in your shadows, too.

**QUICK PICK**
Gwen Talbot Hodges
Watercolor and
gouache on paper
28½" × 20"
(72cm × 51cm)
Private collection

WARM UNIFYING LIGHT
Sunlight filters through the market and influences the color everywhere. Every object in the scene is affected by this warm light, which unifies the whole. Hodges protected some areas with masking fluid to retain whites throughout the glazing process, but she also created luminosity by lifting color to suggest bright light in some areas, adding pure colors as highlights.

**EXERCISE 66:** OBSERVE CHANGING LIGHT

Have you ever left a class and noticed that your work looked different after you got home? Look at your artwork under different lights to appreciate the effects of changing light. I view my work in my studio under full-spectrum fluorescent lighting (see chapter two for more on this), then in daylight, under incandescent light and under regular fluorescent lights. Notice the differences in dominant light when the weather changes. Jot down your observations in your color journal.

**ANGELS KEEP WATCH**
Jane Freeman
Watercolor on cold-press watercolor paper
29" × 20" (74cm × 51cm)

SUBTLETY OF REFLECTED COLOR

The blue-orange opposition seen on a color wheel is modulated in this serene still life. The artist tones down the orange to an earthy sienna that is picked up in subtle reflected colors on treasured antique objects inside the cabinet and on the folded linens.

**SPARKLERS**
Janie Gildow
Colored pencil on Rising Stonehenge paper
15" × 11½" (38cm × 29cm)

THE COMPLEXITY OF GLASS

Gildow has captured her still life with careful observation of complex light reflections in glass; the reflected color swirls around goblets, leading your eye to the flower lying serenely on the table. Reflected light can be very useful, even with a less complicated subject.

# Revealing Color with Glazing

A **glaze** is a transparent layer of color over another color that permits the first one to show through. Glazes alter colors, but don't cover them up. Correctly applied, glazes have a delicate luminosity seldom equaled by mixing colors and applying them as a single layer. Transparent glazes are used in oils, acrylics and watercolors, and also in pastels and colored pencils. Acrylic paints are the ultimate glazing medium because they dry quickly, and once dry, they can't be lifted by successive glazes. Even in fibers, you can glaze the colors of a warp with thinner yarns or apply gauzy fabrics as glazes on a quilt.

Semi-transparent colors can be used as glazes if they're diluted. Opaque colors usually cover the underlying color and mask the white support, leaving a chalky appearance. However, well-diluted opaques can be used for translucent, misty glazes.

Some artists believe you can't layer multiple glazes without making mud, but the trick is to use analogous colors and avoid opaque colors and complements. Practice layering glazes before using them in your artwork.

Correct: glaze on dry background

Incorrect: glaze on damp background

Graded glazes of Rose Madder Genuine, Aureolin and Cobalt Blue

Overlapping glazes of Rose Madder Genuine, Aureolin and Cobalt Blue

Glazes of Permanent Rose, Aureolin and Cerulean Blue, layered wet-in-wet

Successive glazes (three colors)

Analogous glazes

## EXERCISE 67: EXPERIMENT WITH MULTIPLE GLAZES

Run a graded wash of transparent color on an area of a sectioned sheet, thinning the color as you go down the sheet. Let the wash dry completely. Then run a second graded wash of a different transparent color halfway down the first. Notice how the glaze changes the underlying wash. Try different combinations of three or more colors, grading some washes up and some down; then try repeating the first glaze over the others. The more diluted and transparent your glazes, the longer you can work with multiple glazes, particularly if you avoid complementary colors. Try glazes with semitransparent and opaque colors to see how they work. Also, for interesting effects, experiment with wet glazes, brushing color over color without any drying in between. Write comparisons of glazes and glazing techniques in your color journal.

Complementary glazes

Opaque and overpowering glazes

## GLAZING TECHNIQUES

Try your glazes—transparent colors work best—on a sample sheet before glazing your painting. For a clear, bright glaze, use an analogous color. Glaze one primary over another to create a secondary color. To lower intensity, use a complementary glaze. A low-intensity glaze surrounding a bright focal point strengthens the impact of your center of interest.

# Unifying Glazes

You can glaze an entire painting or any part of it, tying areas together beautifully with a single, modifying wash. There can be risks: Your glazes may not be pleasing over all the colors, and colors may bleed into damp glazes. Test your colors to see if they work well together. Glazing can be a useful correction technique when color is out of control with too many colors or disconnected color areas. Try glazing to calm a busy painting or to unify areas that aren't working. If you're painting in watercolor, don't pre-wet the support before you run glazes or you'll pick up the underlayers. Before you begin, decide if you want to reserve the white areas with masking liquid.

**EXERCISE 68:** PRACTICE UNIFYING GLAZES
Paint a simple landscape or practice glazing on an old painting. Run vertical transparent glazes of different pale tints over separate areas in the painting, as shown in this example. Leave areas of unglazed color between the glazes for comparison. Try several different combinations and write the results in your journal.

The colors in the sketch are strongly affected by glazes—the blue sky turns green with a yellow glaze and becomes violet with a pink glaze; the yellow field is warmed by a pink glaze and dulled by the blue. If you isolate a glazed section, you can see the unity of color throughout that area.

**LINDOS LACE**
Jean H. Grastorf
Watercolor on paper
28" × 20" (71cm × 51cm)

STRIKING LIGHT EFFECTS
Grastorf uses poured glazes of transparent primary colors to suggest bright light separating as it does in a prism, particularly striking when contrasted with the white paper. These layers help to unify the colors.

# How Toned Supports Affect Color

Tone your support to set the stage for color dominance or contrast. Pastel painters frequently use tinted papers to contribute to total color impact. Weavers get a similar effect with a warp of a single color influencing every color woven across it. Glazes of transparent colors over a toned support are easily affected by an underpainting. With opaque colors, cover the entire support with a single color reflecting the desired dominant light or, for a vibrant color effect, its complement; then, allow this underpainting to show through by applying a layer of broken, dry-brush color. If you use tinted papers, restore whites with gouache or acrylic white.

**FIRST MOCCASINS**
Mike Beeman
Pastel on gray Canson paper
16" × 20" (41cm × 51cm)

SETTING THE TONE AT THE START
A toned support becomes part of the pastel as the artist builds up layers of color from dark to light. Some oil and acrylic painters also prepare their surfaces with a tone that helps to unify succeeding layers of color.

**EXERCISE 69:** TRY A TONED SUPPORT
Tone a support with a colored wash or use tinted paper. Do two simple paintings of the same subject, one on your toned support and the other on a white support. Use transparent glazes or broken color so the toned support can be seen. How does the toned support affect the painting? There should be a feeling of harmony, but the colors may not seem as bright. Repeat the exercise, using a different color for the underpainting. Note your results in your color journal.

   Tinted paper contributes to the overall color effect when used with opaque media. Transparent watercolor doesn't fare quite so well with colored paper, because the support changes the colors too much. Acrylic on canvas gets a vibrant shock from a complementary underpainting, and a less startling, but pleasing, sparkle from the white canvas showing through broken color.

Oil pastel on colored
pastel paper

Watercolor on tinted
watercolor paper

Acrylic on toned
canvas

Acrylic on untoned
canvas

# Realizing the Color in Shadows

Think of shadows as a transparent veil through which you can see the color of the surface they lie on, slightly darker in value than the surface, but not black and never opaque. Shadows needn't be neutral. Use a deeper value of the surface color, colors complementary to the dominant light illuminating the scene, or creative color that strengthens a color effect, not just cool blue or violet. If you prefer neutral shadows, use chromatic neutrals, mingling the colors rather than mixing them thoroughly. Experiment with different combinations of colors for rich, lively shadows.

**SANTORINI**
Jean H. Grastorf
Watercolor on paper
30" × 22" (76cm × 56cm)
Collection of the artist

AMBIGUOUS PLAY OF LIGHT
Chromatic shadows create movement in a placid street scene and define interesting shapes throughout the picture. While it's useful to establish a light direction and consistent shadows in some pictures, the ambiguous play of light in this one is much more vibrant and exciting.

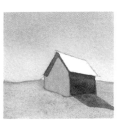

Opaque

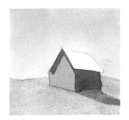

Cool

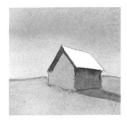

Warm

**EXERCISE 70:** GLAZE COLORFUL SHADOWS
Make three small color sketches of a simple object seen on a sunny day. For the shadow on the first sketch, lay down an opaque dark glaze. That doesn't look so good, does it? Glaze the second shadow with transparent violet, the complementary color to warm yellow light. This is an improvement, because the color of the surface shows through the glaze. Over the third shadow, wash a glaze that reflects the color of the object. Can you think of approaches that would make creative, vibrant shadows? Try them out. Compare your glazes and make notes in your journal on painting shadows.

Avoid making the dark, opaque shadow in the top example. The bottom left example is a typical cool violet-glazed shadow. At right is a more vibrant treatment, showing a warm shadow that's only slightly darker in value than the building. This treatment does a much better job of suggesting warm, bright light.

# Start with Shadows for a Self-Portrait

Years ago I learned to do watercolor portraits by painting the shadow structure on the face first. It's amazing to see how the ghostlike form quickly springs to life when flesh-color washes are laid over these shadows.

## MATERIALS

140-lb. (300gsm) cold-press watercolor paper • Watercolors (see colors below) • Brushes: no. 8 pointed Kolinsky round and ¾" (19mm) flat one-stroke sable or light ox hair brush • Reference photo • Drawing and transfer materials • Craft knife

### SELF-PORTRAIT PALETTE

These six colors seem a bit quirky for a portrait, but they have their advantages. Except for Cadmium Scarlet, there are no heavily staining colors, but the color has to be thinned and used as glazes. Davy's Gray and Cerulean Blue (Red Shade) are the two I use to begin a portrait, defining the facial structure by painting the shadows first. Both lift easily if you need to make corrections at this stage. Then, you can tint lightly, glazing over the shadows and the rest of the face with thinned Cadmium Scarlet and Naples Yellow, which give a velvety look to the skin. Go easy; you can always enhance cheek color, brow and chin later. In these areas, I go with Burnt Sienna to model the form in the facial areas and touches of pale French Ultramarine in the shadows.

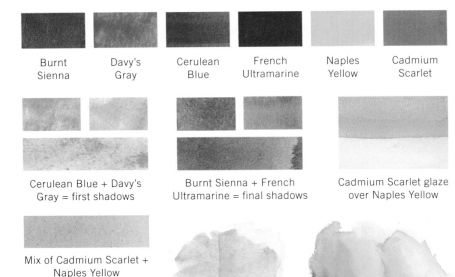

Burnt Sienna | Davy's Gray | Cerulean Blue | French Ultramarine | Naples Yellow | Cadmium Scarlet

Cerulean Blue + Davy's Gray = first shadows

Burnt Sienna + French Ultramarine = final shadows

Cadmium Scarlet glaze over Naples Yellow

Mix of Cadmium Scarlet + Naples Yellow

Glaze of Cadmium Scarlet/Naples Yellow mixture

Mingling colors

Burnt Sienna (to unify glazes in flesh tones and shadows)

## 1 EYES FIRST, THEN SHADOW STRUCTURE

After making my drawing from a reference photo, I use the no. 8 round to paint my eyes first, because I've learned that a portrait usually works if the eyes are convincing. I tone the whites of the eyes slightly with Davy's Gray. Note the pink at the inner corner of the eye and the shadow of the eyelid. Then, I paint the contours and lines of the face with a shadowy mixture of Davy's Gray and Cerulean Blue (Red Shade) watercolors. This will be darkened or warmed up later as needed, but now, I'm looking for structure.

In this close-up you can see the granulation from Cerulean Blue, which will add dimension under the glazes of flesh tones that come later. My eyes appear to be correctly aligned, but I wait to put in the highlights.

## 2 LAYER GLAZES FOR FLESH TONES

I layer thin glazes of a mixture of Naples Yellow and Cadmium Scarlet over the shadows and my skin. Here and there I touch in Burnt Sienna for slightly darker flesh tones. I go back into the Cerulean Blue/Davy's Gray mixture for the hair, with a very small amount of red to give it a violet cast on the shadow side of the head.

## 3 HAVE FUN WITH DETAILS

Now I can play—drawing the straw pattern in the hat and making an art-deco design on the scarf above the brim. Bringing out the dimension in the silver earring is fun, too. And, finally, the girl gets eyebrows and is allowed to wear lipstick.

## 4 BRING WHITE TO LIFE AND GLAZE TO UNIFY

I pick out the highlights in my eyes with the point of a craft knife; then I paint the hat with Raw Sienna and Burnt Sienna and the freehand scarf design with Dioxazine Violet. I add a little Dioxazine Violet (not on my portrait palette) into a soft gray mixed with French Ultramarine and Burnt Sienna for the shadows on my blouse. I unify the skin tones on the face with a thin glaze of Cadmium Scarlet to bring warmth to the portrait.

**SELF PORTRAIT**
Nita Leland
Watercolor on cold-press watercolor paper
22" × 15" (56cm × 38cm)

# When to Paint the Shadows

As you saw in the previous demonstration, some artists start by painting shadows first, building forms based on the light-and-dark pattern of an established direction of light. Then, they glaze color over these shadow patterns. Other artists complete the painting and add the shadows last, so they will be less likely to confuse the direction of light while painting. Still others develop the shadows as they go along, keeping a fixed source of light in mind throughout. Try all three methods and pick the one that suits you.

**SUN TI**
Susan McKinnon
Watercolor on paper
21½" × 29" (55cm × 74cm)
Private collection

**LIGHT AND SHADOW PERFECTLY MATCHED**
Vibrant combinations of warm and cool colors in the shadows pick up the complementary hues that dominate this painting. Transparent glazes lie on the smooth leaf surfaces, and the intricate shadow patterns are a strong counterpoint to the light.

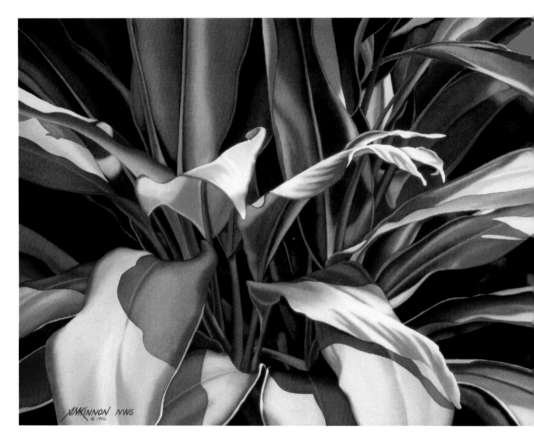

The shadow pattern moves across the sketch, unifying different areas in the picture.

When you add color, the shadows fall into place without calling undue attention to themselves.

**EXERCISE 71:** ATTEMPT A "SHADOWS FIRST" PICTURE
If you've never done a "shadows first" picture, try it now. Sketch your subject and create all the shadows with a low-intensity blue or violet or a chromatic gray. Pay careful attention to the patterns of the shadow shapes, connecting them to achieve a cohesive pattern. When the shadows are finished, glaze over them with the colors of the objects, influenced by the dominant light to unify the picture. You can add additional color and value contrast anywhere it's needed, when the glazes are dry.

# Seeing and Interpreting Changing Light

Different artists rarely represent light in the same way. To paint light, first you must carefully observe the light in nature and then determine what colors you need to achieve that effect or change it, if you want a different effect. Careful observers can see continuous variations in light, but this takes practice. Natural light changes constantly and is primarily influenced by the time of day, the geographic region, the season and weather conditions. Be aware of changes in indoor artificial light as well as outdoor natural light. Use your color journal to record your observations of light effects, then experiment with various ways of using color to represent them.

**THE MANY COLORS OF DOMINANT LIGHT**
These mingled colors show just a few of the myriad effects of dominant light. Try these combinations, then invent some of your own to express your favorite time of day, weather conditions or season in color.

**WAYS OF ACHIEVING LIGHT EFFECTS**
Use these checkpoints to evaluate how the effect of light is achieved in others' artwork and your own:

- Color dominance
- Contrast
- Light source
- Type of light (natural or artificial)
- Color scheme
- Glazing
- Gradation
- Toned support
- Shadows
- Reflected color

MORNING
Pearly soft:
Rose Madder Genuine,
Cadmium Scarlet,
Aureolin, Cobalt Blue

MIDDAY
Strong contrast:
Permanent Rose,
New Gamboge,
French Ultramarine

LATE AFTERNOON
Golden gray:
Permanent Magenta,
New Gamboge,
Cobalt Blue

SUNSET
Brilliant pure color:
Alizarin Crimson,
Cadmium Scarlet,
New Gamboge,
Phthalo Blue

MOONLIGHT
Soft monochromatic:
Cadmium Red,
Phthalo Blue

FOG
Soft monochromatic:
Burnt Sienna,
Raw Sienna,
French Ultramarine,
Davy's Gray

**EXERCISE 72:** STUDY AND SKETCH DOMINANT LIGHT
On the following pages you'll find descriptions of several qualities of dominant light and artworks that illustrate different aspects of light, along with brief explanations of how color contributes to create that particular effect. Study these examples, then make sketches of your own, using color to capture the sensation described. Plan your color effect with color schemes to get the most consistent effect of dominant light. Record the colors you used for your effects for future reference.

# Time of Day

Every time of day has its own special light. Early morning light is luminous and clear, with high-key color and gentle contrasts. Tints of scarlet, blue-green and violet express the awakening day. At midday a harsher light reveals intense contrasts of color and value, bleaching out highlights. Late afternoon light has a softer golden glow, with distant objects veiled in mist moving toward chromatic neutral tones. Twilight and early evening light are luminous, tending toward blue and violet, with the sunset a deep rich crimson. Atmospheric buildup throughout the day causes red rays to scatter widely and fill the sky and landscape with color.

**EXERCISE 73:** SHOW DIFFERENT TIMES OF DAY
Study the paintings on this page to analyze how the artists have depicted a particular time of day. Make your own sketches of color effects showing the changing light of day.

**SUNDOWNERS II**
Larry Moore
Oil on canvas
30" × 30" (76cm × 76cm)

SETTING LIGHT, BRILLIANT COLOR
Even without the title, a viewer might guess that Moore's painting is a sunset. He has used a brilliant palette here, playing with the backlight behind the boat to capture the receding light as well as the advancing darkness in the middle ground and foreground.

**DREAMSCAPE NO. 377**
June Rollins
Alcohol inks on ceramic tile
6" × 8" (15cm × 20cm)

COLOR IN THE DARK OF NIGHT
Rollins has used a powerful complementary palette to represent the dark night with the moon reflected on rolling hills. She pours the ink, then scrapes back to the white before the ink dries. Forming the hills is a trick of the wrist. Knowing which colors to use comes from experience.

# Geographical Location

The color of sunlight in the northern hemisphere is warmer in summer than in winter. The light of the southwest differs from that of New England. What's the dominant light like in your region? If you're not sure about this, you can easily find out by visiting a local art exhibit. Artists tend to paint the light they are most familiar with, often without even being aware of the influence in their work. Study the light in other areas to see how different they are from the light you are familiar with.

**EXERCISE 74:** CAPTURE THE UNIQUENESS OF REGIONAL LIGHT
Study the light of four different regions you've visited or would like to visit. Mingle colors to find combinations that suggest the light of each region and make sketches using the colors.

**PAROS, THREE BOATS**
Elin Pendleton
Oil on canvas
18" × 24" (46cm × 61cm)

A VIVID REMINDER
Certain places come immediately to mind when you think of bright light creating dramatic contrasts, and the area around the Greek islands is certainly one of them. Pendleton used high-intensity primaries plus green and Titanium White on gray-toned canvas to capture that sharp, clear light.

**WHISPERS**
Barbara Kellogg
Acrylic, gouache and collage on paper
22" × 30" (56cm × 76cm)

NORTHERN COOL
Kellogg's mysterious painting suggests a cool northern atmosphere. Neutral grays are tinged with violet and pierced by cool yellow light. Abstraction benefits from the harmony of dominant light by creating an ambience felt by the viewer, even when the subject is vague or the painting is nonobjective.

# Seasonal Light

Many artists see winter light as cold and use cool Phthalo Blue and violet with strong contrasts. Typical spring light is bright and tender, with gentler contrasts and clean, pure color: greens mixed with Cobalt Blue and Aureolin, and budding trees tipped with Permanent Rose. The light of summer is more robust when you use the rich color and contrast of a traditional palette. Think of autumn light and picture siennas and oxides against cool blue skies or brooding chromatic gray skies that imply the onset of winter.

**EXERCISE 75:** PAINT THE FOUR SEASONS WITH LIGHT IN MIND
Let me persuade you to paint the four seasons one more time—it's a great way to work with light. This time, show the harmony of light in every season. Use some of the colors described on this page as your starting point, keying your color to characteristics of the seasons with compatible palettes or color schemes.

**SPRING AWAKENING**
David R. Daniels
Watercolor on paper
33" × 65"
(84cm × 165cm)

WHEN ALL THINGS COME ALIVE AGAIN
The artist's free painting style combines with his bold palette to create a wonderful representation of the season of new growth. Unlike many artists, Daniels isn't afraid to use a lot of green.

**FOREST JEWEL**
Harold Walkup
Watercolor on rough watercolor paper
18¾" × 13" (48cm × 33cm)

THE COLORS OF WINTER
Prismatic colors glance off every surface in this sparkling winter scene. Reflected light from the stately tree adds warmth to the picture and brings the viewer's eye back to the center of interest. As you can see, a winter scene can be so much more than white snow and blue shadows.

# Weather Effects

Changes in the weather also have strong effects on dominant light. Clear weather has sharp contrasts and strong colors; fog and mist have close values and limited colors. A rainy day may be all neutral, except for the heightened color of wet objects reflecting in the puddles. Sometimes you can get a dramatic sense of a sudden storm approaching with a sunlit area surrounded by a background of dark storm clouds.

**EXERCISE 76:** DO SOMETHING ABOUT THE WEATHER
List words that describe weather conditions, for example: sunny, partly cloudy, stormy, rainy. Look them up in a thesaurus or dictionary. What colors would you use to paint these different situations? Write ideas in your color journal. Sketch a variety of weather conditions, using color to create the dominant light.

**CORNER OF**
Mark E. Mehaffey
Acrylic on panel
20" × 20" (51cm × 51cm)

WARMING UP WINTER SNOW
We've had a storm and now the sun is coming out and melting the snow. Do you see what Mehaffey has done here? Those touches of red where the sun is beginning to warm the landscape bring a smile. What a wonderful way to enhance a winter scene.

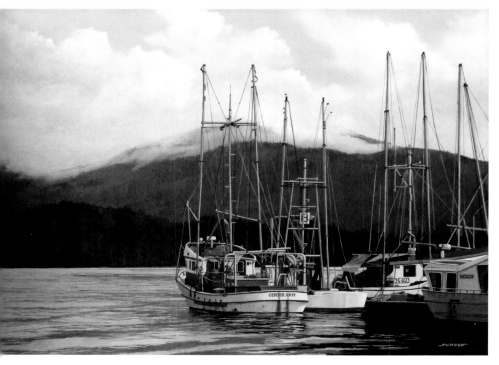

**BAROMETER RISING**
Douglas Purdon
Oil on linen
24" × 36" (61cm × 91cm)

ANCHORS AWEIGH
Lifting clouds signal that weather is improving. Purdon's boats sit in still waters. The quiet blues dominate, but the artist has strategically placed warm accents to entertain the viewer at the center of interest.

# UNIFYING COLOR AND DESIGN

IN ART THE CONTROL OF REASON MEANS THE RULE OF DESIGN. WITHOUT REASON ART BECOMES CHAOTIC. INSTINCT AND FEELING MUST BE DIRECTED BY KNOWLEDGE AND JUDGMENT. — JAY HAMBIDGE

**SIMPLIFIED**
Jean Pederson
Acrylic on canvas
16" × 12"
(41cm × 31cm)

**COLOR CODED**
Jean Pederson
Acrylic on canvas
36" × 48"
(91cm × 122cm)

Successful artwork is solidly based on proven principles with self-expression as part of the equation. Knowledge of design gives you confidence that you're going in the right direction; your intuition tells you if your plan really works. Georgia O'Keeffe called it "filling a space in a beautiful way."

Design is the arrangement of specific elements—line, shape, value, color, size, pattern and movement—in a composition. Color, as it interacts with other elements, is a significant force in design. The principles of design bring visual order to these elements. The ruling principle of artistic design is unity. Ideally, when a work is complete, nothing may be added or subtracted without destroying its unity. Your concept and arrangement of design elements should form a harmonious whole. Good design creates balance and unity, reinforces your expressive idea, and prevents confusion and disorder.

Plan these design relationships to support your expressive color concept, but don't treat your plan as though it were cast in concrete. You'll use some elements more than others, which helps to define your style. On the following pages we'll go over the elements and principles as they relate to color. When you fully understand the rules of design, you can deliberately and creatively break them for effect.

# Line

The element of line is the versatile backbone of a design. Line may be structural, confining shapes or describing a form. Line is sometimes descriptive, representing specific things with linear characteristics, such as a rope or the twigs on a tree branch. Lines may be decorative, lyrical, calligraphic or textural. Intersecting lines help to locate a center of interest. The character of a line may be elegant or strident, lazy or energetic, qualities that are enhanced by color.

**RODEO DRIVE I**
Angela Chang
Transparent watercolor
on paper
21" × 29" (53cm × 74cm)

LINES LEAD THE WAY
The colorful lines in this painting move rhythmically in and out of the picture, turning hot and cold. The artist selected intense colors that emphasize movement and that glow against a chaotic background of a city in perpetual motion.

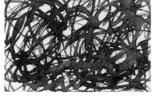

**EXERCISE 77:** INTEGRATE LINE AND COLOR
Make sketches featuring colored lines. Try a variety of complementary, analogous and neutral lines, and study their effects. First, make structural lines, containing objects. Then make descriptive lines, decorative lacy lines and symbolic lines, using colors representing feelings or emotions. Vary the color contrasts between the line and the background to change your emphasis. Note all these effects in your color journal.

Make a sharp, aggressive red line for excitement; a serene blue one for tranquility. A colored line analogous to its background harmonizes with it, while a complementary line stands out in sharp contrast. A jumble of colored lines creates texture and optically mixed color.

# Shape

Shapes—our next design element—may be simple, but they must also be visually interesting, with varying dimensions and edges. Whether your shapes are realistic or abstract, you can be inventive with color. A successful arrangement of colorful shapes is a visual delight. First, design the shapes and then make your subject fit into these shapes.

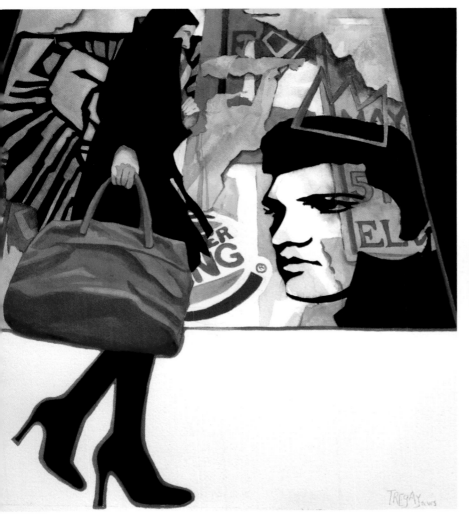

**THE KINGS AND I**
Susan Webb Tregay
Watercolor on
watercolor paper
21" × 21" (53cm × 53cm)

SHAPES THAT MOVE YOU
Tregay has created a powerful design of abstract shapes with a representational subject, contrasting strong colors with black and linear accents that move your eye irresistibly from one intriguing shape to another. As your eye moves throughout the picture, it doesn't take long for you to catch on to the visual pun in the title.

COMBINE TO SIMPLIFY
Combine several small shapes into larger shapes to simplify your composition and enhance the color effects.

**EXERCISE 78:** DESIGN COLORED SHAPES
Cut or tear shapes of different colored papers in color schemes of your choice. Try various arrangements in your color journal until you have several you like. Make small color sketches based on your collages.

Vary the colors of the shapes slightly, even when they are similar, to create a more active surface. What colors do aggressive, energetic shapes call for? Sensuous shapes? Gentle shapes?

# Value

Artists frequently debate the question of which element is more important, color or value. Well, that depends on the artist, the subject, the message, maybe even on how you happen to feel on a particular day. Don't ever underestimate the importance of value, even if you're a colorist. Value planning should be one of the first steps in the development of your picture.

High-key values

Low-key values

Full-contrast values

**EXERCISE 79:** COORDINATE COLOR AND VALUE
Values help distinguish shapes and identify objects; color key is dependent on values for its expressive effect. The high-key light values shown here express a gentle, atmospheric feeling; the low-key darker values are more dramatic; the full-value contrast gives a strong visual impact.

Use collage to relate colors, shapes and values without the distraction of detail. In your color journal, arrange colored paper or magazine clippings in a few cut or torn shapes, paying special attention to value contrast. Make abstract or representational shapes, whichever you prefer. Try several arrangements before you glue them down with paste or acrylic medium. Make some high-key, low-key and full-contrast designs. Then, pick the collages you like best and interpret them in paint.

**OTTERBEIN UNIVERSITY, TOWERS HALL**
Nita Leland
Watercolor on paper
24" × 18" (61cm × 46cm)
Private collection

CONNECTING WITH COLOR IN FULL-VALUE ARTWORK
Architectural portraits are usually full-value contrast paintings. By using a limited palette you can connect the subject to its surroundings with small touches of color that move throughout the picture, like the tinted clouds above. I placed my strongest contrasts of color and value in my focal point, the tower on the right.

# Size

Sizes of color areas have substantial impact on the strength of your design. When color areas are equal in the element of size, the design remains static and the color expression ambiguous. Different-sized pieces of color are more interesting than the same colors in equal-sized shapes. Big, bold shapes showcase color, as in Georgia O'Keeffe's large-scale close-ups of flowers.

The larger a color area, the greater the color effect. Colored shapes lose some of their impact when they are evenly distributed in a repetitive pattern. In concentrated areas they have greater effect, especially if the field around them is a complementary color.

**EXERCISE 80:** RELATE SIZES OF COLOR AREAS
Select or paint two complementary-colored papers. Cut each into an 8" (20cm) square, then into 2" (5cm) squares. Assemble half the squares to create a checkerboard pattern. Combine the remaining squares in a separate design, arranging larger areas of colored squares to create movement. Snip one square into a few small shapes to create a focal point. Note how three contrasts—of complementary color, intensity and size— add emphasis to the design. Use size relationships of colors to create effects of excitement or calm.

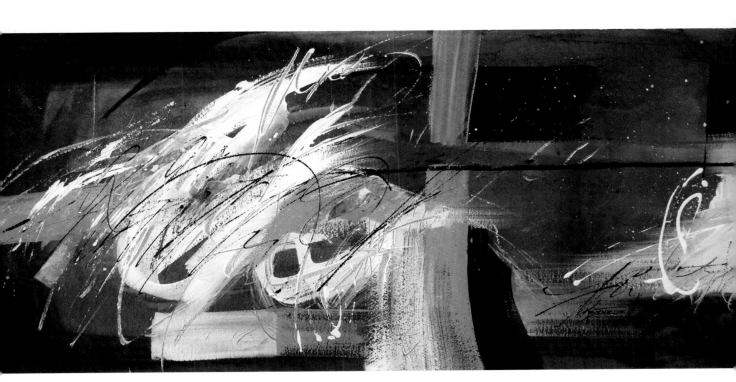

**A TRIP TO THE MIND**
Karen Becker Benedetti
Fluid acrylic, watercolor and collage on watercolor board
30" × 48" (76cm × 122cm)

ACTION AND REACTION
On a background of large blue shapes, small bold accents of contrasting color capture the eye at once. The orange strips are strategically placed to move the viewer into the center of the painting, where quieter shapes provide respite until the eye is inevitably drawn back into the excitement on the animated side.

# Pattern

Similarity and repetition of design elements create patterns across your artwork that guide the viewer's journey through your composition, sometimes providing decoration or the appearance of surface texture. When you repeat colors, make them relevant to the design and the color mood you want to express. Plan your repeated colors carefully to move the eye around the composition and into the center of interest. Bear in mind that pattern paintings don't always need a single focal point.

**EXERCISE 81:** PLAN PATTERNS WITH PURPOSE
Plan a pattern of shapes, colors and values in a small collage, either realistic or abstract. Snip pieces of colored illustrations from magazines or colored art papers. Start with large shapes. Move these around to help you visualize color and value patterns. Then add smaller colored shapes to create a moving path around the picture. Make a color sketch based on your collage, emphasizing color patterns.

   Three patterns are working in the small magazine collage shown. The yellow flowers are the main pattern; they are accented with repeated patterns of small red flowers to keep your eye moving; and the third pattern, texture on the tree stump, also contributes to the flow of the design.

**LEMONS, CHERRIES AND STRIPES**
Chris Krupinski
Transparent watercolor on rough watercolor paper
30" × 22" (76cm × 56cm)

AN EYE-CATCHING JUXTAPOSITION
Krupinski juggles several types of colored patterns and shapes throughout this colorful still life. The juxtaposition of natural fruit forms with geometric stripes makes an interesting arrangement. Repetition of shapes with variations in their sizes creates an energetic design pattern.

# Movement

Color plays an active role in controlling direction and speed of movement in a composition. Horizontal movement is serene, vertical is dignified, and diagonal is active. Color temperature also affects speed of movement: Warmer colors appear to move more quickly than cooler hues. Use warmer colors in the foreground to capture attention, then move through progressively cooler hues into deep pictorial space. To create an energetic push-and-pull effect, reverse color temperatures. To slow down the movement of high-intensity hues, lower their intensity.

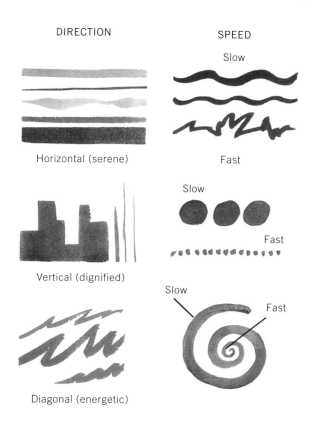

DIRECTION

Horizontal (serene)

Vertical (dignified)

Diagonal (energetic)

SPEED

Slow

Fast

Slow

Fast

Slow

Fast

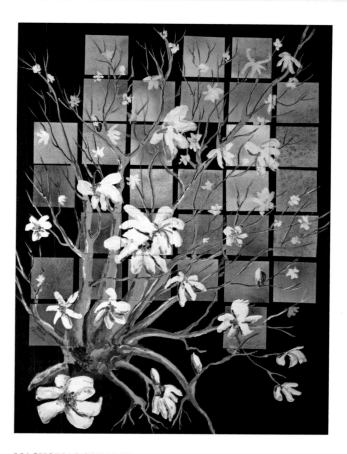

**EXERCISE 82:** CONTROL MOVEMENT
Do some warm-ups like those shown with your favorite medium, experimenting with colors to change the energy of lines and shapes. Practice matching your body energy with your strokes for more expressive lines: slow and meditative horizontals or bold, aggressive verticals. Make a sketch with several large horizontal shapes. Add two or three verticals or diagonals. Can you see how this energizes your design? Repeat the exercise, reversing the color temperature or changing your color scheme, using colored lines and shapes to create movement. You can use calm blue horizontals for serenity, powerful green verticals for dignity, vibrant red zigzags for energy. Allow intervals between lines and shapes to control the speed of movement. The warm-colored line that winds into a spiral moves more quickly where it is tightly wound than at its outer edge, where the color is cooler.

**MAGNOLIAS SQUARED**
Jane Phillippi
Transparent watercolor with opaque white watercolor on black mounting board
25" × 20" (64cm × 51cm)

ENERGY ON THE DIAGONAL
Most of Phillippi's "Trees Squared" series of watercolor collage constructions feature dramatic tree shapes painted on textured, 2" (5cm) squares collaged onto black board. The magnolia's branches reach out in a strong diagonal movement from the lower left corner, almost as if reaching for the sky.

# Harmony

Harmony is a principle that results from the relationships of similar elements in a design, such as restful lines, monochromatic or analogous color, serene movement, close values, or comparable shapes and sizes. All of these contribute to a sense of unity, the guiding principle of design.

**EXERCISE 83:** MAKE HARMONY YOUR GOAL IN A SERIES
Use analogous colors, close values, restful horizontals and simple shapes to make a series of three serene, harmonious sketches. If necessary, use a tiny bit more emphasis on one or more of the following elements to strengthen the visual design: richer colors, slightly stronger values, or more energetic shapes or lines. Don't go too far, or the effect will deviate too much from the idea of harmony.

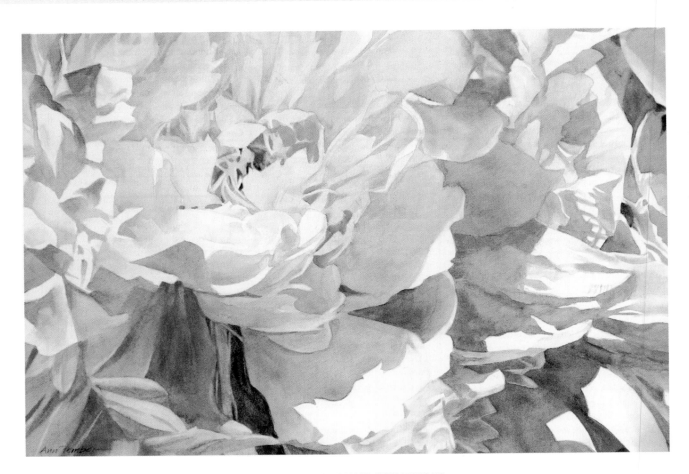

**PEONY BLOOM**
Ann Pember
Watercolor on paper
14½" × 21½" (37cm × 55cm)

JUST ENOUGH CONTRAST TO REMAIN HARMONIOUS
This high-key floral arrangement stays within a limited range of values that flow together harmoniously. There is enough contrast in color and value to create subtle visual excitement and exquisite light in a serene painting.

**EXERCISE 84:** SEE HOW YOU USE THE ELEMENTS AND PRINCIPLES
The elements and principles of design are meant to be guidelines—memorize them, use them consciously and eventually they'll become second nature to you. Make a checklist and study your recent artwork to see how you use these important design tools. Which ones appear most frequently in your work? Which are the most effective? Where are your weak spots?

ELEMENTS:
- Line
- Shape
- Value
- Color
- Size
- Pattern
- Movement

PRINCIPLES:
- Harmony
- Contrast
- Rhythm
- Repetition
- Gradation
- Balance
- Dominance

# Contrast

If you think too much harmony makes a boring picture, include soft contrasts of colors, lines and shapes in your composition. Dynamic contrast attracts attention to the most important area. Use value contrast for visual sensation and color contrast for emotional expression. Contrast edges, lines and shapes, changing colors to generate activity and movement. To dominant horizontals add gentle obliques; to analogous colors, a flicker of complementary contrast; to high-key color, more value contrast. Make your piece vibrate with contrasting, energetic color by using color schemes based on differences rather than similarities. Exaggerate color and value contrasts for impact.

**EXERCISE 85:** CREATE COLOR EXCITEMENT WITH CONTRAST
Create a solid design with simple shapes and value patterns. First, plan a sketch using an unrealistic color scheme with exciting colors. Then, whip up a color collage to see how the contrasting colors look together. If the piece seems too busy or the colors don't seem to work, lower the intensity of some of the colors or lay a unifying glaze to create dominant light.

**LOTUS**
David R. Daniels
Watercolor on paper
40" × 52" (102cm × 132cm)

BRING ON THE CONTRASTING COLOR
A full range of values from light to dark provides color excitement, with the bright flower emerging from light foliage against the dark background. Compare this with Pember's *Peony Bloom* on the previous page to understand the difference between harmony and contrast in color design.

# Rhythm

Establish rhythm by varying the spaces between related elements in a composition. Use line and color to aid the rhythm: a staccato hot-pink zigzag or a sensuous, elegant blue flow. Avoid interrupting a rhythmic progression, unless you intentionally wish to stop the movement. Be consistent with the sequence of shapes and colors, but provide variety. Conflicting rhythms disturb unity, so don't try to tango in the middle of a waltz.

**ANCESTRAL SPIRIT DANCE #208**
Willis Bing Davis
Oil pastel on black rag board
60" × 40" (152cm × 102cm)

THE RHYTHM OF WELL-PLACED LINES AND SHAPES
This dynamic piece is unified by a network of rhythmic colored lines and shapes against a black background that captures your attention. To work out an effective color pattern with pulsing, staccato rhythms, use repetition with variation, as shown on the next page.

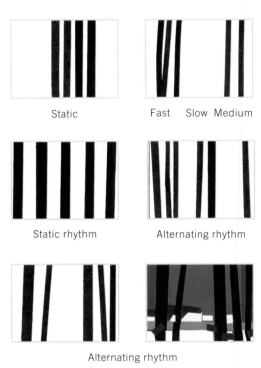

Static    Fast  Slow  Medium

Static rhythm          Alternating rhythm

Alternating rhythm

**EXERCISE 86:** PLAY WITH RHYTHM IN COLLAGE
Cut narrow strips of black construction paper in assorted widths. Arrange the strips vertically on small rectangles drawn in your color journal, varying the spaces between groups of verticals. Make several rhythmic arrangements and paste the pieces down. Can you sense how your eye moves more quickly across close verticals? The best place for a focal point is where the eye is moving at a leisurely pace. Make a color collage based on one of your designs, using intervals of color to enhance rhythmic movement.

Rhythm causes your eye to move quickly through closely spaced elements and more slowly across larger intervals. Vary spaces and intervals throughout your composition to keep the eye moving.

# Repetition

Repetition of line, color, value or shape reinforces whatever idea you're trying to communicate with that design element. Your viewer often singles out a certain color or shape and follows it through the composition. Use good judgment in your repetitions and avoid random placement. Plan carefully and place repeats where they will enhance rhythm, movement and pattern, and help the viewer's journey through the composition. Use variety with repetition to prevent boredom. There is no magic number for recurrences of a color.

**EXERCISE 87:** PRACTICE APPLYING VARIATION TO REPETITION
Develop a sketch exploring color repetition. Give your repetitions variety and rhythm. When working from nature, be selective among all the colors and shapes you have to choose from. Simplify. Find the important colors and place them strategically. Then repeat them with variations: red that is muted to Burnt Sienna or cooled down to violet; blue that is grayed or slightly tinged with green.

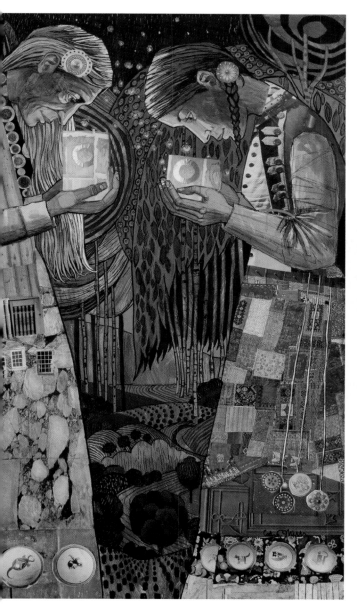

**RUTH & NAOMI'S LIGHT**
Cody F. Miller
Cut paper, acrylic and charcoal on Masonite
33" × 25½" (84cm × 65cm)

REPETITION WITH SLIGHT CHANGES HOLDS INTEREST
Similar repeating shapes are changed slightly in size, value, color or direction and placed in rhythmic sequences. The warm foreground colors advance, with the cool, lower intensity background receding into the distance.

**HAND-PRINT**
Doris J. Paterson
Acrylic on paper
7½" × 11" (19cm × 28cm)

RHYTHMIC COLOR PATTERNS
Paterson works intuitively with color in paintings that recall the spirit of a child. Follow the repeated patterns of symbolic shapes and colors and notice how subtly they are changed as they draw your eye irresistibly through the design.

Demonstration

# Maintain Rhythm with Brushwork

Oil and acrylic painter Lisa Palombo's intense palette follows the first precept of color contrast—contrast of pure hues. Notice how freely she applies her spectral paint colors directly on the paper, without mixing them on the surface to make mud. Working the entire surface to the same level as she builds her composition, she maintains a consistent rhythm with her strokes, creating a compelling image of moving water and fish.

## MATERIALS

140-lb. (300gsm) cold-press watercolor paper • Golden Heavy Body Acrylic paints: Anthraquinone Blue, Cadmium Orange, Cadmium Red Medium, Cadmium Red Light, Cadmium Yellow Medium, Cadmium Yellow Light, Permanent Green Light, Phthalo Blue, Titanium White, Ultramarine Blue • Golden heavy gel medium • Large and medium filbert brushes • Drawing pencil

PAINTING PREP

I tape all four sides of a full sheet of dry watercolor paper to my vertical easel. Then, I set up Golden Heavy Body Acrylic paints on my Sta-wet palette, which helps to keep them from drying too fast, along with spraying the paints now and then. The consistency of this paint is a lot like oils, my medium for thirty years. I feel like I'm icing a cake.

## 1 START WITH A COLOR MAP

I began painting koi in my oil waterscapes and chose to paint the fish in acrylics for this demonstration. After making a loose, gestural pencil drawing, I start painting freely with Ultramarine Blue, Cadmium Red Light and Cadmium Yellow Medium mixed with Cadmium Yellow Light. I like to fill the page with a color map using large filbert brushes.

## 2 DISTRIBUTE ADDED COLOR THROUGHOUT

Next, I mix Permanent Green Light with Titanium White and Cadmium Yellow Light, and distribute the greens throughout the entire surface. My focus is to build up the composition evenly and at the same level at every stage.

# 3 DEVELOP COLOR CONTRAST
Sweeping brushstrokes of dark blue (Ultramarine Blue and Anthraquinone Blue) establish the underlying rhythms of the water moving around the fish. I develop the color on the orange koi (using Cadmium Red Light, Cadmium Red Medium and Cadmium Orange), which contrasts with the blue water.

# 4 USE COLOR TO CREATE SHAPE
Now, more broken color is added in contrasting color (Phthalo Blue) to bring out the shape of the yellow koi and suggest flickering light beneath the surface of the water, flowing over the fish. I'm also defining edges and refining brushstrokes.

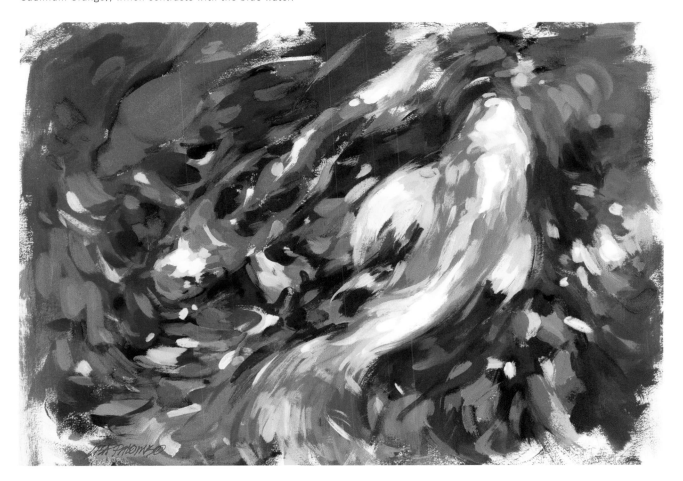

# 5 EVALUATE AND ADJUST
Smaller medium-length filbert brushes come into play to finesse the details. My painting process is intuitive and almost automatic, but to be sure I feel the painting is finished, I check my use of value, warm and cool colors, shades and intensities— as well as complementary colors—and I make adjustments where needed.

SUN KISSED
Lisa Palombo
Acrylic on 140-lb. (300gsm)
cold-press watercolor paper
22" × 30" (56cm × 76cm)

# Gradation

Gradual changes in design elements indicate movement, providing a graceful transition from one color area to another. For example, you can change color temperature gradually from warm to cool or change color values from light to dark. As shapes change, alter their colors, too. Gradation supports unity better than abrupt change, unless you wish to express a concept like violence or anger.

**ON THE EDGE**
Edwin H. Wordell
Mixed watermedia on collage papers
40" × 60" (102cm × 152cm)

GRADATION CREATES MOVEMENT
Wordell uses gradation to draw you through a tunnel-like shape into the background. Warmer colors, lighter values and higher intensities are near the front of the shape, with gradual changes of these elements as you move into the tunnel.

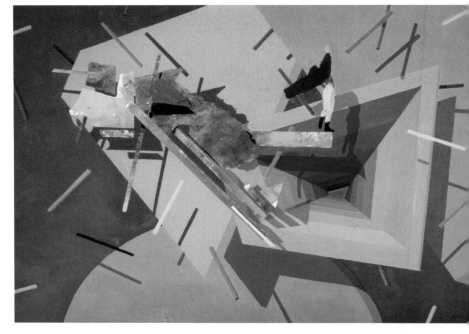

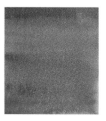

Temperature

Intensity and value

Neutral to intense color

Line and temperature

Shape, intensity and color

Size, intensity and value

**EXERCISE 88:** MAKE GRADATION WORK IN COLOR
Consider how you can use gradation with elements of design to create change and movement. Experiment with the gradual changes shown in these illustrations. Change a cool graceful line to an agitated line by gradually adding a warmer color. Change a color from warm to cool and from light to dark at the same time. Transform a red circle into a blue oval. Using two complements, move from one to the other with a series of changes through a neutral passage. Make a sketch combining color gradation with changes in other elements of design.

Gradual changes in design elements can be executed in numerous ways, contributing to rhythmic movement across a piece or into background space. How could you use some of the gradations shown with your subject matter?

# Balance

Balance results when design elements are distributed to produce an aesthetically pleasing whole. Identical elements on both sides of a picture make a symmetrical, formal design. Asymmetrical balance means unlike or unequal elements are arranged to counterbalance each other. Color intensity, value and temperature are other balancing factors.

The more elements you include, the more difficult your balancing act. Formulas don't work. Play with the color until you feel it works. Will a small hot spot balance a large, cool area? Does an intense passage seem too heavy for a neutral area? Use formal balance to suggest dignity, but don't get stuffy about it. The more emotional your message is, the more asymmetrical the balance and the more conflict in colors. Each touch of color changes color balance. When the balance essential to unity is achieved, your piece is finished. You'll know it when you see it.

 Symmetrical

 Off balance

 Asymmetrical

**EXERCISE 89:** MASTER A BALANCING ACT
Select a color scheme and cut assorted pieces of colored papers for the major shapes, repeating some shapes in a variety of sizes and colors. Visualize your piece first as a symmetrical design, placing matching colors and shapes equally on each side and gluing the pieces down. Cut another set of pieces identical to the first and crowd them together to exaggerate imbalance. Cut a third set and balance these in an asymmetrical composition. Alter the pieces as needed. Glue them down and use this as a model for a color sketch.

The symmetrically balanced collage looks a little stiff, to me; the center collage is too heavily weighted on one side; the asymmetrical collage seems better balanced. Trust your intuition to tell you when you've established visual balance with major and minor shapes. Ability comes with practice.

**BACK IN FIVE II**
Linda Daly Baker
Watercolor on 300-lb. (640gsm) cold-press watercolor paper
16" × 16" (41cm × 41cm)

ASYMMETRICAL COLOR BALANCE
Vertical shapes stabilize this design, and the slightly off-center doorway makes it more interesting. The counter-balance is with the horizontal center of interest—a bicycle and its strong attraction to the vertical red design on the wall.

# Dominance

When elements conflict, dominance restores unity. Color dominance makes the color statement coherent, focusing attention on your expressive intent. Colors usually dominate through intensity or quantity: the brightest color or the greatest area of color. Small areas of a single bright hue, when contrasted with a large neutral field, control because of their brilliance. A large shape of a single color overpowers several small shapes of different colors. Many bright colors are ruled by the one with the greatest area or highest intensity. A dominant color theme, with counterpoints of contrasting colors, creates interest and movement.

**EXERCISE 90:** ESTABLISH COLOR DOMINANCE
Select a color scheme for a sketch and plan your color to achieve dominance in one or more ways:
- temperature (warm or cool)
- shape (curved or angular with colors to match)
- intensity (bright or dull)
- dominant light

Using the elements and principles of design, select one to have greater importance than the others. Decide on your color dominance; plan the hue, value and intensity of every color area, its temperature, size and placement, for a unified composition.

**I'M SO HAPPY I COULD CROAK**
Sandy L. Ford
Acrylic on canvas
60" × 36" (152cm × 91cm)

GUIDE THE VIEWER'S EYE
The cool colors appearing here dominate in quantity, but the warm siennas and browns at the top of the picture push forward through the cattails and pull the eye down to the little frog about to croak.

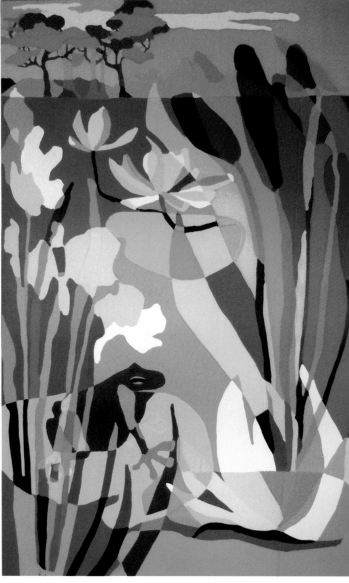

**UNDER THE SANIBEL SUN**
Karen Margulis
Pastel on sanded paper
5" × 7" (13cm × 18cm)

DOMINANT COLORS UNIFY
Here the artist allows warm reds and golds to dominate the color scheme, while analogous complements (blues and violets) play a supporting role in proclaiming the majesty of this natural phenomenon.

Demonstration

# Build and Enrich Color Layer by Layer

In this demonstration Margulis has a mental picture of her design, which she blocks in before anything else: high horizon line, a diagonal crossing from the lower left to the middle right and returning to left near the horizon. Her layout balances the picture space as she builds layers of color in pastel and is still evident in the final stages. Color dominance appears at the grand finale with broad strokes of red for the poppies, laid onto complementary greens of wild grasses and foliage, in an authentic interpretation of a real scene.

## MATERIALS

8" × 10" (20cm × 25cm) piece of La Carte pastel paper in Salmon • Hard and soft pastels in a variety of colors, including greens, reds, blues, yellows and white

MEMORIES IN FULL BLOOM
My photos and memories of the poppies I saw in full bloom during a trip to Sweden have inspired many pastel paintings since then. I use a photo reference sometimes to jumpstart the process, but the painting soon takes on a life of its own. When I take a photo, I'm able to recall the scene later with all my senses. I can still remember how moved I was, standing at the edge of the poppy field. I'll incorporate that emotion into the painting. Shown here is the color palette I will use.

## 1 A WARM-TONED BEGINNING
My support is a sanded surface that allows many layers of pastel to be applied. This surface gives a soft look to my pastel paintings. The toned support will make the greens in the field look more vibrant. I start with a quick, loose sketch using a light-colored piece of NuPastel, a hard pastel that doesn't fill in the tooth of the paper as quickly as soft pastels.

## 2 BLOCK IN THE DARKS AND THE DISTANCE
I block in the dark areas with a dark blue Terry Ludwig pastel, a handmade soft pastel that doesn't crumble. The square shape allows for making different marks, from lines to big sweeps of color. The distant land mass is a darker blue, and the sky includes two lighter shades of blue and a pale yellow.

## 3 INTRODUCE COOL COLORS

I continue to develop the dark areas of the foreground with cool, dark greens in the shadows, adding some of this to the base of the distant tree line and making a few marks in the distance to suggest trees. Now, I work from back to front using lighter, cooler greens for the distant fields. Short horizontal strokes in the distance help to push the fields back.

## 4 ADD WARMTH

Then, I come forward and add more to the wheat colors. Notice I have not yet touched the poppies, which are the stars of my painting. They will come last, and I will be able to add them on top of the greens.

## 5 ADD FOREGROUND GRASSES

I continue adding the grasses using warmer greens in the foreground. I have changed the direction of my strokes to vertical marks to suggest close detail, but notice that I am still making big, broad marks.

## 6 SUGGEST INSTEAD OF STATING IT ALL

Make linear marks to suggest grass, but don't get carried away trying to paint every blade of grass.

## 7 BRING IN BOLD COLOR

It's time to block in the poppies before continuing with the grass. I make bold marks with a deep brick red, applied with a natural rhythm, rather than trying to copy how they appear in my reference photo or en plein air. To finish the poppies, I use three different red pastels to suggest light striking every bloom. Each flower is a simple mark.

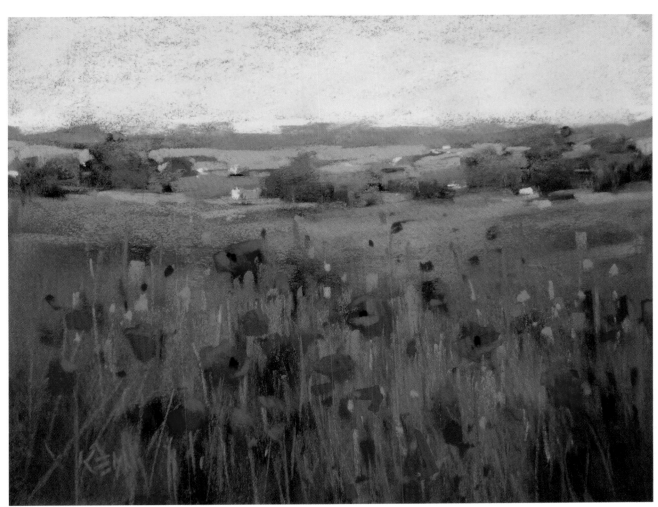

## 8 SUBTLE TOUCHES STRIKE A BALANCE

I add the finishing touches—a few strokes in the distance to suggest farm buildings—and touch some bright greens into the grass. The distant treetops are pushed back into space with light, atmospheric swipes of my soft pastel.

**WHERE POPPIES GROW**
Karen Margulis
Pastel on toned pastel paper
8" × 10" (20cm × 25cm)

# ASTM Color Index Guide

Brands of paint may differ widely in color and handling characteristics, even when made from the same pigments. The colors listed on these pages are generally acceptable substitutes for the colors I suggest in this book. There may be others, as well. To choose paints for your palette, do your own tests on transparency, intensity, tinting strength and lightfastness, using this chart as a starting point. You may use this chart for oils, acrylics and other mediums, but colors may differ because of differences in binders and other additives. Not all colors are available in every brand or medium.

| SWATCH | HUE | COMMON NAME | COLOR INDEX NAME | PIGMENT |
|---|---|---|---|---|
| | Process red (magenta) | quinacridone magenta | PR122 | quinacridone magenta |
| | | permanent rose, quinacridone rose | PV19 | gamma quinacridone (R) |
| | Red-violet | permanent magenta, quinacridone violet | PV19 | gamma quinacridone (B) |
| | Red | permanent alizarin crimson | PR N/A + PR206 | quinacridone pyrrolidone + quinacridone maroon |
| | | alizarin crimson | PR83 | dihydroxyanthraquinone |
| | | permanent carmine | PR N/A | quinacridone pyrrolidone |
| | | rose madder genuine | NR9 | natural madder |
| | | rose doré | PV19 + PY97 | gamma quinacridone + arylide yellow FGL |
| | | quinacridone red | PR209 | quinacridone red |
| | | pyrrole red | PR254 | diketo-pyrrolo pyrrole red |
| | | cadmium red | PR108 | cadmium sulfoselenide |
| | Red-orange | cadmium scarlet, cadmium red light | PR108 | cadmium sulfoselenide |
| | | scarlet lake | PR188 | naphthol AS |
| | Orange | permanent orange | PO62 | benzimidazolone orange |
| | | perinone orange | PO43 | perinone orange |
| | | pyrrole orange | PO73 | diketo-pyrrolo pyrrole orange |
| | | cadmium orange | PO20 | cadmium sulfoselenide |
| | Yellow-orange | cadmium yellow deep | PY35 | cadmium zinc sulfide |
| | | hansa yellow deep | PY65 | arylide yellow RN |
| | Yellow | new gamboge, Indian yellow | PY153 | nickel dioxine yellow |
| | | cadmium yellow | PY35 | cadmium zinc sulfide |
| | | azo yellow | PY154 | benzimidazolone yellow |
| | | transparent yellow, arylide yellow, hansa yellow | PY97 | arylide yellow FGL |
| | | permanent yellow lemon | PY175 | benzimidazolone yellow |
| | | hansa yellow light | PY3 | arylide yellow 10G |
| | | cadmium lemon | PY35 | cadmium zinc sulfide |
| | | cadmium yellow lemon | PY37 | cadmium sulfide |
| | | aureolin | PY40 | cobalt potassium nitrite |
| | Yellow-green | phthalo green yellow shade | PG36 | chlorobrominated copper phthalocyanine |
| | | permanent green light | varies | varies; test for lightfastness |
| | Green | Hooker's green | varies | varies; test for lightfastness |
| | | viridian | PG18 | hydrated chromium oxide |
| | | phthalo green blue shade | PG7 | chlorinated copper phthalocyanine |

| SWATCH | HUE | COMMON NAME | COLOR INDEX NAME | PIGMENT |
|---|---|---|---|---|
| | Blue-green | phthalo turquoise | PB15:3 + PG36 | beta copper phthalocyanine + chlorobrominated copper phthalocyanine |
| | | turquoise blue | PB15:3 + PG7 | beta copper phthalocyanine + chlorinated copper phthalocyanine |
| | | cobalt teal blue, cobalt turquoise light | PG50 | cobalt titanium oxide |
| | Process blue (cyan) | phthalo blue green shade beta | PB15:3 | copper phthalocyanine |
| | | manganese blue hue | PB15 | copper phthalocyanine |
| | Blue | cerulean blue | PB35 OR PB36 | cobalt tin oxide or cobalt chromium oxide |
| | | phthalo blue red shade alpha | PB15:1 | copper phthalocyanine |
| | | cobalt blue | PB28 | cobalt aluminium oxide |
| | | French ultramarine | PB29 | sodium aluminum sulfosilicate |
| | Blue-violet | ultramarine violet | PV15 + PB29 | sodium aluminium sulfosilicate (blue violet shade) + sodium aluminum sulfosilicate |
| | Violet | dioxazine violet | PV23 | carbazole dioxazine |
| | | cobalt violet | PV14 | cobalt phosphate |
| | Low-intensity red | Indian red | PR101 | calcinated synthetic red iron oxide |
| | | caput mortuum, Mars violet | PR101 | calcinated synthetic red iron oxide |
| | | brown madder, quinacridone burnt scarlet | PR206 | quinacridone maroon |
| | | perylene maroon | PR179 | perylene maroon |
| | | burnt sienna | PR101 or PBr7 | calcinated synthetic red iron oxide or natural iron oxide |
| | | light red, Venetian red, English red | PR101 | calcinated synthetic red iron oxide |
| | | burnt umber | PBr7 | natural iron oxide |
| | Low-intensity yellow | yellow ochre | PY43 | natural hydrated yellow iron oxide |
| | | Naples yellow | varies | varies; test for lightfastness |
| | | Naples yellow deep | PBr24 | chrome titanium oxide |
| | | raw sienna | PBr7 | natural iron oxide |
| | | quinacridone gold | varies | check availability |
| | | gold ochre | PY42 | synthetic hydrated yellow iron oxide |
| | Low-intensity blue | indigo | PB66; varies | indigo; test for lightfastness |
| | | indanthrone blue | PB60 | indanthrone |
| | | Antwerp blue | PB27 | hydrous ferric ferrocyanide or ferriammonium ferrocyanide |
| | Low-intensity green | olive green | varies | varies; test for lightfastness |
| | | green gold | varies | varies; test for lightfastness |
| | | terre verte (green earth) | PG23 | celadonite |
| | Neutral | neutral tint | varies | varies; test for lightfastness |
| | | Payne's gray | varies | varies; test for lightfastness |
| | | ivory black | PBk9 | burnt animal bone |
| | | Mars black | PBk11 | ferosoferic oxide |
| | | Chinese white | PW4 | zinc oxide |
| | | titanium white | PW6 | titanium oxide |

# Index of Color Exercises

# Index

# Contributing Artists

**JOHN AGNEW**
www.angelfire.com/id/wildscenes
*Keel-Billed Toucan*, page 67; *Looking for the Shore*, 120 © John Agnew

**DENISE ATHANAS**
www.deniseathanas.com
*Free Spirit*, page 17; *Green Reflections*, page 122 © Denise Athanas

**M.E. "MIKE" BAILEY**
www.mebaileyart.com
*Casino Dawn*, page 100 © Mike Bailey

**LINDA DALY BAKER**
www.lindadalybaker.com
*Afternoon Breeze*, page 121; *All in a Row*, page 25; *Back in Five II*, page 163; *Hangin' Around*, page 55 © Linda Daly Baker

**MIKE BEEMAN**
www.mikebeeman.com
*Easy Pose*, page 94; *First Moccasins*, page 138 © Mike Beeman

**KAREN BECKER BENEDETTI**
www.karenbenedetti.com
*A Trip to the Mind*, page 153 © Karen Becker Benedetti

**FABIO CEMBRANELLI**
www.fabiocembranelli.com
*Saint Emilion*, page 131; *White Flowers*, page 42 © Fabio Cembranelli

**ANGELA CHANG**
www.angelachang.net
*Afternoon at the Ramos Café*, page 8; *Rodeo Drive I*, page 150 © Angela Chang

**ROGER CHAPIN**
*Blue Hills*, page 126 © Roger Chapin

**DAVID R. DANIELS**
www.mrwatercolor.com
*Birch Landscape*, page 33; *Lotus*, page 157; *Spring Awakening*, page 146 © David R. Daniels

**WILLIS BING DAVIS**
www.facebook.com/pages/Willis-Bing-Davis-Art-Studio/114722461921347
*Ancestral Spirit Dance #208*, page 158 © Willis Bing Davis

**SYLVIA DUGAN**
*Life Is Just a Bowl of Cherries*, page 117 © Sylvia Dugan

**SANDY L. FORD**
www.sandylford.com
*I'm So Happy I Could Croak*, page 164 © Sandy L. Ford

**JANE FREEMAN**
www.janefreeman.com
*Angels Keep Watch*, page 135; *Party Pear*, page 92 © Jane Freeman

**JANIE GILDOW**
www.janiegildow.com
*Sparklers*, page 135 © Janie Gildow

**LAWRENCE C. GOLDSMITH**
www.lawrencecgoldsmith.com
*Twilight Radiance*, page 51 © Lawrence C. Goldsmith

**JEAN H. GRASTORF**
www.jeangrastorf.com
*Lindos Lace*, page 137; *Santorini*, page 139 © Jean H. Grastorf

**JANE HIGGINS**
*To Market*, page 45 © Jane Higgins

**GWEN TALBOT HODGES**
*Quick Pick*, page 134 © Gwen Talbot Hodges

**JUDY HORNE**
www.judyhorne.net
*Angel Dancers*, page 106; *Love That Turquoise!*, page 15 © Judy Horne

**DONNA HOWELL-SICKLES**
www.donnahowellsickles.com
*Songs for the Piecutter*, page 75 © Donna Howell-Sickles

**BARBARA KELLOGG**
www.barbarakelloggartist.com
*Whispers*, page 145 © Barbara Kellogg

**PATRICIA KISTER**
*Just Organic*, page 27 © Patricia Kister

**CHRIS KRUPINSKI**
www.chriskrupinski.com
*Lemons, Cherries and Stripes*, page 154; *Pitcher with Peaches and Cherries*, page 32 © Chris Krupinski

**LYNN LAWSON-PAJUNEN**
www.lynnlawsonart.com
*Memories of Maui #1—Red Ginger*, page 46 © Lynn Lawson-Pajunen

**NITA LELAND**
www.nitaleland.com
*Adobe*, page 129; *Aquarium*, pages 2–3; *Color Burst*, page 57; *Dream On*, page 73; *Fading Light*, page 61; *Focus*, page 52; *Free Spirit*, page 77; *Kudos to the Square*, page 174; *Los Tres Amigos*, page 109; *Mirage*, page 103; *Otterbein University, Towers Hall*, page 152; *Pirouette*, page 85; *Relics*, page 81; *Self Portrait*, page 141 © Nita Leland

**KAREN LIVINGSTON**
*Thistles*, page 38 © Karen Livingston

**GEORGIA MANSUR**
www.georgiamansur.com
*Autumn Colors*, page 6–7; *Rockin'*, page 87 © Georgia Mansur

**KAREN MARGULIS**
www.kemstudios.blogspot.com
*Doing the Dance*, page 79; *The Grand Finale*, page 30; *Under the Sanibel Sun*, page 164; *Where Poppies Grow*, page 167 © Karen Margulis

**LARRY MAULDIN**
www.theartistindex.com/LarryMauldin/portfolio.htm
*After Midnite*, page 124 © Larry Mauldin

**SUSAN MCKINNON**
*Sun Ti*, page 142 © Susan McKinnon

**MARK E. MEHAFFEY**
www.mehaffeygallery.com
*Corner Of*, page 147; *Like Minds*, page 27; *Red Tarp on a Cold Day*, page 130; *Rooster*, page 115 © Mark E. Mehaffey

**CODY F. MILLER**
www.codyfmiller.com
*Ruth & Naomi's Light*, page 159; *Tabitha's Gift*, page 120 © Cody F. Miller

**LARRY MOORE**
www.larrymoorestudios.com
*Barnography*, page 113; *Sundowners II*, page 144 © Larry Moore

**CARLA O'CONNOR**
www.carlaoconnor.com
*After Eight*, page 83 © Carla O'Connor

**JULIE FORD OLIVER**
www.juliefordoliver.com
*Abandoned*, page 29; *Ancient Pitcher*, page 112; *Yellow Crocs*, page 75; *Zinnia Glory*, page 29 © Julie Ford Oliver

**MARY PADGETT**
www.marypadgett.com
*Strawberries*, page 105 © Mary Padgett

**LISA PALOMBO**
https://lisapalombo.com
*Nuclear Cows*, page 107; *Out of the Blue*, page 54; *Sun Kissed*, page 161 © Lisa Palombo

**DORIS J. PATERSON**
*Hand-Print*, page 159 © Doris J. Paterson

**JEAN PEDERSON**
www.jeanpederson.com
*Color Coded*, page 149; *Simplified*, page 148 © Jean Pederson

**ANN PEMBER**
www.annpember.com
*Peony Bloom*, page 156 © Ann Pember

**ELIN PENDLETON**
www.elinart.com
*Paros, Three Boats*, page 145 © Elin Pendleton

**JANE PHILLIPPI**
*Magnolias Squared*, page 155 © Jane Phillippi

**DOUGLAS PURDON**
www.dougpurdon-artist.com
*Barometer Rising*, page 147; *Morning Departure*, page 69; *Retreating Storm—Ocean Grove, NJ*, page 125 © Douglas Purdon

**STEPHEN QUILLER**
www.quillergallery.com
*Aspen Patterns, Gold & Blue*, page 102 © Stephen Quiller

**ELLIE RENGERS**
*Times of Life*, page 119 © Ellie Rengers

**JUNE ROLLINS**
www.junerollins.com
*Dreamscape #100*, page 53; *Dreamscape #377*, page 144; *Dreamscape #640*, page 63 © June Rollins

**JOAN ROTHEL**
*The Morning After*, page 45 © Joan Rothel

**JADA ROWLAND**
www.jadarowland.com
*Vermeer's Table*, page 132 © Jada Rowland

**SUSAN SARBACK**
www.susansarback.com
*Breakfast*, page 101 © Susan Sarback

**THOMAS W. SCHALLER**
www.thomasschaller.com
*Chambers Street—NYC*, page 118; *Composition in Violet*, 133; *Night in the City*, page 16; *The Conversation—Girona*, page 116 © Thomas W. Schaller

**MARY JANE SCHMIDT**
*Tropical Series 125—Tropic Leaves*, page 68 © Mary Jane Schmidt

**PAUL ST. DENIS**
www.paulstdenisartist.com
*Blue Abstract*, page 50; *Marketplace*, page 9; *Raptor*, page 117 © Paul St. Denis

**MAGGIE TOOLE**
www.maggietoole.com
*Still Hopeful*, page 127 © Maggie Toole

**SUSAN WEBB TREGAY**
www.tregay.com
*My Fearless Future*, page 114; *Skipper*, page 15; *The Kings and I*, 151 © Susan Webb Tregay

**VELOY VIGIL**
*Tenderness*, page 65 © Veloy Vigil

**HAROLD WALKUP**
www.artbyharold.com
*Berry Farm Morning*, page 104; *Forest Jewel*, page 146; *Orange Tree Reflections*, page 95 © Harold Walkup

**EDWIN H. WORDELL**
*On the Edge*, page 162 © Edwin H. Wordell

**KUDOS TO THE SQUARE**
Nita Leland
Color-aid paper collage on cold-press
illustration board
10" × 10" (25cm × 25cm)

**Exploring Color Workshop, 30th Anniversary Edition**.
Copyright © 2016 by Nita Leland. Manufactured in USA. All
rights reserved. No part of this book may be reproduced in
any form or by any electronic or mechanical means including
information storage and retrieval systems without permission in
writing from the publisher, except by a reviewer who may quote
brief passages in a review. Published by North Light Books, an
imprint of F+W Media, Inc., 10151 Carver Road, Suite 200, Blue
Ash, Ohio, 45242. (800) 289-0963. First Edition.

SRN: S7755
ISBN 978-1-4403-4515-9

Project Managed by Noel Rivera
Edited by Stefanie Laufersweiler
Designed by Jamie DeAnne
Production coordinated by Jennifer Bass

The permissions on pages 172–173 constitute an extension of
this page.

a content + ecommerce company

fwcommunity.com

20  19  18  17     5  4  3  2

DISTRIBUTED IN CANADA BY FRASER DIRECT
100 Armstrong Avenue
Georgetown, ON, Canada  L7G 5S4
Tel: (905) 877-4411

DISTRIBUTED IN THE U.K. AND EUROPE
BY F&W MEDIA INTERNATIONAL LTD
Brunel House, Forde Close, Newton Abbot, TQ12 4PU, UK
Tel: (+44) 1626 323200, Fax: (+44) 1626 323319
Email: enquiries@fwmedia.com

### Metric Conversion Chart

| To convert | to | multiply by |
|---|---|---|
| Inches | Centimeters | 2.54 |
| Centimeters | Inches | 0.4 |
| Feet | Centimeters | 30.5 |
| Centimeters | Feet | 0.03 |
| Yards | Meters | 0.9 |
| Meters | Yards | 1.1 |

Photo by Bob Leland

# About the Author

An Otterbein University graduate with a double major in English and speech/theater, Nita Leland started her art career in 1970 in a YMCA watercolor painting class while raising four children. She has taught hundreds of art workshops throughout the United States and Canada, beginning in 1980 with Exploring Color Workshops. Her student-centered workshops and books are useful to the practicing artist and teacher, as well as the novice.

Nita is the author of several best-selling art-instruction books published by North Light Books, including *Exploring Color* (1985), *The Creative Artist* (1990), *Creative Collage Techniques* (1994), *Exploring Color Revised* (1998), *The New Creative Artist* (2006), *Confident Color* (2008) and *New Creative Collage Techniques* (2011). Her informative articles on color, creativity and collage have appeared in numerous art-instruction magazines, including *The Artist's Magazine*, *Somerset Studio*, *Watercolor* and *Watercolor Magic*.

Nita's award-winning artwork, which includes transparent watercolor, collage and experimental watermedia, has been juried into many shows. She manages her website Exploring Color & Creativity (www.nitaleland.com) and a blog (www.nitaleland.blogspot.com) and is the featured artist in several North Light videos: *Creating Confident Color*, *Paper Collage Techniques*, *Creative Art Class* and *Collage Art Techniques*, available at NorthLightShop.com.

# Acknowledgments

I'm deeply indebted to Jamie Markle, creative publisher of North Light Books, for the opportunity to develop this special edition of *Exploring Color*. Having my favorite editor, Stefanie Laufersweiler, on my team has made the job a pleasure, as always. Thanks to Mona Clough for shepherding my proposal through the acquisitions process and to designer Jamie Olson and the production team, including editor Noel Rivera. I'm grateful to all who contributed their expertise to this and the two *Exploring Color* books that preceded it. Artists frequently tell me how much they appreciate these guides, and I hope future artists will find this expanded, updated version equally useful.

As a teacher, I owe my greatest thanks to my students at Hithergreen and Rec West Enrichment Center, whose ongoing feedback and support continue to be invaluable. I also want to thank a few special people: I'm grateful to Fritz Henning for finding merit in my original manuscript in 1984, and to David Lewis and North Light Books for believing *Exploring Color* worthy of the revised edition in 1998. Finally, I'm grateful to the fifty-seven amazing artists whose works grace the pages of this book, especially Karen Margulis and Lisa Palombo, who contributed step-by-step demonstrations.

# Ideas. Instruction. Inspiration.

Receive FREE downloadable bonus materials when you sign up for
our free newsletter at artistsnetwork.com/Newsletter_Thanks.

Find the latest issues
of *Watercolor Artist*
on newsstands, or visit
artistsnetwork.com.

These and other fine North Light
products are available at your
favorite art & craft retailer, book-
store or online supplier. Visit our
websites at artistsnetwork.com
and artistsnetwork.tv.

Follow North Light Books for the latest
news, free wallpapers, free demos and
chances to win FREE BOOKS!

## Visit artistsnetwork.com and get Jen's North Light Picks!

Get free step-by-step demonstrations along with
reviews of the latest books, videos and down-
loads from Jennifer Lepore, Senior Editor and
Online Education Manager at North Light Books.

## Get involved

Learn from the experts. Join the conversation on